Penguin Classics of World Art

The Complete Paintings of Dürer

Albrecht Dürer was born in Nuremberg in 1471, the son of a goldsmith. He made his debut as an artist with the famous silverpoint *Self-Portrait*, which he executed at the age of thirteen while an apprentice in his father's workshop. After overcoming parental opposition he was bound for three years to the painter Michael Wolgemut. He then undertook journeyman travels, visiting Colmar, Basle and Strasbourg. He returned to Nuremberg in May 1494 where he married Agnes Frey. In the autumn of that year he made his first visit to Italy and this initial encounter with the ideas of the Renaissance had a profound effect upon him and the direction of his art. Dürer returned home in the spring of 1495 and took up his woodcut and engraving work; the remarkable series of watercolours of alpine scenery, among the most evocative in landscape painting, date from this year. The first of Dürer's great books, *The Revelation of St John*, was published in 1498. In 1505 he again visited Italy, where he was fêted and lived the life of a nobleman. In a letter he wrote, 'How I shall long for the sun in the cold. Here I am a gentleman, at home I am only a parasite.' He met Giovanni Bellini whom he greatly admired and painted several works, including *The Feast of the Rose Garlands*. On his return he concentrated on the study of mathematics, geometry, Latin and humanist literature, and sought the company of scholars rather than of his fellow artisans. In 1512 he became court painter to the Emperor Maximilian I and in 1520 he obtained from Maximilian's successor, Charles V, confirmation of his post and pension. In the latter part of his life Dürer devoted more time to his theoretical interests and made plans to write a treatise on art. The last major works, the portraits of Muffel, Holzschuher and Kleberger, *The Virgin with the Pear* and the magnificent *The Four Apostles*, were all executed in 1526. Dürer died on 6 April 1528 and his remains lie in the cemetery of the Church of St John in Nuremberg.

Dürer's enormous *œuvre* consists of woodcuts, engravings, paintings, preparatory and independent drawings, theoretical treatises and a detailed diary of his Netherlands journey. Dürer was the first German artist to have a reputation which, during his lifetime, spread far beyond his own country, and his work can be compared with the great contemporary Italian artists. His genius enabled him to handle with superb craftsmanship the cultural traditions of his native land, whilst at the same time assimilating the ideas and techniques of the Renaissance. In 1506 he wrote to a friend from Venice, 'I have stopped the mouths of all the painters who used to say that I was good at engraving but, as to painting, I did not know how to handle my colours.' It is generally thought that Dürer's graphic art is superior to his paintings but as Alastair Smith writes, 'Although his panels and canvases are lesser works of art, they are perhaps clearer documents of his personality. They constitute the conscious effort of a German, born a draughtsman and print-maker, to learn an alien tradition ... That Dürer's paintings were admired by ... men like Bellini and Mantegna, is measure enough of their achievement.'

The Complete Paintings of

Dürer

Introduction by **Alistair Smith**
Notes and catalogue by **Angela Ottino della Chiesa**

Penguin Books

Penguin Books Ltd, Harmondsworth, Middlesex, England
Viking Penguin Inc., 40 West 23rd Street, New York, New York 10010, U.S.A.
Penguin Books Australia Ltd, Ringwood, Victoria, Australia
Penguin Books Canada Limited, 2801 John Street, Markham, Ontario, Canada L3R 1B4
Penguin Books (N.Z.) Ltd, 182–190 Wairau Road, Auckland 10, New Zealand

First published by Rizzoli Editore 1968
This translation first published in Great Britain by Weidenfeld & Nicolson Ltd, 1971
Published in Penguin Books 1986
Text adapted and updated by Sebastian Wormell

Photographic sources

Colour plates: Ashmolean Museum, Oxford; Blauel,
Munich; British Museum, London; Brunel, Lugano;
Marques, Lisbon; Metropolitan Museum of Art, New York;
Meyer, Vienna; National Gallery, Washington D.C.; Photo
Flammarion, Paris; Domínguez Ramos, Madrid; Schroll,
Vienna; Scala, Florence; Staatliche Kunstsammlungen,
Kassel; Staatliche Museen, Gemäldegalerie Dahlem,
Berlin; Wallraf-Richartz-Museum. Cologne.
Black and white illustrations: Archives Photographiques,
Paris; Accademia Carrara, Bergamo; Rizzoli Archives,
Milan; Bayerische Staatsgemäldesammlungen, Munich;
Hessisches Landesmuseum, Darmstadt; Kunsthalle,
Bremen; Museum Boymans-van Beuningen, Rotterdam;
Museum of Fine Arts, Boston, Mass.; Národni Galerie,
Prague; Steinkopf, Berlin.

Introduction

Dürer was highly aware of being Dürer. Perhaps the most outspoken document of this self-consciousness and our clearest guide to his intentions is his self-portrait of 1500 (plate XVI). Here the artist does not portray himself objectively but invents an image of himself for (public) display. We do not see a record of Dürer as he was, but as he declared himself to the world – the artist in his public persona. He presents himself *imitatio Christi*, with the long centre-parted hair and in the full-face pose usually reserved for images of the Redeemer himself. The steadfast gaze, the unearthly luminosity of the stare, the inhuman symmetry of the pose all make the comparison between the artist and Christ. But what may seem a smack of arrogance was a deeply serious protestation. Dürer openly declares that he is to emulate Christ in his own way. In his miraculous creativity, in his self-sacrifice and in his attempt to communicate the truth to men, he will adopt the most dedicated mode of life. Further, just as the artist's appearance is translated into the image of Christ, so his name is translated into the language of the Latin past. The signature – *Albertus Durerus Noricus* – is almost a supplementary proclamation that the artist would remain a Northerner *(Noricus)* but would master the visual style of the antique world.

Dürer made this declaration of artistic intent at the age of twenty-eight, after having made several self-portraits in various media. His first showed him to be a child prodigy (page 83). It is executed in the difficult medium of silverpoint in which the sharp, precise line and the lack of opportunity for changes demand an unfaltering hand and an unhesitant mind. What is astonishing is not only the boy's technical success but also the image itself. It is, in the whole period of history, rare for a young boy to make a self-portrait, but for a thirteen-year-old to do so in an age when the self-portrait as a genre was not yet established, pre-

supposes a self-awareness almost as unhealthy as the conceptual feat is daring. This sophistication is borne out in the treatment of the image. The cool, detached, self-contained boy is the product of the chillingly objective introspection of the young artist.

The clear gaze of the child became the more knowing scrutiny of the adolescent. Greater self-knowledge and a study of his own moods are evident in the pen-drawing at Erlangen (page 83). Here the hand steadying the head and the sombre expression of the dark face pre-figure the later pose of *Melencolia I* (page 117). The young man (of nineteen or twenty) was already conscious of the double-edged quality of his genius. Soon afterwards, he made his third autobiographical drawing (page 83). On the back of a sheet on which a cushion is minutely studied six times, he studied a hand in the attitude of drawing, this looming larger than his head, as if, at this time, the development of his technique was more important than his thought.

It is in his painted *Self-portrait* of 1493 (plate I) that he first adopts a persona. Fully adult in his self-awareness, he cloaks himself in a disguise. The fashionable doublet, rakish cap and eryngium flower (symbol of fidelity in love) define him as Dürer the Lover. The splendour of the costume, however, pathetically sets off the carefully dishevelled locks and the sad, appealing stare of the suppliant separated by his travels from his future bride.

Dürer's habit of minute self-examination, both physical and psychological, is documented in the above works. As he matured, however, his scrutiny turned to include not only his interior self but also his exterior environment. His consciousness deepened, his curiosity widened. Having been impressed by Italian art through prints, he undertook his first journey to Italy (Autumn 1494 – Spring 1495). This, the first recorded pilgrimage of a German artist south of the Alps,

changed the further development of all German visual expression. Here Dürer became acquainted at first hand with "the arts of measurement, perspective and other like matters", as he was later to write. It was here that his aspirations first became truly concrete. Previously self-aware enough to adopt the artificial guise of the Lover in his 1493 *Self-portrait*, he now consciously assimilated the Italian style. The effect upon him, personally and stylistically, is obvious in the Prado *Self-portrait* of 1498 (plate XI). He appears as a svelte, composed young man, his hair carefully curled as if by a servant, his hand gloved in denial of the part that manual labour played in his art. He is, in short, Dürer the Gentleman, laying claim to the social position granted to Italian artists but not to their German counterparts who were ranked as mere craftsmen. Conscious now of the gulf between German and Italian art, aware not only of his talents but of his mission, he deliberately set out to change the history of German art and to make his own works the seeds of this change. In the Munich *Self-portrait* (plate XVI) he signals his dedication to the teaching of the gospel in Germany – the gospel of the Italian style.

Previous to 1494, Dürer had founded his art on the models available to him in the North, where there was a strong graphic tradition. His drawings and woodcuts to this date, and also his painted portrait, show him to be peerless in his draughtsmanship and observation. The rhythm of his contours defines the emotional content of his works and yet simultaneously describes three-dimensional objects. Abstract, formal value exists side by side with realistic description. His encounter with Italian art introduced him to classical subject-matter, to the techniques of scientific perspectival construction and anatomical analysis. The works executed between his two sojourns in Italy (the second lasted from 1505 to 1507) show the artist's attempt to come to grips with Italian criteria of art-making. His Madonnas (plates VIII and IX), his newly-found anatomical precision (*Adam and Eve* engraving, page 117), his perspective (plate XXIII) and his sense of the elegant and heroic (*St George*, plate XXII) are all direct products of Italian example. He was undoubtedly impressed by the characteristic brilliant colour and expressive landscapes of Venetian painters. His own watercolours (plates II – VIIB), while partaking of Venetian emotional expression through landscape, retain their northern sense of the particular. Similarly his *Portrait of Oswolt Krel* (plate XIII) adopts the Venetian motif of a cloth back-drop,

but the linear excitement is northern in origin. The total is pure Dürer, however, in its precise, frank characterisation of the neurotic, impetuous Krel, the hysterical expression of the head being heightened by the searing red foil and twisting tree-trunks.

Dürer's conscious assimilation of Italian ideals, which intensified during and after his second visit, seems to have demanded over the years that he make some paintings which are purely northern in spirit. It is almost as if he felt the need to step out of the artificially induced classic personality and paint, occasionally, *au naturel*. Works devoid of Italian proportion and antique dignity but full of sympathy and tenderness, often laced with gothicising femininity and lyricism, appear throughout the years (plates XXVII – XXIX and XLI).

Dürer, nevertheless, increasingly measured his own achievement in painting by Italian standards. In 1506, he wrote to his friend Pirckheimer from Venice, "I have stopped the mouths of all the painters who used to say that I was good at engraving but, as to painting, I did not know how to handle my colours". His true achievement is perhaps not colouristic, but rather lies in his highly intellectual, sophisticated use of the Italians' main contributions to painting, i.e. realistic pictorial space and highly plastic figures. These two attributes are in a major way responsible for the highly physical and realistic effect common to all Italian pictures around 1500. Dürer's greatest use of this reality-creating vocabulary is, strangely, in the creation of a visionary experience, *The Adoration of the Trinity* (plate XLV). Here the universe is represented at the end of time with the Trinity accepting saints, pre-Christian characters and all manner of earthly men into the City of God. Beneath this, dawn breaks over the "new earth" re-created after destruction by fire. The artist himself is its only inhabitant. The high, luminous colour leaps to the eye with the suddenness of a flash of intuition. This intuition becomes concrete; imagination is given physical reality by the amazing illusionism of Dürer's description. The plastic emphasis makes the massed figures project from the plane; their overlapping diminution produces infinite depth – space itself. The inclusion of portraits heightens the reality of the dream. Miraculously, the heavy tangible rows of figures float in the air. Their weight is given weightlessness by the magnetism of the Trinity. The spectator is sucked into the composition by the sheer force of the perspectival illusion.

These space-creating techniques and methods of

ordering a multitude of figures were obviously gleaned by Dürer from the Italians. But he in no way sacrifices, in the unity of the design, his own northern concreteness of detail. He has learned how to make his pictures one unified whole to which the linear detail is subordinated. Previously, when attempting an image which could be seized by the eye in one glance and its atmosphere sensed by the spectator in one moment (plate XXXIX), he had found it necessary to relax his detail. Now we find that his portrait poses or figure groupings (plates L and LI) will have an almost geometric simplification of contour, while, in areas, the modelling may similarly tend to rationalised generalisation (plates LII and LIII). His latest pictures amazingly combine a unified image, to which the spectator can relate immediately, with a core of detail which is read piece by piece after the total image has been appreciated. Portraits read in this manner (plates LVIII and LXIV) thus present the spectator with a definite analogy to the meeting of an actual person. First a general impression is formed, then a closer acquaintance is possible. The hallmark of Dürer's later paintings is not simply a precision of characterisation (plates LIX – LXII) in which each man's particular individuality is portrayed with sympathy and admiration (plate LVII). There exists also a greater sculptured quality than in the earlier works (plate LIV), and he even imitated sculptured busts in the oil medium (*Catalogue* no. 185). This final, three-dimensional, marbled manner shows him closer to the ideals represented by Mantegna than ever before. The Italian who most impressed Dürer in his youth is also his last influence.

Art historians have always stressed the superiority of Dürer's graphic work over his paintings. Although his panels and canvasses are lesser works of art, they are perhaps clearer documents of his personality. They constitute the conscious effort of a German, born a draughtsman and print-maker, to learn an alien tradition, a tradition which stretches back to the era of antique sculpture and reaches its apex in Italian painting around 1500. That Dürer's paintings were admired by the perfectors of the style, men like Bellini and Mantegna, is measure enough of their achievement. What these paintings could not teach to the German artist, Dürer put in verbal form in his treatises, emulating the Italian artist-theoretician to the last. One might echo Camararius who asked, "What can one say of the steadiness and exactitude of his hand?" by adding, "What can one say of the steadiness of his purpose?"

ALISTAIR SMITH

An outline of the artist's critical history

Waagen, writing in the mid-nineteenth century, maintained that the appeal of Dürer's works depends on the degree to which they reflect a pure, noble and truly German spirit. "When we consider the conditions under which such a quantity of true works of art were made, our admiration turns to emotion. One is tempted to compare the artist to a tree which springs up on barren ground and is gnawed by cold and battered by winds but which nevertheless asserts its latent strength. It has a hard, gnarled bark, and thrusts itself vigorously upwards, spreading out a rich leafy plumage." The literature on Dürer abounds in better definitions and more apt analogies than this, but Waagen's description is worth considering because it pinpoints those characteristics in Dürer's art which have been constantly referred to throughout three centuries. The importance of the man, the biographical context, the problems of environment, the links with Italy, the limitations (dryness, harshness, an apparent lack of a sense of formal beauty, the hard, almost metallic, colouring, the compositional weaknesses) and the merits (imagination, scientific knowledge, and technical versatility): all of these are aspects of his art which have been dwelt on time and time again.

The man himself has always been interesting. His qualities, such as mildness, good breeding, devoutness, honesty and loyalty, became legendary in the decades following his death, thanks to a reputation which was without parallel in his day. Later, the revelations of the letters, diaries and other autobiographical writings could well have modified if not completely changed the accepted picture of his character. The bizarre and eccentric quirks of character coupled with a certain naivety, evident even in his maturity, gave a fuller image of the artist which added to the too austere or over-assured characterisations of the famous self-portraits. "Poor Dürer", wrote Goethe, in Bologna on 18 October 1786, "to think that in Venice he miscalculated and made a deal with that bunch of priests which cost him weeks and months of his time; when he was travelling in the Netherlands, he bartered those superb works of art, with which he had hoped to make his fortune, for parrots; to save himself tips he made portraits of the servants who had brought him a dish of fruit. The thought of that poor fool of an artist distresses me infinitely, because ultimately my fate is the same as his, with the difference that I know how to look after myself a bit better." Goethe's provocative assessment was not followed up. For Schlegel Dürer was the Shakespeare, the Jakob Böhme, the Luther of painting. Franz Pforr, the head of the confraternity of St Luke and a member of the Nazarene movement, considered Dürer the indispensable model for an original and modern art. To Peter Cornelius we owe the two epithets "passionate and ascetic" with which Dürer's work has long been credited. On 20 May 1815, Cornelius organised a celebration at his own house to mark Dürer's birthday. Arranged around the portrait of the master were an oak wreath and an assortment of palettes, paint brushes, compasses and burins, and on a table set up as an altar were prints and engravings. An autobiographical extract was read, and the group made a solemn pledge to commemorate the event every year. The ceremony was described by Friedrich Overbeck. In 1840 Overbeck painted a large *Triumph of Religion in the Arts* (or *Alliance of the Church with the Arts*) in which Dürer was given a place of honour. The illustrator of the *Apocalypse* was seen as both the guardian of virtue and decency and as a champion of the Catholic church. His *Self-portrait* of 1500 (Munich) in which he appears posed as the Redeemer (*Catalogue* no. 59), his hair parted in the middle, falling in luxurious ringlets, with a short beard and long smooth moustache around a sensuous mouth, became the talisman of the new school. In other words, the image of Dürer as a simple, devout, indefatigable, versatile and essentially German figure was replaced by a more spiritual and universal concept of him. The celebrations which took place in Nuremberg, Berlin and Munich in 1828, to mark the third centenary of his death, established the Biedermeier image of Dürer as it is represented in Christian Rauch's monument, which was unveiled in Nuremberg in 1828. The hair framing the face is carved in stylised curls and ringlets, the cloak is straight out of a theatrical wardrobe and the pose is senatorial. This image is matched by Gottfried Keller's description in *Henry the Green* of the Munich Carnival of Artists in 1840 in which Dürer brought up the rear of the procession with symbols and personifications on either side. In this period the man and his work were considered in the most arbitrary manner. Goethe, who for a long time hesitated between admiration and disapproval, was ecstatic about the pen drawings decorating one of Maximilian's prayerbooks (Munich). His enthusiasm left obvious traces on the German graphic art of the last century and contributed far more to Dürer's popularity than the demonstrations of coteries. In 1808 Alois Senefelder, the inventor of the lithographic process, published the drawings made for the prayerbook; the consequences were immediate: Pforr's frontispiece for *Götz von Berlichingen* (1810) recalls Dürer's decorative style, as do Cornelius's *Faust* illustrations of about the same period. Eugen Napoleon Neureuther (a pupil of Cornelius) demonstrates Dürer's influence in his illustrations for a volume of ballads and stories by Goethe – which were quite inordinately praised by the poet. The fashion lasted right up to the time of Adolf Menzel and was assimilated easily into the organic decorative forms of *Jugendstil*.

It was obviously necessary to redefine the essential characteristics of the artist through basic research into the background and through establishing his relationship to the milieu and personalities of his day. The work was all the more difficult on account of the accumulated weight of legend and tradition. It was difficult to pierce the stereotyped image. There were still unhistorical interpretations, though along different lines. In the *Birth of Tragedy* Nietzsche identified the Knight of the famous engraving with Schopenhauer: "Alone, with his dog and his horse (altogether without hope), intrepid in the face of the fearsome monsters which surround him". Panofsky's researches, however, led him to an exactly opposite view, which is that the artist intended to represent the Christian soldier (derived from Erasmus's *Enchiridion* . . .), who is confident in his intention of following the road leading to eternal salvation, "fixing his eyes steadily and intensely on the thing itself" even in the presence of Death and the Devil.

Thus the conception of Dürer throughout has mirrored the paradoxes that lie at the heart of four centuries of German culture: the conflict between the desire for universality and the love of detail, the tendency towards realism and at the same time towards abstraction, the need for norms, for a moral canon, which is counterbalanced by spiritual *Angst*. To the Humanists Dürer was Apelles; to the Baroque period he seemed a barbarian; Goethe saw him as a hero; the Romantics idolised him; for the Nazarenes he was a defender of the Faith; the historians of the late nineteenth century regarded him as a Protestant; finally Nietzsche and Mann cast him in the role of Faust. Dürer was a different symbol for each age.

The influence of Dürer's graphic art has been immense: nearly all Northern art of the sixteenth century was influenced by his work, and his motifs were used extensively by artists from Poland to France, in the Balkans – including Mount Athos – and from Spain to the New World. Furthermore his graphic work played a crucial role in the development of Italian Mannerism, and there was even a brief but effective Dürer revival in the cultured circle of Rudolph II at the beginning of the seventeenth century. In contrast to the Romantics' enthusiasm, Wölfflin's formalistic approach stimulated a more profound aesthetic understanding of Dürer's work, and the research carried out into the artist's background by Thausing, Flechsig and the Tietzes has filled another gap. It was work such as this that made possible Winkler's work on attribution. Finally Panofsky, with his extensive experience of iconography and his many personal contributions towards the understanding of the artist's biographical and cultural background, of his theoretical writings and his links with Italy, evolved a complex interpretation of the master. His remains the standard work; it has put Dürer's various stylistic sources in perspective, so that the complexity of his work can be appreciated in its totality.

I have also prepared the horoscope of our Albrecht Dürer and have sent it to him . . .; the wheel of fortune is there, which means that he earns [much] money, because of the favour of Mercury, due to his talents as a painter. Besides Mercury . . . Venus also appears, which signifies that he is a good painter. L. BEHEIM, Letter to W. Pirckheimer, 23 May 1507.

Whereas Albrecht Dürer, a loyal servant of us and our kingdom, has taken great pains in the drawings executed at our bequest, . . . and whereas the said Dürer, according to many accounts, exceeds in fame many other painters, we are moved to require of you . . . that the said Dürer shall be absolved from all dues normally payable to the city . . . in consideration of our wishes in this matter and of his celebrated art. MAXIMILIAN I, Letter to the Council of Nuremberg, 12 December 1512.

It seems to me that the origin of the Venetian saying, according to which all German cities are blind save Nuremberg which sees with one eye, is to be sought in the fact that your people have established themselves as men of intellectual wisdom and considerable industry . . . The same holds true also in the sphere of art . . . That this conviction has taken root even in Italy is due to that Apelles of our day, Albrecht Dürer, whom the Italians, always loath to express praise for Germans, admire so much that they disparage themselves, sometimes to the point of displaying their works under his name in order to sell them more easily. U. VON HUTTEN, Letter to W. Pirckheimer, 25 December 1518.

My heart rejoices for our Dürer; he is an artist worthy of eternal fame. ERASMUS OF ROTTERDAM, Letter to W. Pirckheimer, 19 July 1523.

I should like Dürer to paint my portrait; why should I not desire this of such an artist? ERASMUS OF ROTTERDAM, Letter to W. Pirckheimer, 8 January 1525.

First Albrecht Dürer embellished the world with his pictures
and filled every place with his magnificent art.
Now only the heavens remain for him to adorn with his
 painting.
Leaving the earth, he rises towards the stars.

All the components of genius, all that is honest and sincere,
 all that is wise and worthy of praise,
friendship and art repose in this tomb.

O Albrecht, would that tears would bring you back to life,
that the earth could not cover your mortal remains.
But since neither tears nor laments can alter fate,
let anguish express all that is due to the dead.
 W. PIRCKHEIMER, Three epitaphs to Dürer, 1528.

This is the image of Albrecht Dürer, the famous
Nuremberg painter, of great renown,
whose art was far superior

to that of all other masters of his day.
... He was held in great esteem by princes, noblemen
and all the artists,
who still praise and value his works,
and learn from his example.
H.SACHS, Rhyming inscription for a woodcut of Dürer made by
E.Schön, 1528.

I remember the painter Albrecht Dürer, a man famous on
account of his talents, once saying that as a young man he had
preferred paintings with varied and dazzling colours. . . . Later,
as he grew older, he began to observe nature and tried to convey
its actual appearance; he had understood, then, that the best
ornament of art is simplicity. MELANCTHON, Letter to G.von
Anhalt, 17 December 1546.

I cannot describe with what contempt I regard our sham painters
of puppets: they have seduced women with their theatrical poses,
artificially coloured faces, and garishly coloured clothes. Oh
manly Albrecht Dürer, how much I prefer your sculptured form,
despite the ridicule it has suffered from the ignorant. J.W.
GOETHE, Von deutscher Baukunst, 1772.

You must not ridicule or underestimate anything,
must not exaggerate or coarsen anything;
you should see the world
as Albrecht Dürer saw it,
throbbing with life,
driven by a vital force, unchangeable.
 J.W.GOETHE, Hans Sachsens poetischer Sendung, 1776

Of all the great men who could claim that they have been victims,
at one time or another, of misguided criticism, or of tradition,
none would have better reason than Albrecht Dürer. While critics
admitted that his drawing possessed qualities of precision and
expressiveness, he was reproached for employing a gothic manner
of representing ugly everyday reality. He was criticised for
painting drapery too minutely and too dryly; defects were found
in the poses of his figures, and a harshness in the general effect of
his pictures. There is some truth in all these judgements – the
germ, as it were, which has bred all these errors of criticism. It is
true that he was not able to compose figures well; this skill was
developed later in the Flemish and Lombard schools. . . . Dürer
has been criticised for depicting the vulgar commonplaces of
everyday life in his drawings. It is true that he drew his inspiration
solely from those around him, but his understanding of their
characters, their way of life and of the social conditions of the age,
and the care and precision with which he executes them, result
in figures which give evidence of profound study [from life] . . .
His drawing does not belong to the classical taste, and there is
never any suggestion of the seductive form of the nude figure
beneath the drapery . . . His Madonnas are considered his most
attractive and successful works; and, contrary to the traditional
belief, few, if any, were modelled on his ugly wife Agnes. In fact
it is difficult to find any similarities between the numerous
representations of the Madonna in his engravings, woodcuts,
drawings, paintings and other graphic works: each has her own
special character, either in her features or in the expression of her
soul. They are not heavenly images like Raphael's or Guido

Reni's, but seem rather to be embodiments of the German idea
of maternal affection; they are nearly all mature women, who
scarcely ever display qualities of virginal delicacy. J.H.MERCK,
in "Der Teutscher Merkur", III, 1780.

If Raphael and Albrecht Dürer have attained perfection, what
should a true pupil avoid if not arbitrariness? J.W.GOETHE,
Letter to F. Müller, 21 June 1781.

The figures in your paintings, Albrecht Dürer, seem to be real
people conversing with each other. One would recognise each
one in a crowd, so exactly are they characterised; each is per-
ceived in a way so essentially his own, that he fulfills his function
perfectly. None of them is imperfectly characterised, which
certainly could not be said of those most alluring paintings by
modern masters; each figure is drawn from life and is vividly
portrayed as a living being: those who are weeping seem really
to weep; those who are angry really are angry; those who pray
pray in earnest. Every detail makes itself felt: no gesture is
superfluous or used simply to please the eye or to fill a space; each
individual element has equal importance and allows us to grasp
unequivocally the total effect. Everything the great master
portrays is convincing and leaves a permanent impression on the
mind. . . .
 I do not agree at all with those who maintain that if only Dürer
had been to Rome for any length of time and had become aware
of the pure, idealised beauty of Raphael, he would have become
a great painter; that one should make allowances and, moreover,
marvel at what, in the circumstances, he was able to to do. I find
nothing to make allowances for, and in fact I am positively
delighted that destiny granted Germany a painter so intrinsically
national as Dürer. Any other eventuality would have meant the
distortion of his character, since he was not Italian.
 He was not born to the perfection or the sublime achievements
of a Raphael; his aim was to show us people as they really are, and
he succeeded to an extraordinary extent. All the same, I remember
that, as a young man, when I first saw paintings by Raphael and
yourself, beloved Dürer, in a marvellous gallery, it struck me that
of all the artists whose work I knew these two, for some reason,
possessed a particular quality which established an immediate
rapport with my own temperament. Their simple, distinct and
convincing manner of representing people, without recourse to
the metaphorical elegances of other painters, pleased me. At the
time, however, I did not dare to admit such views, as I feared
public derision and knew that most people considered the work
of German artists to be rigid and dry. W.H.WACKENRODER,
Ehrengedächtnis unsers ehrwürdigen Ahnherrn Albrecht Dürers, in
"Deutschland", 1796.

I consider Dürer's Self-portrait of 1493, made when he was
twenty-two years old, priceless [Catalogue no. 12] . . . the draughts-
manship is first class, detailed and exact; the parts harmonise
perfectly; the execution is of the highest standard and absolutely
worthy of Dürer, although the colours are thinly painted and
have become more opaque in parts.
 Dürer painted this priceless work on a fine panel; a real con-
noisseur would have put it in a gilt frame and conserved it with
loving care, but it had no frame and was not looked after. . . .
J. W. GOETHE, Tag-und Jahres-Hefte, 1805.

We used to consider Dürer as a serious artist who imitated nature with punctilious care and a keen appreciation of life, of colours and forms, who sometimes managed to represent these things without his habitual unpleasant harshness . . . we recognised, moreover, that he possessed a rich imagination; however, we believed him graceless and considered him incapable of transposing into a tranquil and poetic key. These drawings by Dürer [in Maximilian's *Golden Book* in the Munich Staatsbibliothek] justified and extended our opinion of his artistic talent. Here he appears freer than we had formerly thought possible, more enchanting, serene, witty, and far more skilful than we had expected in his choice of motifs, despite the limitations [of space] and the symbolic significance of the representations. The work was intended to be purely decorative and yet, without rejecting his apparently narrow terms of reference, the master was able to create a wealth of interesting motifs. It is almost as if he has displayed before our eyes the whole spectrum of artistic devices, from the figures of the divinity right down to the decorative designs of the calligraphers. W.K.F. (GOETHE[?]), in "Jenaische Allgemeine Literatur-Zeitung", 19 March 1808.

. . . What needs to be done is to collect together all the existing copies of Dürer's work and make them public property, thus creating a monument worthy of him; only when this has been done shall we be able to assess him properly, for to understand an artist one must see his works. In thus paying tribute to the man, we should also secure a complete knowledge of his greatness for the future. Those who love him should always remember that his greatest attribute is his personality: this least apparent facet of his works is an element of their perfection; and the almost total lack of any external event in his life is one of the conditions of his development.

Those who do not know of Dürer have a serious lacuna in their concept of our history; but for those who do know of him, the mere mention of his name evokes associations, as if it were synonymous with "Germany" or "fatherland". H.GRIMM, *Albrecht Dürer*, 1866.

Until now the name "Dürer" has been synonymous with German art. He was generally considered, despite certain reservations, to stand for German art in the same way as Rembrandt stood for Dutch art and Rubens for Flemish art. . . .

Today this view no longer holds good. There are new concepts of the essential characteristics of German art, and Grünewald, formerly considered as a peripheral figure, has assumed a central importance. It is he who now reflects, in the true sense of the word, the German spirit; he is no longer thought of as an isolated figure: the work of Altdorfer, Cranach the Younger, Hans Baldung Grien and others can be closely related to his. Now it is rather Dürer who appears to be isolated. . . . It is difficult to dismiss such views as these. Although it can easily be established that Dürer's art is firmly rooted in German soil, and that he seems, even now, to exercise a *de facto* pre-eminence, this position has often been claimed, quite convincingly, for others.

Certainly there is no other artist into whose character we can acquire such a close personal insight as into Dürer's. We have extensive biographical documentation for him, whereas the personal lives of Grünewald and even Holbein are, by comparison, mere shadows. It is not even possible to establish what they looked like, whereas everyone knows, or thinks he knows, what Dürer looked like. Besides this, letters, diaries and notes have survived – documents which provide insights into his appealing character. We can imagine him alive and live with him; we can witness his profound emotions and thus become intimate with him. But beyond this, who could deny that he possesses, to a supreme degree, a national character? Not always, it is true; there are some works which baffle us, but there are others in which he seems to communicate with us like a living person. H.WÖLFFLIN, Lecture on Dürer, 1921.

. . . the artist who, alone, was the first in the North to apply his tireless mind to the problems which had occupied the Italian artistic world for more than a century and who made them accessible to his fellow nationals was the greatest German artist: Albrecht Dürer.

Dürer was the first Northern artist to combine the visual forms of antiquity and Italian art. He was affected at an early stage by Italian engravings and drawings, which drew him into their sphere of influence. . . . He sensed the existence of a new world in the clear light beyond the Alps and in antiquity, a world which followed different laws from those of the medieval tradition of his own country, and he applied all the vigour and strength of his mind and spirit to discovering the key to the closed door. His desires were fulfilled, to some extent at least, by his two journeys to Northern Italy.

Thus his theoretical ideas were formed, and we can trace the stages of their evolution from the end of the preceding century. But his aspirations towards the ideal classical-Italian form were opposed by his artistic inheritance, the empiricism of the nordic countries and the uninterrupted tradition of the Middle Ages, particularly in the treatment of the human body. It must have been as difficult for him to come to terms with this world conceptually – rather than superficially as later artists did – as it is for us today, as the heirs of the spiritual renaissance of Northern man, to approach his art, or indeed almost any of the art of our national past, without inhibitions of taste. The dichotomy between the subjective concept of beauty, and objective understanding, a perception of the world conditioned by scientific thought which has dominated artistic developments in Europe up to Impressionism (and is only now called in question by new modes of expression), was manifested – most strikingly personified in the forceful individualism of Leonardo – in a conscious hostility towards the very different way of seeing of the "gothic" world with its negation of and scorn for objective reality, with its deductive methods (so detested by Leonardo) and its delight in spiritual things and in the existence of elemental spirits.

It was a deep chasm, which could be bridged only with great difficulty; Dürer realised this, and never quite succeeded in bridging it altogether. In the new century his ceaseless, painstaking energies were directed towards discovering the laws governing the form of those curiously fascinating images, to appropriating them, to adapting them to his own world, and eventually to mastering them. J.SCHLOSSER MAGNINO, *Die Kunstliteratur*, 1924.

To think of Dürer means to think of love, of grace and self-awareness. It means an understanding of that which is most profound and impersonal, of all those things that are beyond and

above the material confines of our ego but which determine and sustain it. It is history as legend, a history which is always material and present, since we are far less individual than we either hope or fear ourselves to be. T.MANN, *Dürer*, 1928, in *Altes und Neues. Kleine Prosa aus fünf Jahrzehnten*, 1953.

. . . The old persistent dualism of German art, pure nature or pure fantasy, is compounded in him, through his contact with Italy, as a new dualism: nature and the laws of nature.

Where was the secret? For us it did not exist, but Dürer believed that Italian artists possessed a secret, that they were endowed with a special, almost magic quality.

He describes how, in his youth, he would have given all he possessed if the Venetian painter Jacopo de' Barbari, who was travelling in the North, would reveal the mystery of proportion to him. . . . For us it was a question of a proportional norm (not a mystery), which was related, if I am not mistaken, to a spatial norm, to the *"dolce prospettiva"*. Pacher had understood this perfectly, but Dürer's was a different disposition: he was the Northern equivalent of Pollaiuolo; he was obsessed by form, not space – over and over again by form.

His curiosity in this sphere was insatiable – almost as great as that of a Leonardo: a finger, a book, a hand, a plant, a fold, a wood; but, I would say, he never has the assurance or the methodical confidence of the Italians. On every occasion he tried to immerse himself in the objects themselves, but he was hampered by the old craftsmanlike technique which would rob a hand of its gesture and meaning and obscure the features through sheer technical caprice. Even as he studied botany, geology, entomology and surgery, the old empiricism got in his way, and the free study he had conceived became obstructed, clogged and unwieldy. He began as a Pollaiuolo or a Verrocchio and finished by resembling more closely (particularly in his first phase) Schiavone or Zoppo. One might even ask oneself whether the first trip to Venice in '95 took him sooner to Murano and Vivarini's workshop than to Venice and that of Bellini. . . . It would be too Italian and too simple to single out from the German painter's *oeuvre* the few portraits *alla veneta* and say that in them Dürer is at his best; it would be to understand too little.

His highest ambition was, soon, to achieve precisely that fully integrated and rounded rhythm which was just beginning to emerge in Florence and Rome and which he had more or less begun to understand in Leonardo's earlier experiments in Lombardy. In any case, it was after the second journey to Italy in 1506 that he made his most ambitious efforts. . . . But, to the end, he was plagued by the thorny remnants of the old abstractions, and the half-conceived norm became corrupted in mannerism. It was at this stage that Pontormo was drawn to him, as Vasari noted in that famous passage from which the critics of Germany have extracted every ounce of value. Dürer's tormented and disquieting spirit taxes us to the limit with the perpetual question: what is form? or, more precisely, what is art? The enquiry overburdened the artist at work; his question thus remains open, even in his most famous engravings which, after so many years, I still always find – and I am not ashamed to admit it – rather difficult to read. R.LONGHI, in "Romanità e germanesimo", 1941.

The study of perspective . . . and of human and animal proportion – both already highly developed in Italy – found in Dürer a devoted enthusiast. But although he applied the laws in his own work, he remained equally faithful to his own "personal" gothicised concept of space – so much so, in fact, that almost all his works (apart from those most directly influenced by Italian models) present, one might say, simultaneously, a partial overlapping of the two ideas. It is as if the image has, at the same time, been conceived in accordance with the traditional German practice in use at the time and realised through the new system. There is thus a double standard for, and concept of, time and space and it is the interlocking of the two, which are opposed but which make equal demands, which gives his works that characteristic and inimitable quality of vibrancy which distinguishes them so clearly from both the static, decorative quality of late Gothic art and from the monumental character, achieved through volume and chiaroscuro, of Italian art. We should say, rather, that it is precisely this chiaroscuro element which cannot (or does not want to) shake off the Gothic shadow. Even when his design is constructed architectonically according to the new Renaissance canons, he continues to model his figures and landscapes with a delicate but constricting technique which never achieves the subtle *sfumato* effects we admire in a Pollaiuolo, a Giambellino and, most of all, a Leonardo. G.DORFLES, *A.Dürer*, 1958.

The personality of Albrecht Dürer offers itself to analysis, whether it be from the point of view of his historical importance or of the expressive content of the works, loaded as they are with contradictions which are only ultimately resolved – one might say sometimes *in extremis* – by his quite exceptional vigour and consequent formal assurance, into a tight and coherent unity. His conception of art and of the social position of the artist was undoubtedly affected by his constant efforts to raise himself above the traditional craftsman status of the German artist – who was still constricted, far into the fifteenth century, by the practice and customs of the workshop – and to confer on art, following the example of the Italians, the dignity of a science, thus assuring the artist the status of a practitioner of the liberal arts. On the other hand, he was constantly preoccupied by technique, by the manual practice of different engraving processes, and his continual experimentation and his awareness of the expressive potential inherent in the different techniques, and his search for an extreme formal perfection, bound him, with the strength of a longstanding and natural affection, to the craft tradition of his country. So we find existing side by side in Dürer a self-effacing and painstaking diligence, a tenacious dedication to achieving a faultless manual dexterity, and obvious humanistic sympathies, an intellectual acuity which made it necessary for him to theorise about his art. And although before him Michael Pacher had attempted to establish a more profound link with Italian art without rejecting his artistic origins, it is Dürer alone who can be considered as both the most national and the most universal of all German artists: he was as susceptible to the lure of the Renaissance as he was bound to the "gothic" traditions of the North. This kind of bi-polaristic or dualistic character in his conception of art, formed by the two opposing traditions which met in him, found, quite naturally, its counterpart in the astonishing extension of his expressive range: from the fantastic,

hallucinated visions of the *Apocalypse* to the precise "objective" treatment of the biblical patriarchs, from the supreme – though perhaps austere and dramatic – composure of the Holzschuher and Muffel portraits to the terrible admonitory fierceness of the *Four Apostles*. R.SALVINI, *Dürer, Incisioni*, 1964.

Dürer's mind was not one to achieve synthesis; his was rather the talent of an observer, obsessed by the appearance of all phenomena but drawing hardly any conclusions. Yet the sheer range of his observation, its restless probing power, and its ability at times to stimulate his imagination, cannot be paralleled in any other artist – not even Leonardo. It was a curiosity about how everything works which came originally, one might guess, from curiosity about himself. It was, fundamentally, a personal quest and an attempt to hold a dialogue with posterity. Observation penetrated so far that it bared his heart when he described – in words and in drawing – his dream: a psychological self-portrait. M.LEVEY, *Dürer*, 1964.

Dürer's writings

. . . From there [Seeland] we went to Middleburg, where, in the abbey, one can admire Mabuse's great painting, a work which is less appealing in its composition and drawing than in its colouring. . . .

On the Saturday after Easter [6 April 1521] I left Antwerp for Bruges, together with Hans Lüber and master Jan Prevost, a good painter and himself a native of Bruges. . . .

There [in the Prince's Residence at Bruges] I saw the chapel painted by Rogier van der Weyden, and some paintings by a talented old master. . . . Thence they took me to the Church of St James to see the magnificent paintings by Rogier van der Weyden and Hugo van der Goes, both of them great painters. In the Church of Our Lady I admired the statue . . . of the Virgin by Michelangelo of Rome. They also took me to many other churches, and showed me all the wonderful paintings in which Bruges abounds. . . .

[At Ghent] I saw the polyptych in the Church of St John [*The Adoration of the Mystic Lamb* by Jan van Eyck]: it is a very deeply considered painting; the figures of Eve, Mary and God the Father are particularly good. *Tagebuch der niederländischen Reise*, 1520–21.

. . . Until now many gifted young scholars have turned to the art of painting, but they have not been given proper instruction and have only been taught the technical practice. They have, thus, grown up in ignorance [of painting], like wild trees which have not been pruned. And although some of them have acquired a certain freedom of handling through constant practice, with the result that their work is not devoid of skill, yet they do not conform to rational principles and can be seen to depend only on personal taste. Painters of intelligence and genuine artists who have seen such works have, with good reason, scorned the blindness of these fellows. For one who really knows there is nothing more displeasing than to discern a fundamental error in a picture, however faultless the technique may be. The reason why such painters should have found satisfaction in their mistakes is solely that they have not studied the art of proportion, without which no one can either be or become a true artist; this is the fault of their masters who were themselves ignorant of this art. Since this [proportion] is the true foundation of all painting, I have proposed that I should myself impart the principles and systems of proportional measurement to all those who are desirous of understanding art . . . so that they may understand reality and learn to reproduce it, so that they do not concentrate their attention exclusively on art and acquire a proper and complete maturity. . . . Today, in our land, there are some who revile the art of painting and say that it serves idolatry, that paintings and images lead the Christian to superstitious beliefs, no less . . . but a painting brings more good than harm when it is well made and, from the artistic point of view, correctly done. With what honour and respect art was regarded by the Greeks and Romans is proved sufficiently by ancient texts; in the course of time, however, art disappeared and remained buried for more than a thousand years until, two hundred years ago, it was once more brought to light by the Italians. Art is easily lost, but – although it may be only with difficulty and after a long time has elapsed – it is rediscovered. *Unterweisung der Messung* . . . (Dedication to W. Pirckheimer), 1525.

. . . The German painters . . . are not inferior to anyone in their use of colour, but they have shown themselves wanting in the arts of proportion, perspective and such like. . . . Without proportion no picture can ever be perfect, even if it is executed with all possible care. . . . It is therefore necessary for all those who wish to grasp this art (of painting) first thoroughly to learn the art of proportion and how to draw things in plan and in perspective. . . . What is quite simple cannot be truly artistic, and what is artistic demands diligence, dedication, and work, if it is to be understood and mastered. If a work is incorrectly designed, then however great the care and diligence spent on it the work is in vain; whereas one which is correctly proportioned can never be criticised by anyone. *Proportionslehre* (Dedication), 1528.

The paintings in colour

List of plates

The numerals in parenthesis which follow the title of each plate refer to the catalogue numbers given to the paintings (pp. 88–114).

16

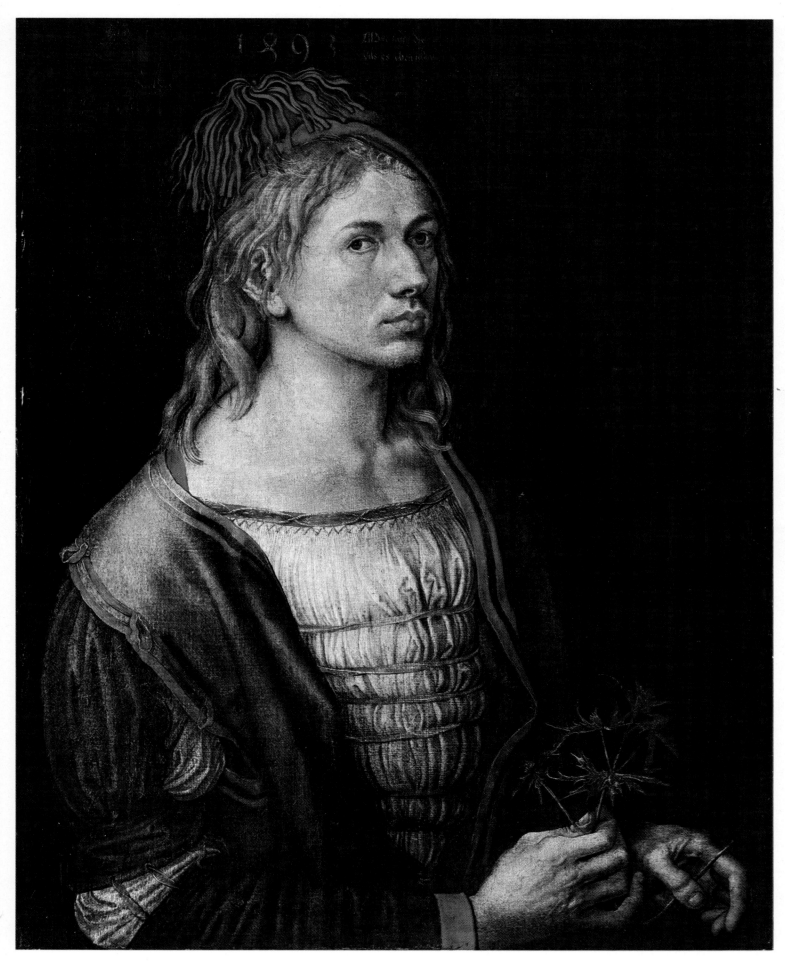

PLATE I SELF-PORTRAIT WITH ERYNGIUM FLOWER Paris, Louvre
Whole (44.5 cm.)

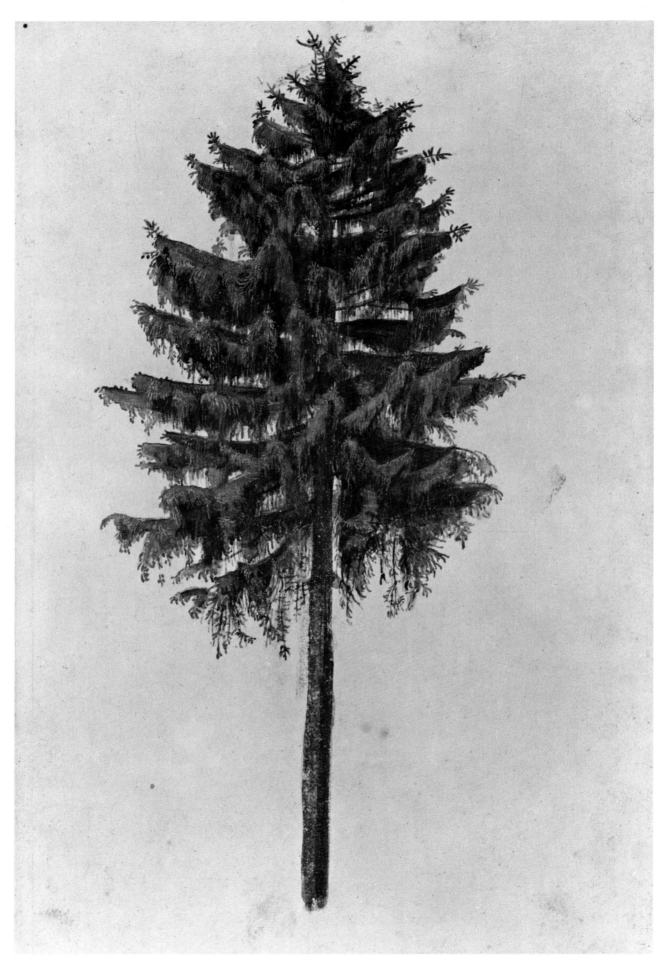

PLATE II PINE TREE London, British Museum
Whole (19.6 cm.)

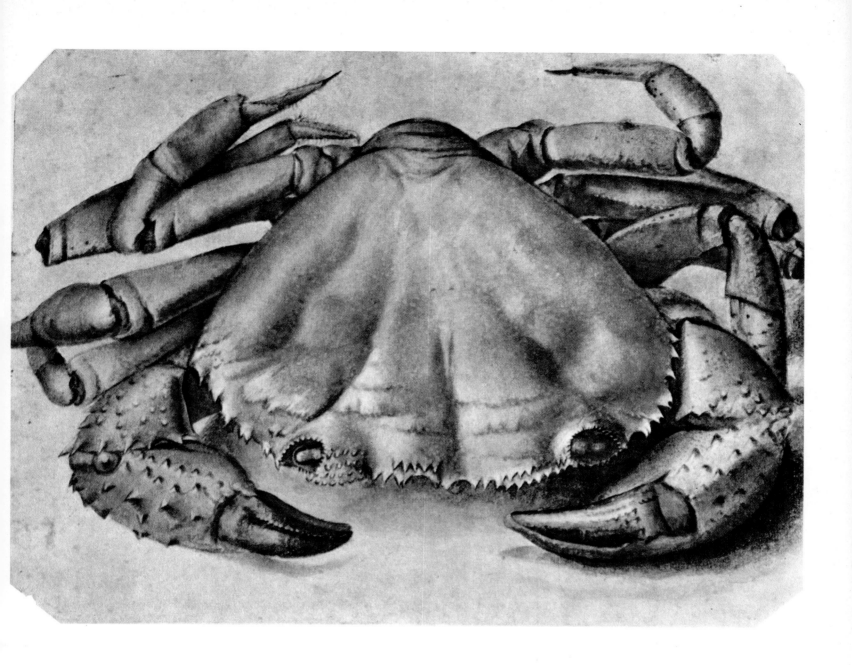

PLATE III SEA CRAB Rotterdam, Museum Boymans-van Beuningen
Whole (35.5 cm.)

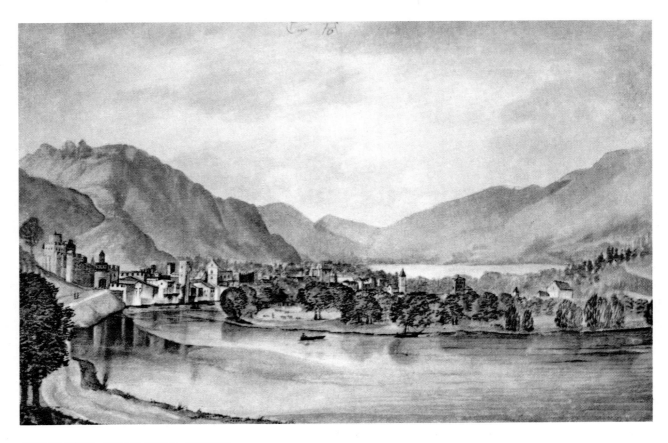

PLATE IV A VIEW OF TRENT Formerly Bremen, Kunsthalle
Whole (35.6 cm.)

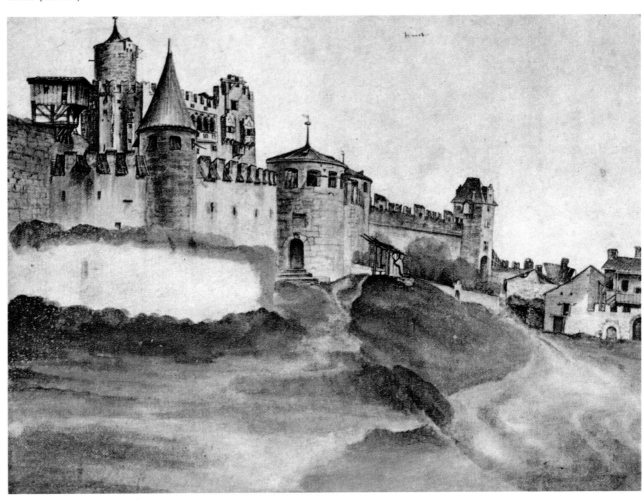

PLATE IV B THE CASTLE OF TRENT London, British Museum
Whole (25.7 cm.)

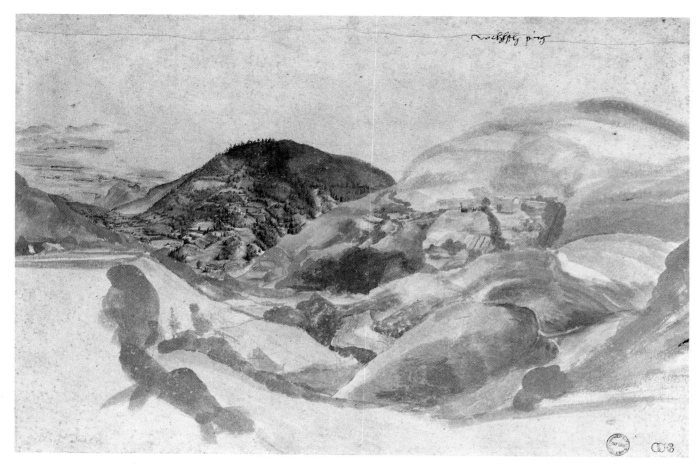

PLATE V A ALPINE LANDSCAPE Oxford, Ashmolean Museum
Whole (31.2 cm.)

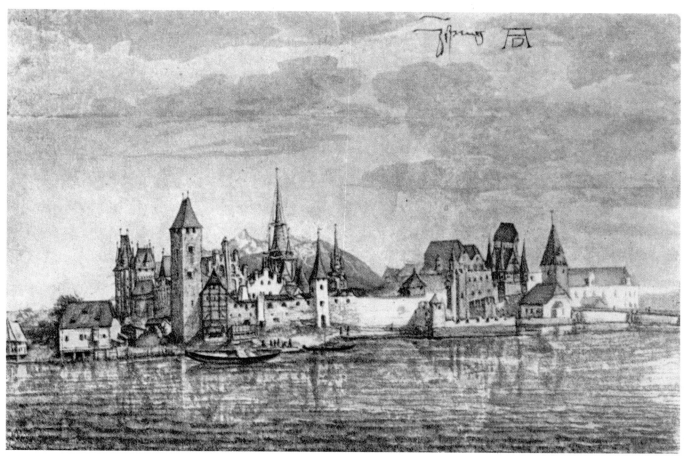

PLATE V B VIEW OF INNSBRUCK Vienna, Albertina
Whole (18.7 cm.)

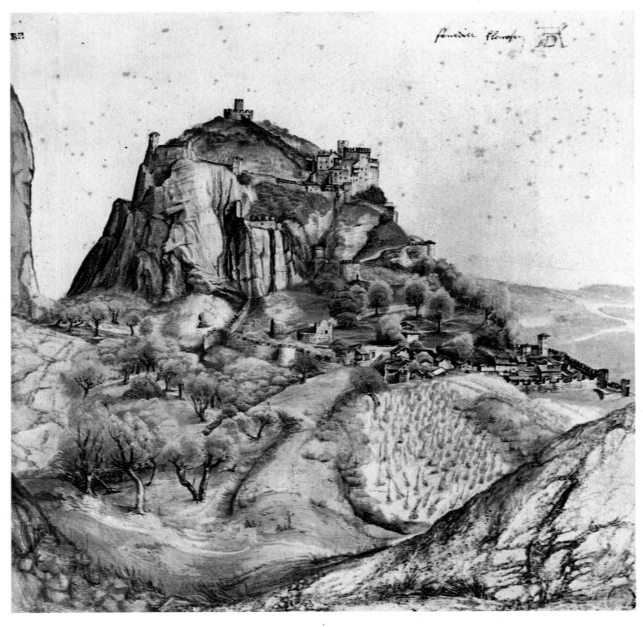

PLATE VI A VIEW OF ARCO Paris, Louvre
Whole (22.1 cm.)

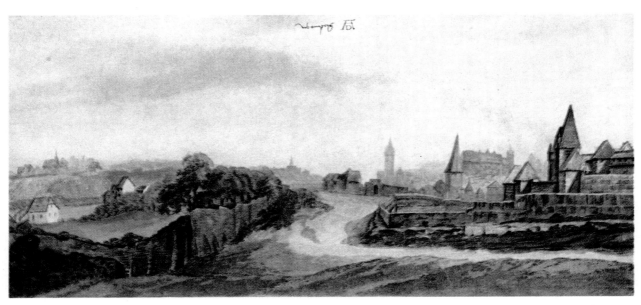

PLATE VI B VIEW OF NUREMBERG Formerly Bremen, Kunsthalle
Whole (34.4 cm.)

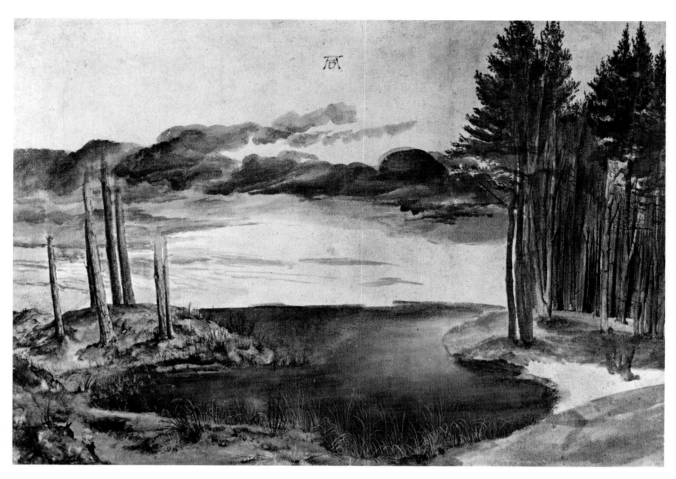

PLATE VII A POND IN A WOOD London, British Museum
Whole (37.4 cm.)

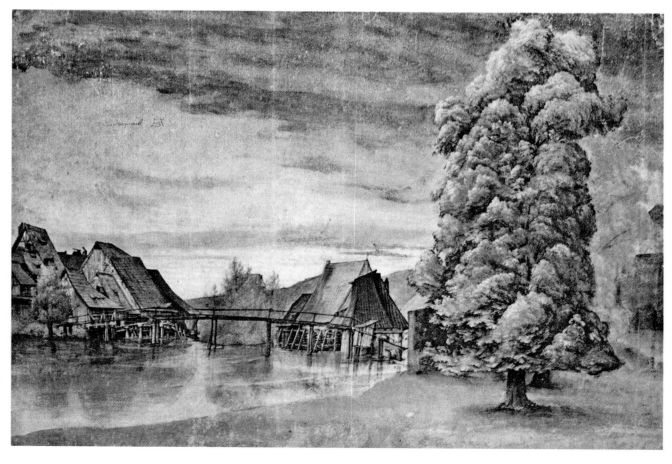

PLATE VII B MILLS ON A RIVER BANK Paris, Bibliothèque Nationale
Whole (36.7 cm.)

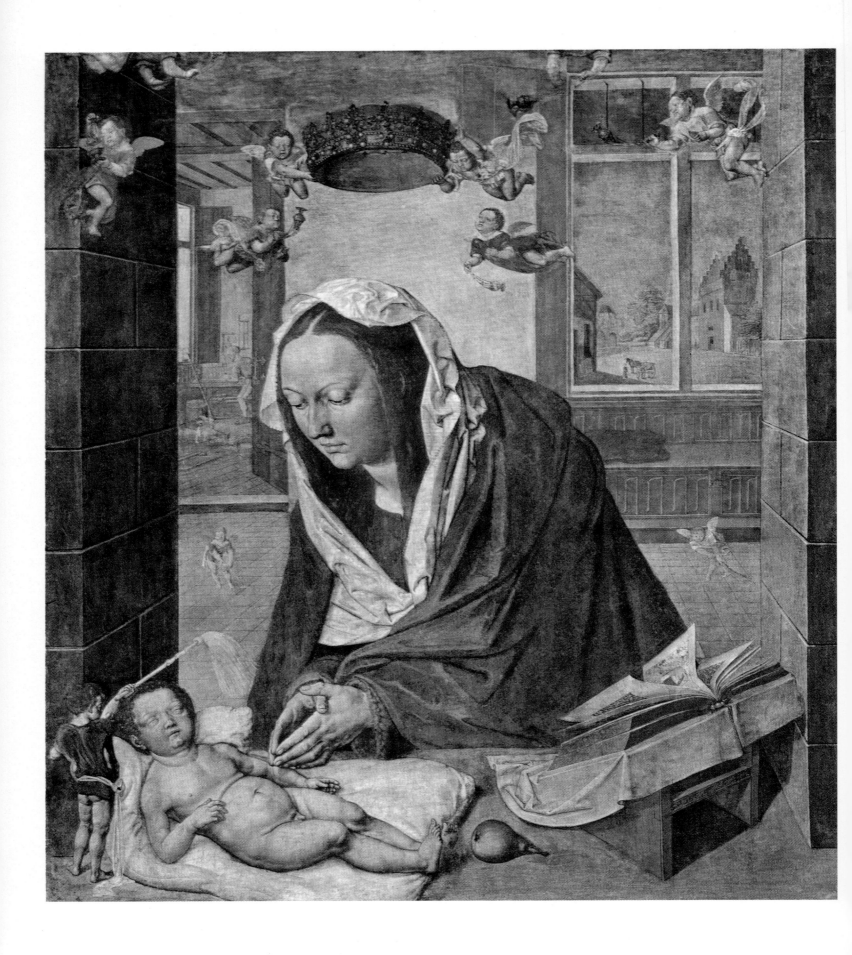

PLATE VIII　　DRESDEN ALTARPIECE Dresden, Gemäldegalerie
Virgin adoring the Infant Jesus (96.5 cm.)

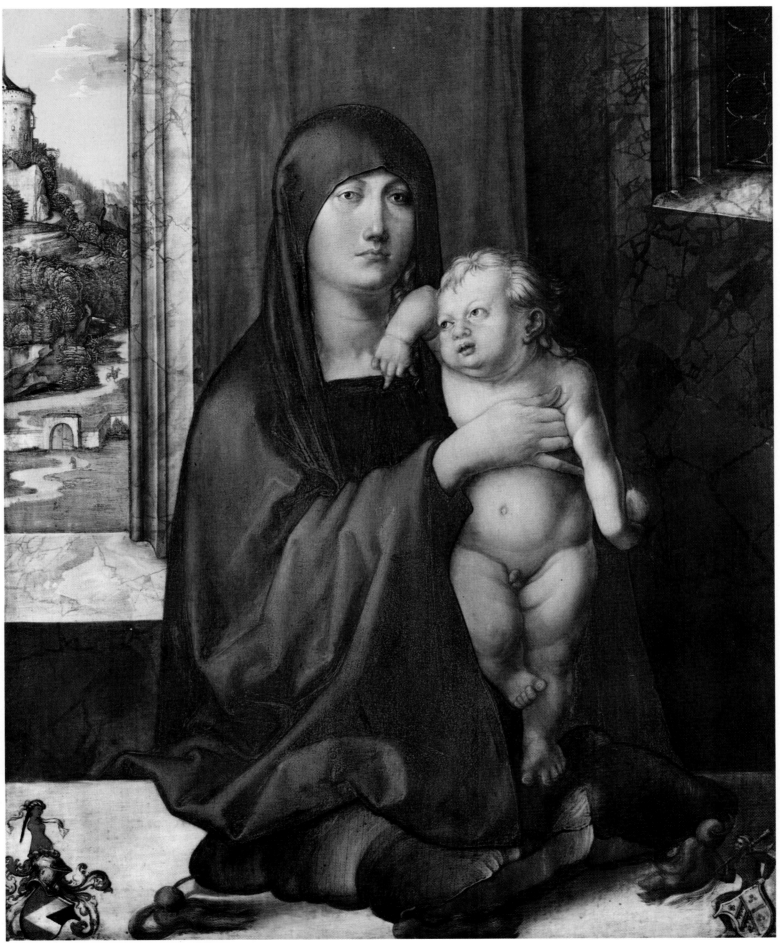

PLATE IX VIRGIN IN HALF LENGTH Washington, National Gallery of Art, Kress Collection
Whole (39 cm.)

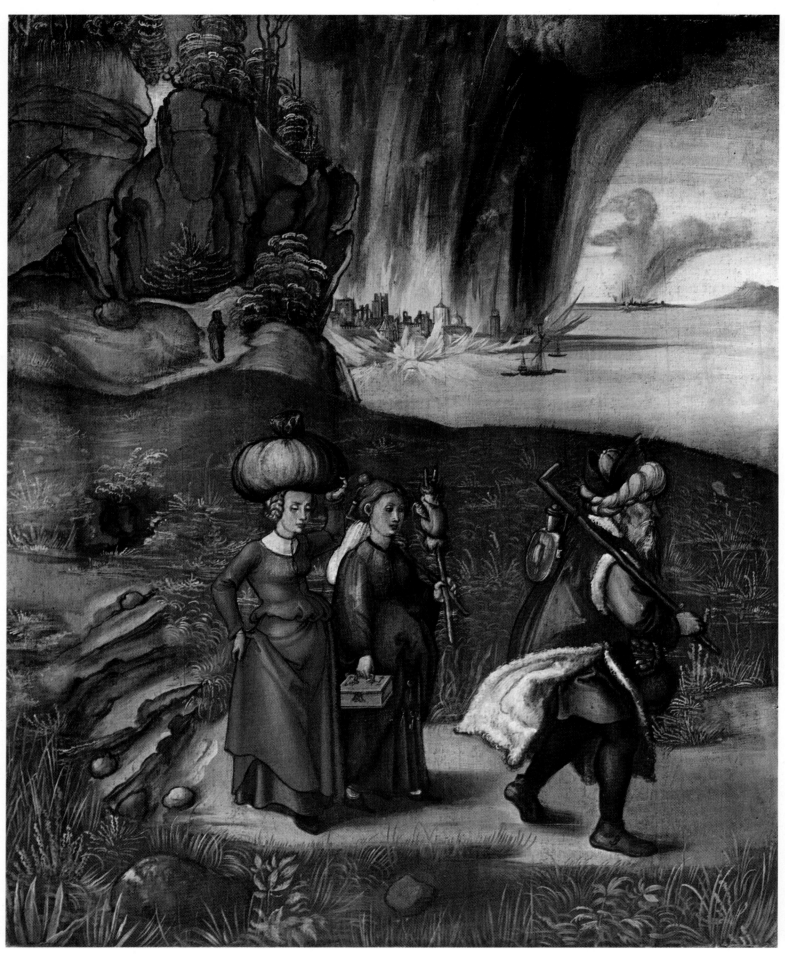

PLATE X LOT AND HIS DAUGHTERS Washington, National Gallery of Art, Kress Collection
Whole (39 cm.)

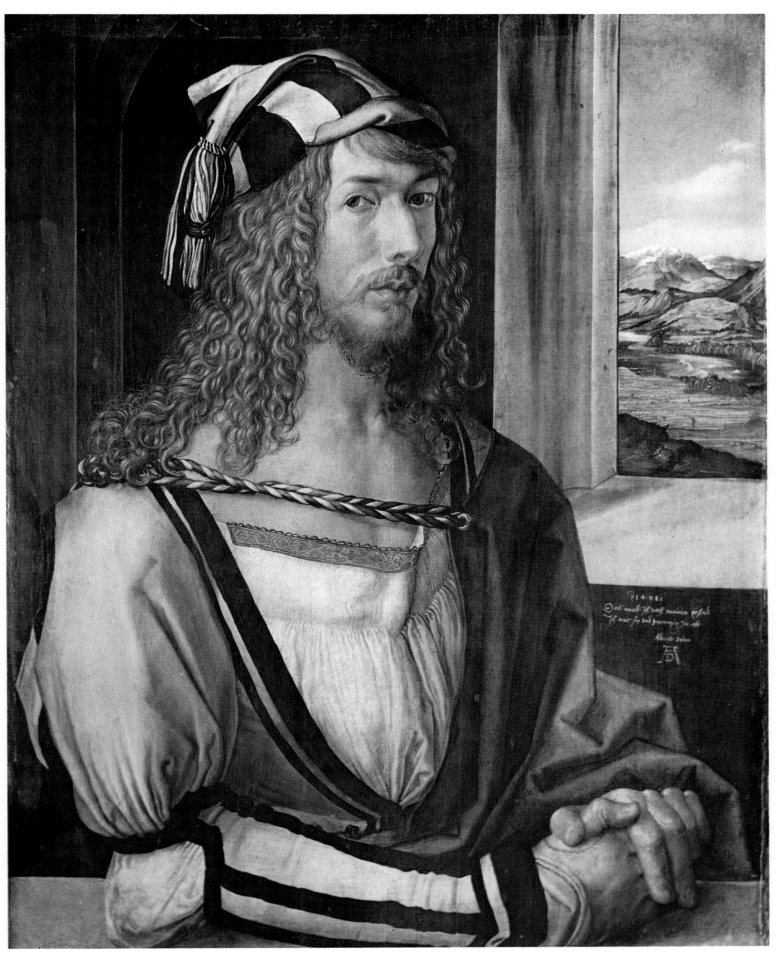

PLATE XI SELF-PORTRAIT Madrid, Prado
Whole (41 cm.)

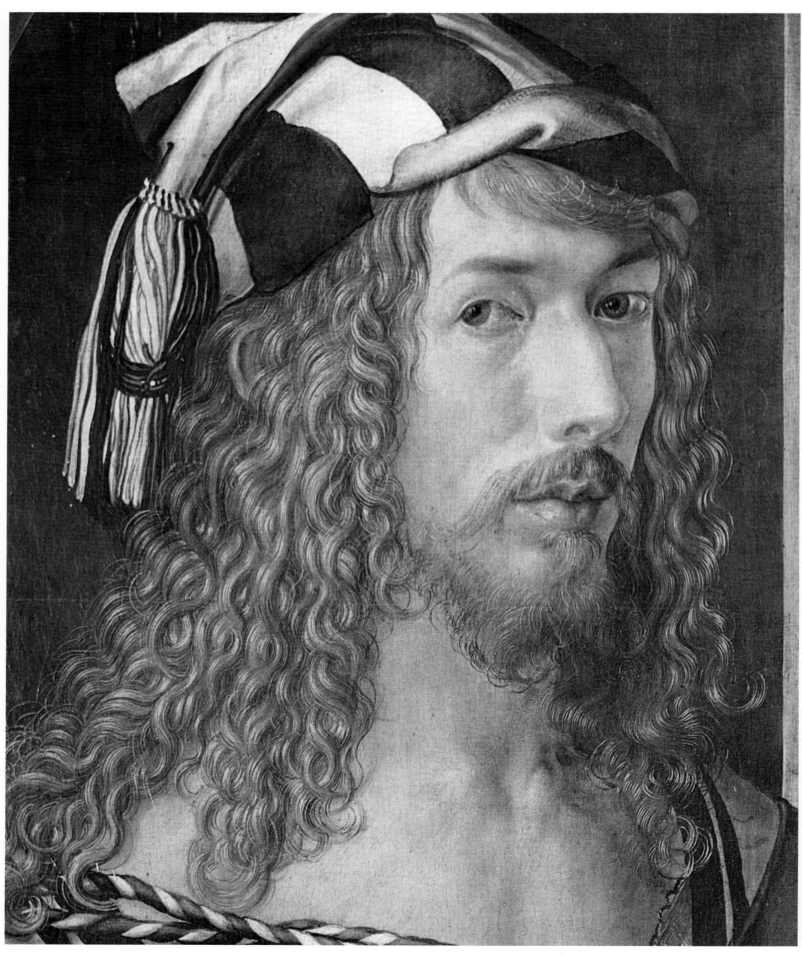

PLATE XII SELF-PORTRAIT Madrid, Prado
Detail (actual size)

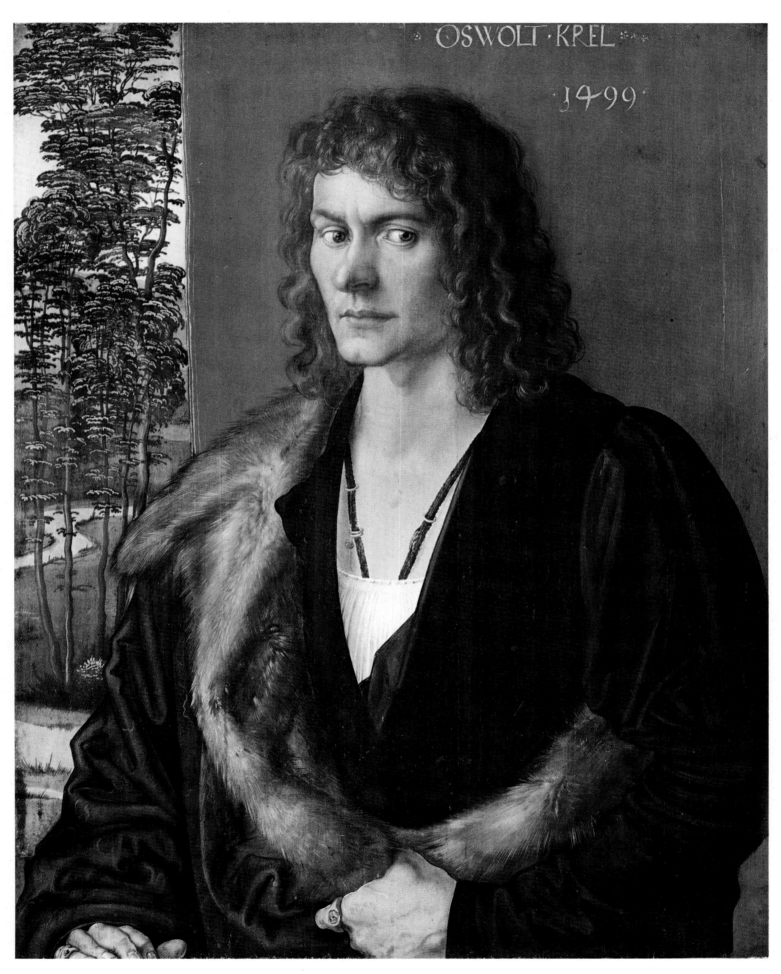

OSWOLT·KREL

1499

PLATE XIII PORTRAIT OF OSWOLT KREL Munich, Alte Pinakothek
Whole (39 cm.)

PLATE XIV PORTRAIT OF OSWOLT KREL - WINGS Munich, Alte P nakothek
(15.7 cm. each)

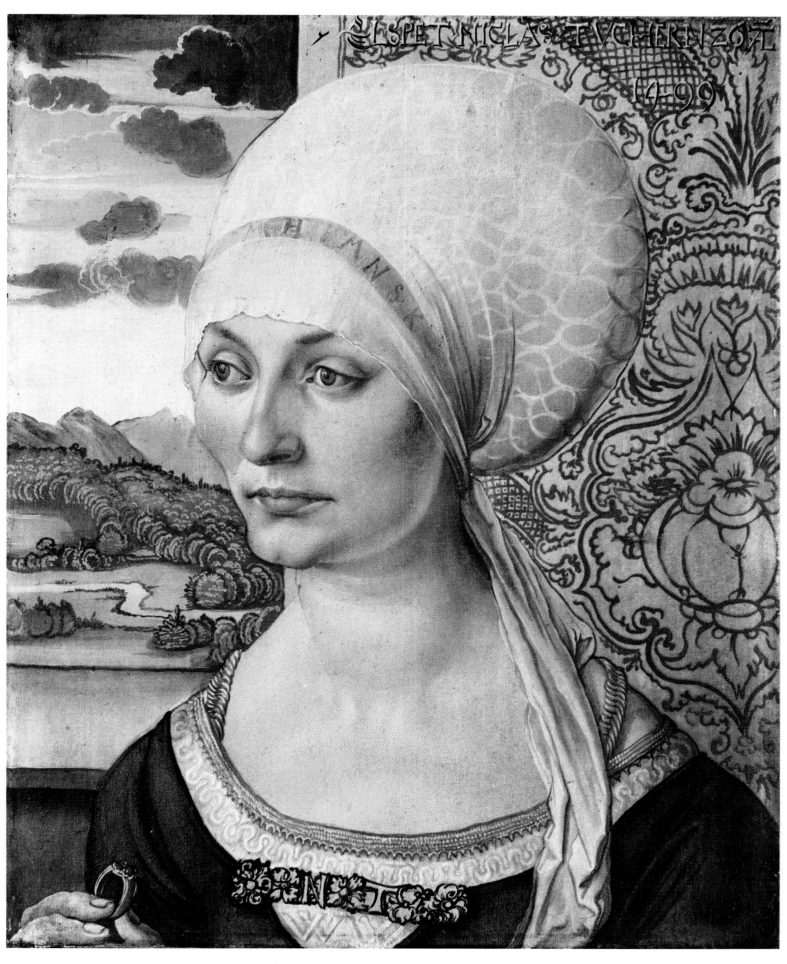

PLATE XV PORTRAIT OF ELSPETH TUCHER Cassel, Gemäldegalerie
Whole (22 cm.)

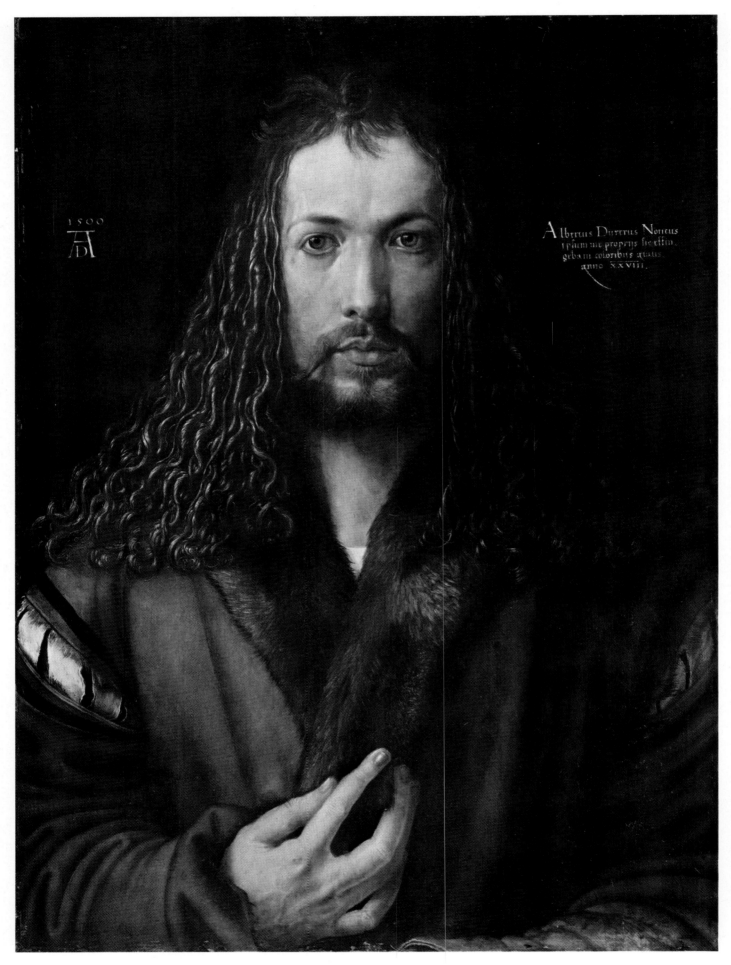

1500

AD

Albertus Durerus Noricus
ipfum me proprijs sic effin
gebam coloribus ætatis
anno xxviii.

PLATE XVI SELF-PORTRAIT Munich, Alte Pinakothek
Whole (49 cm.)

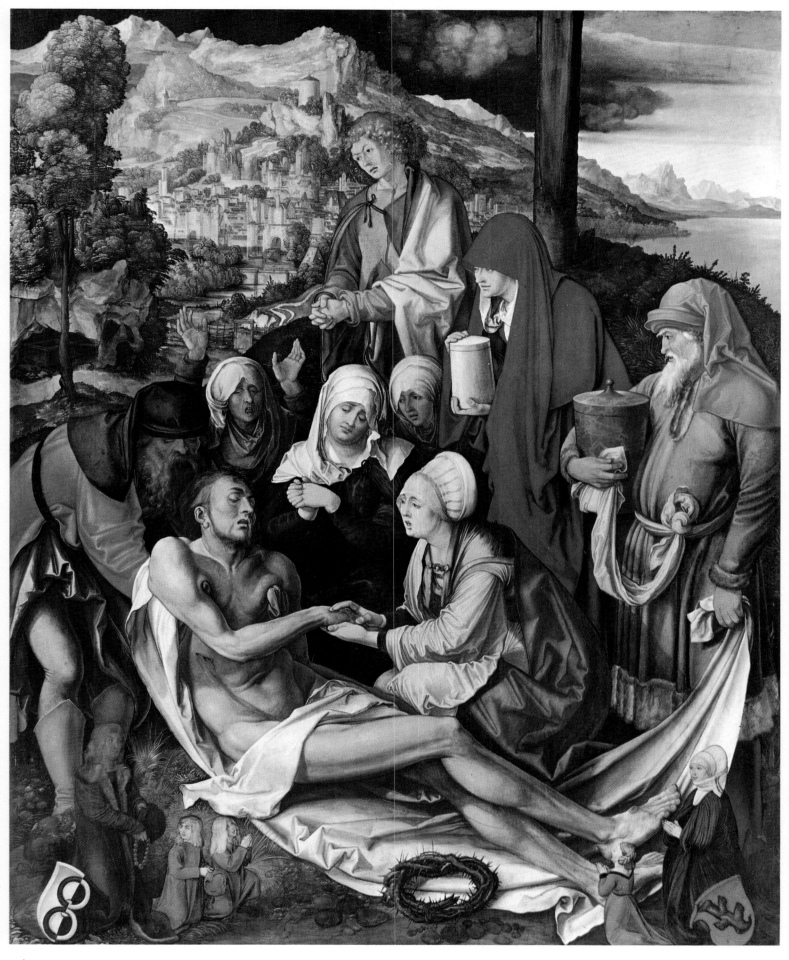

PLATE XVII LAMENTATION OF CHRIST Munich, Alte Pinakothek
Whole (121 cm.)

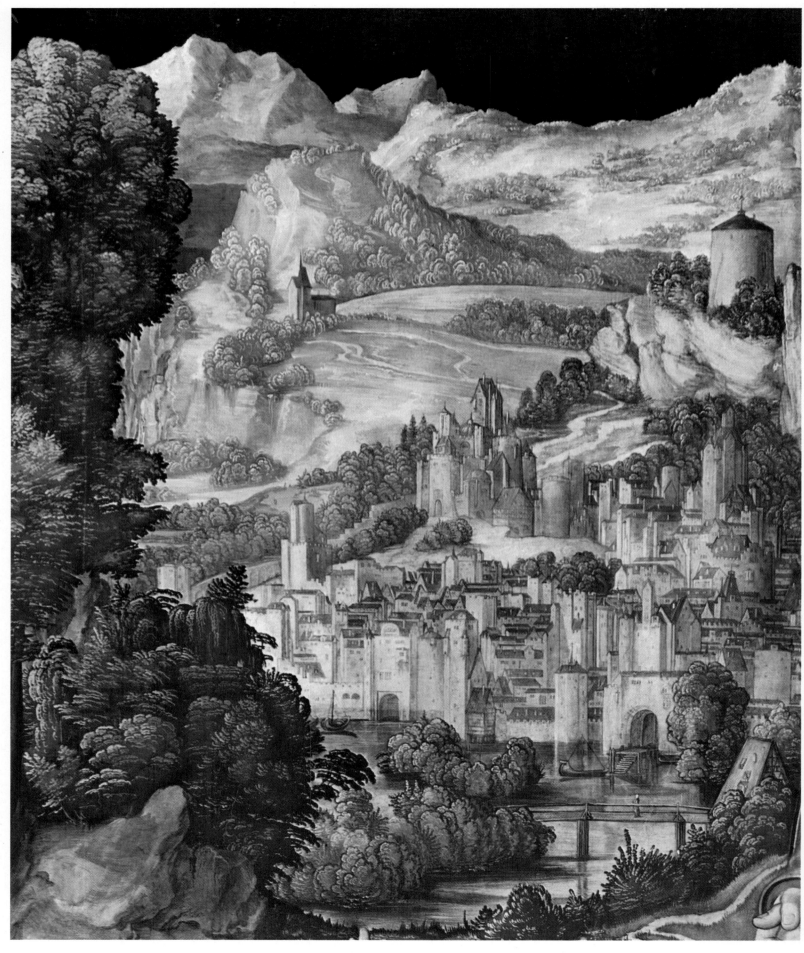

PLATE XVIII LAMENTATION OF CHRIST Munich, Alte Pinakothek
Detail (41 cm.)

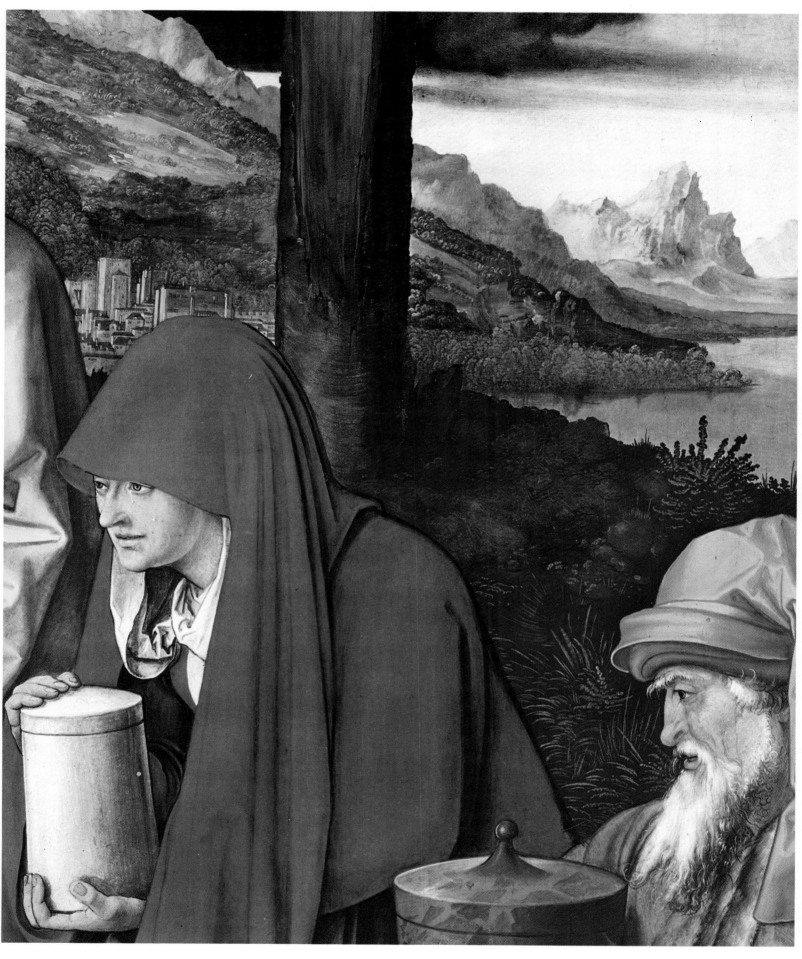

PLATE XIX LAMENTATION OF CHRIST Munich, Alte Pinakothek
Detail (41 cm.)

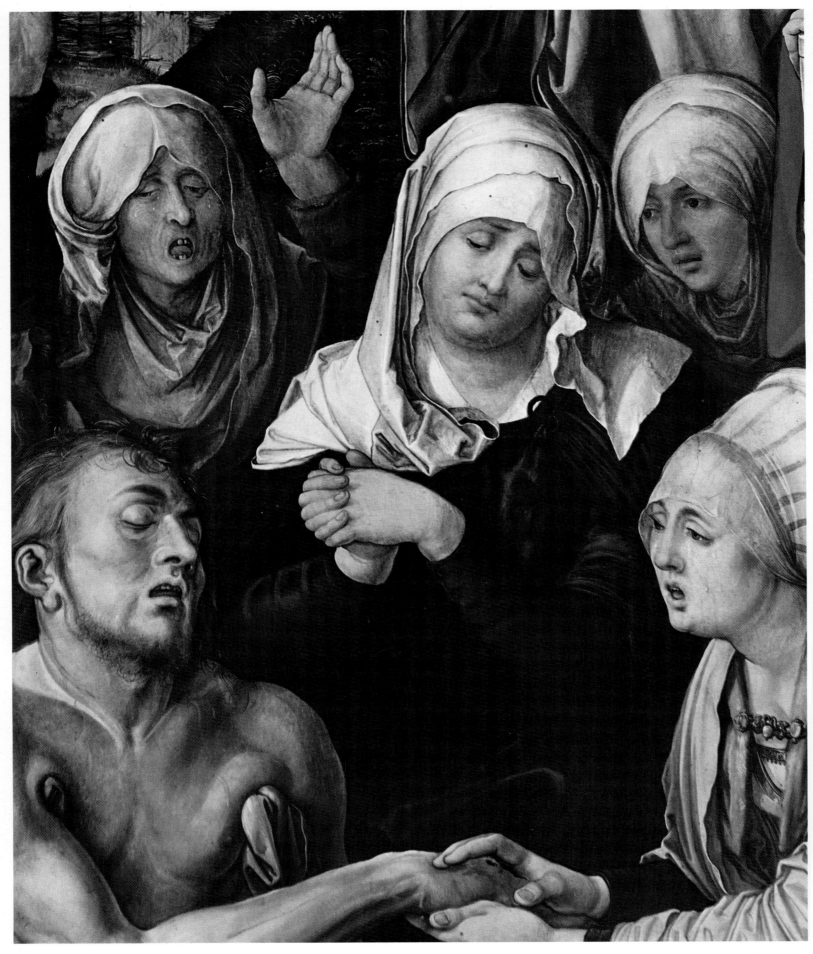

PLATE XX LAMENTATION OF CHRIST Munich, Alte Pinakothek
Detail (41 cm.)

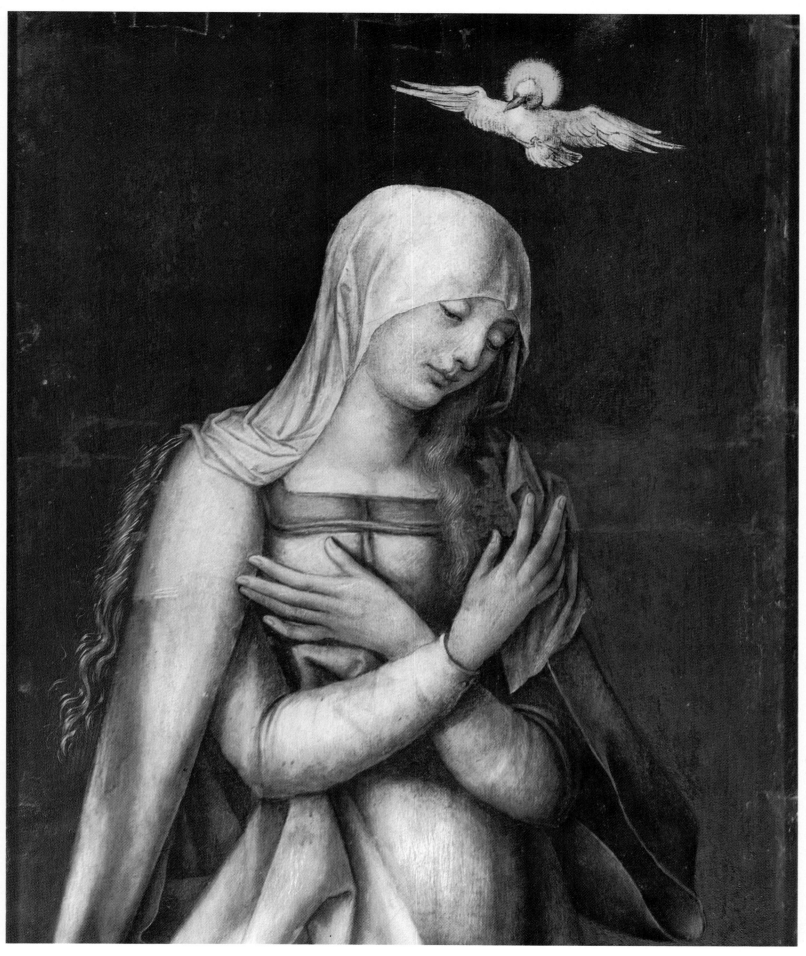

PLATE XXI PAUMGARTNER ALTAR Munich, Alte Pinakothek
Detail of *Virgin with the Dove* (61 cm.)

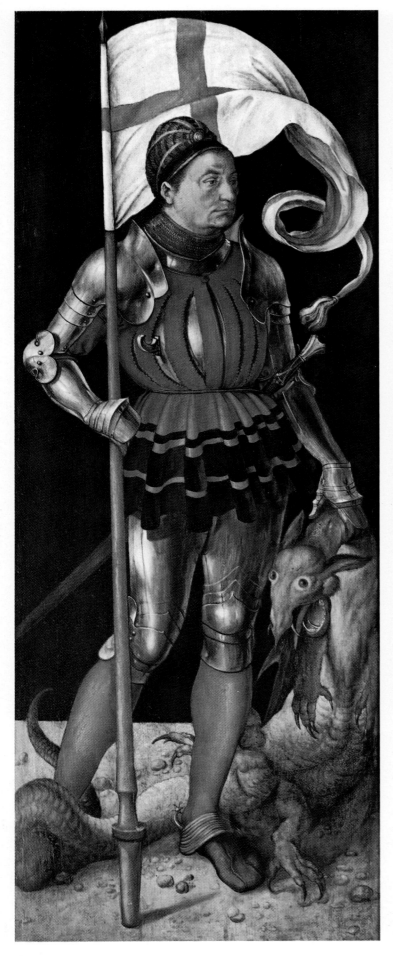
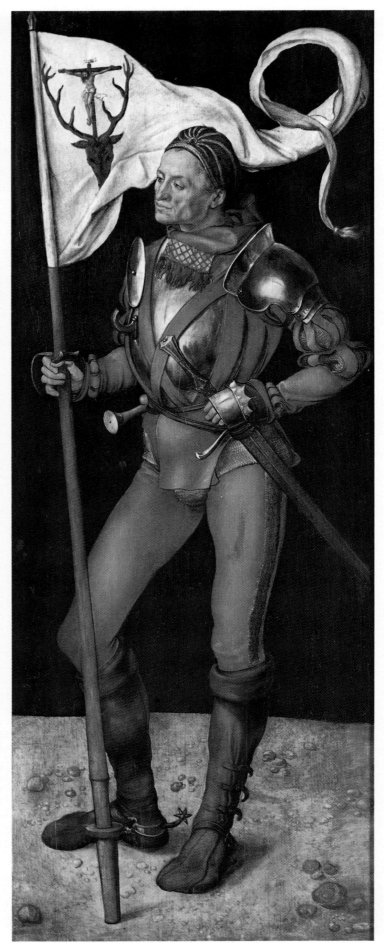

PLATE XXII PAUMGARTNER ALTAR Munich, Alte Pinakothek
St George and *St Eustace* (61 cm. each)

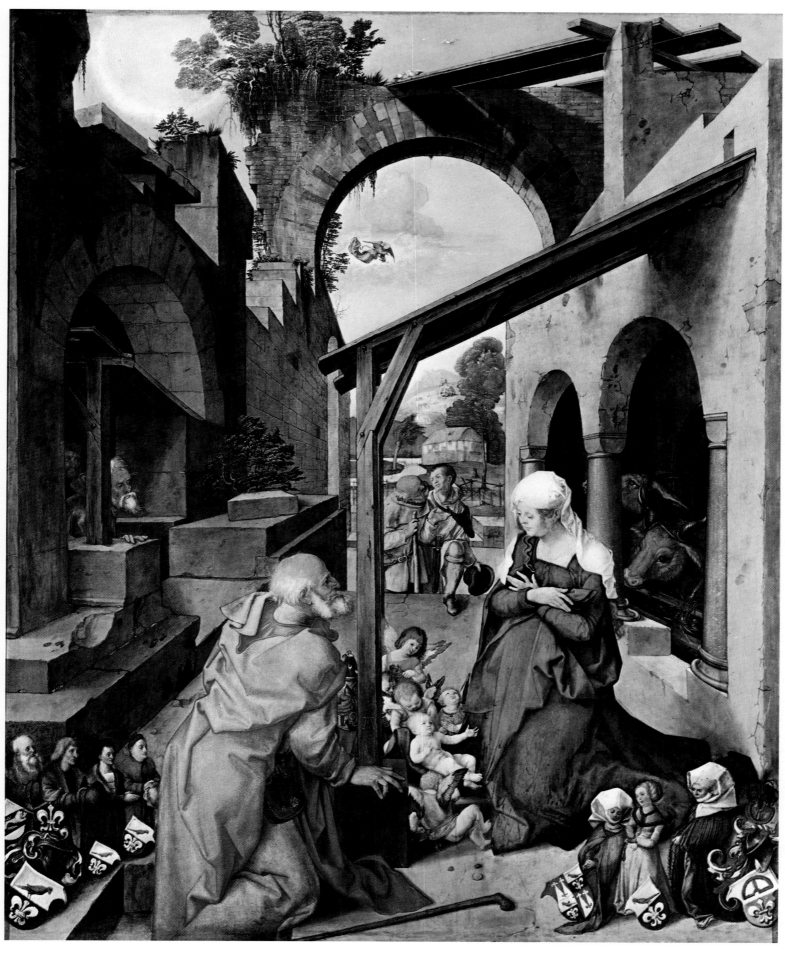

PLATE XXIII PAUMGARTNER ALTAR Munich, Alte Pinakothek
The Nativity (126 cm.)

PLATE XXIV PAUMGARTNER ALTAR Munich, Alte Pinakothek
Detail of the *Nativity* (28 cm.)

PLATE XXV PAUMGARTNER ALTAR Munich, Alte Pinakothek
Detail of the *Nativity* (28 cm.)

PLATE XXVI PAUMGARTNER ALTAR Munich, Alte Pinakothek
Detail of *St Eustace* (60 cm.)

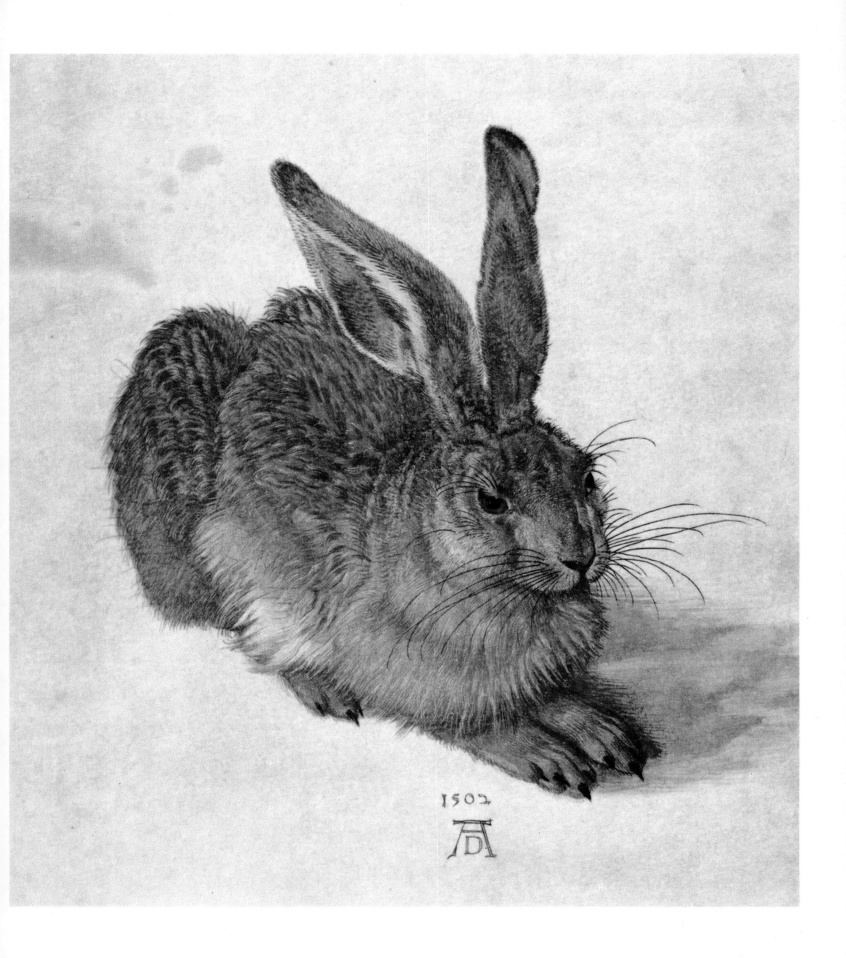

PLATE XXVII YOUNG HARE Vienna, Albertina
Whole (22.6 cm.)

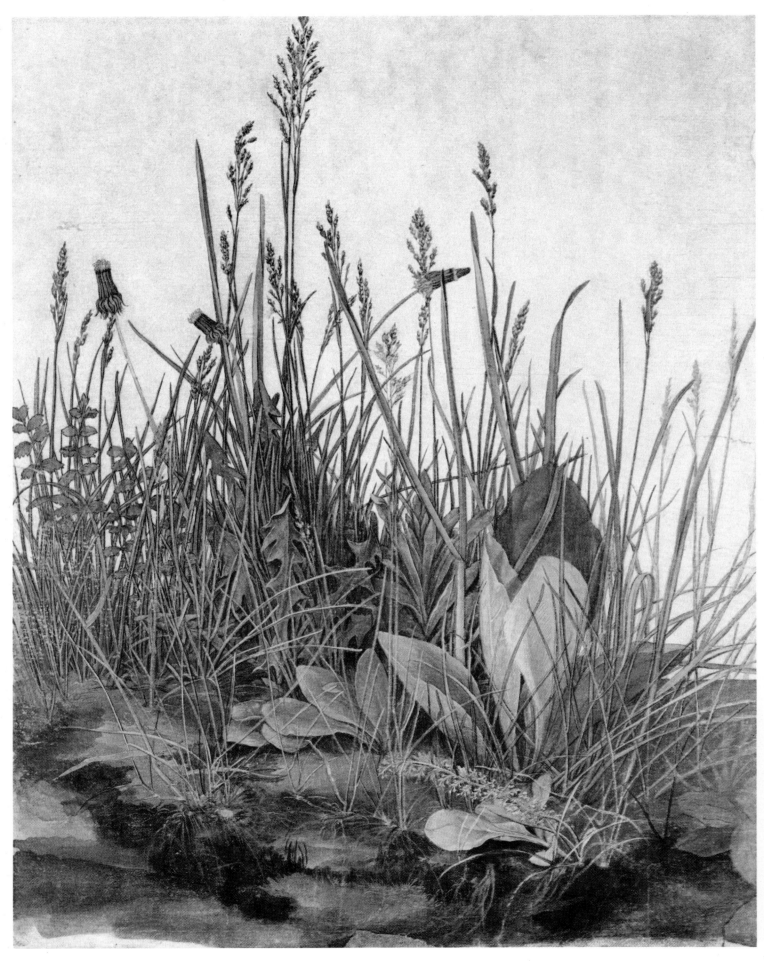

PLATE XXVIII THE GREAT PIECE OF TURF Vienna, Albertina
Whole (31.5 cm.)

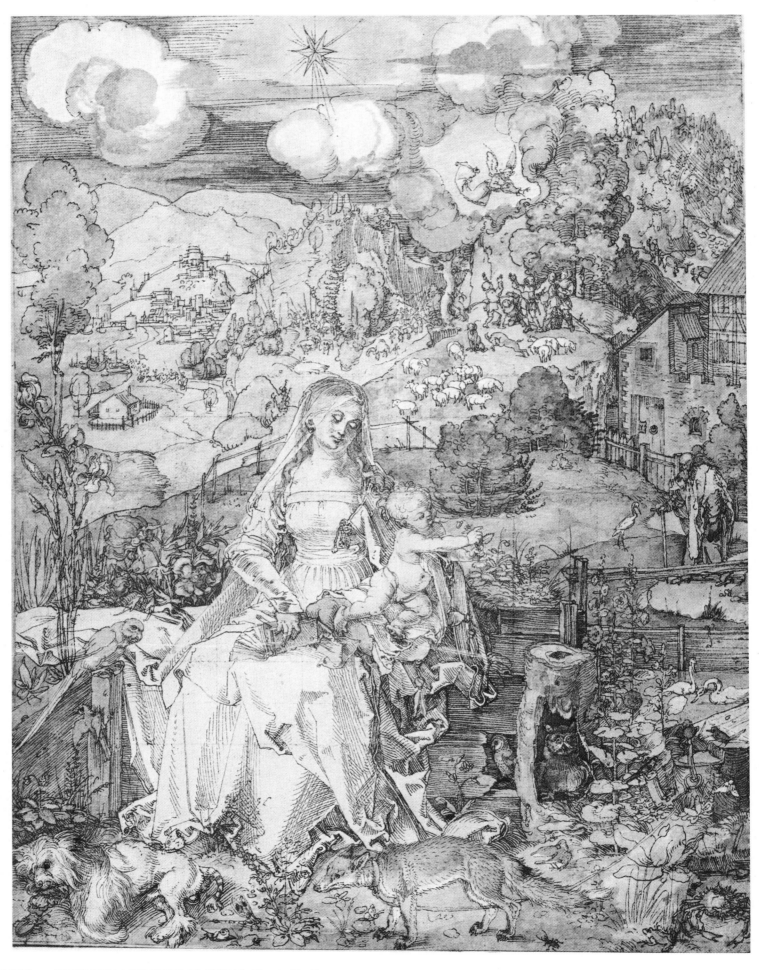

PLATE XXIX VIRGIN WITH A MULTITUDE OF ANIMALS Vienna, Albertina
Whole (24.3 cm.)

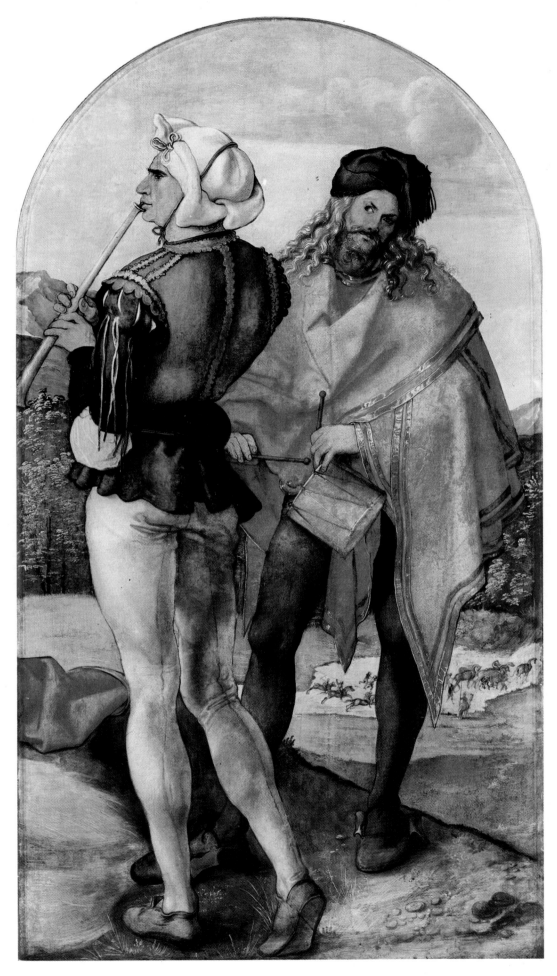

PLATE XXX TWO MUSICIANS Cologne, Wallraf-Richartz-Museum
Whole (51 cm.)

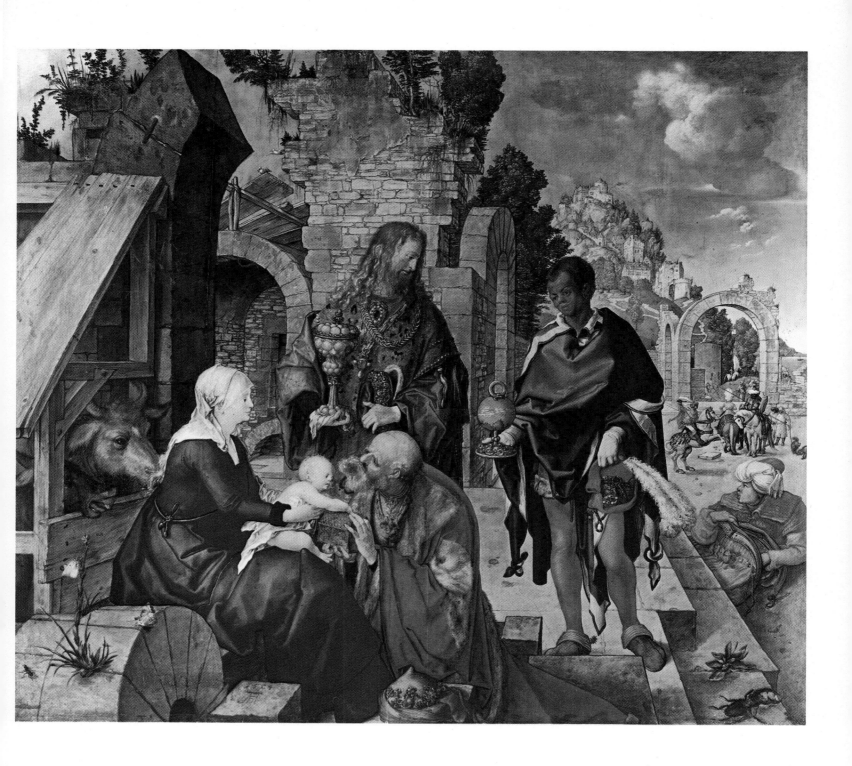

PLATE XXXI ADORATION OF THE MAGI Florence, Uffizi
Whole (114 cm.)

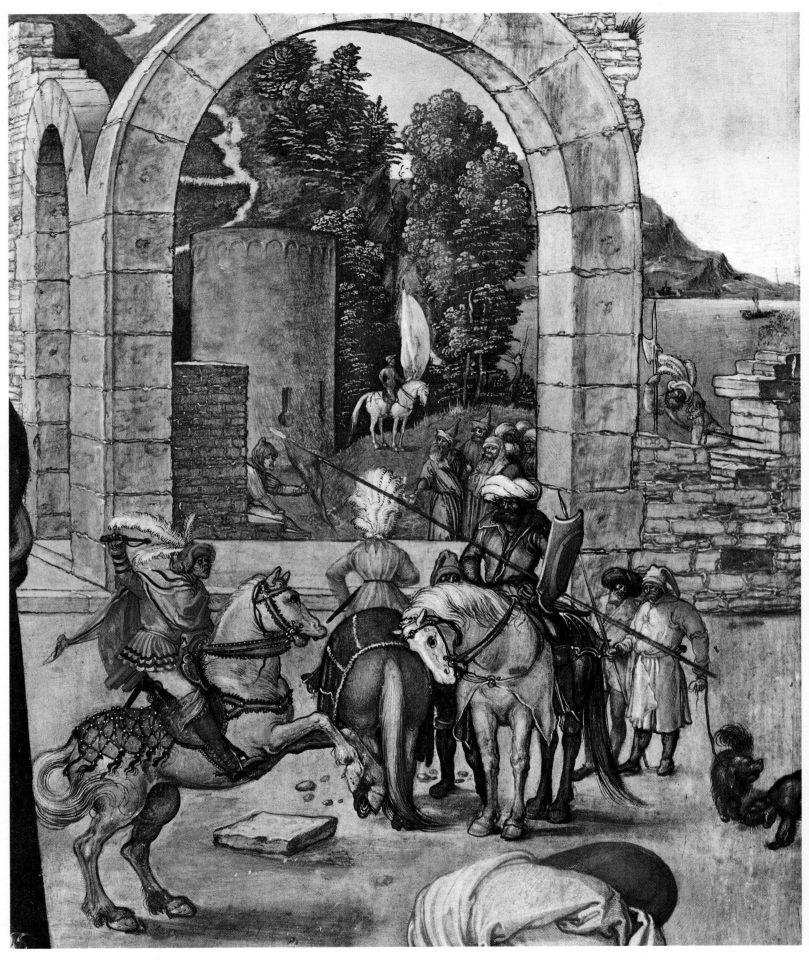

PLATE XXXII ADORATION OF THE MAGI Florence, Uffizi
Detail (actual size)

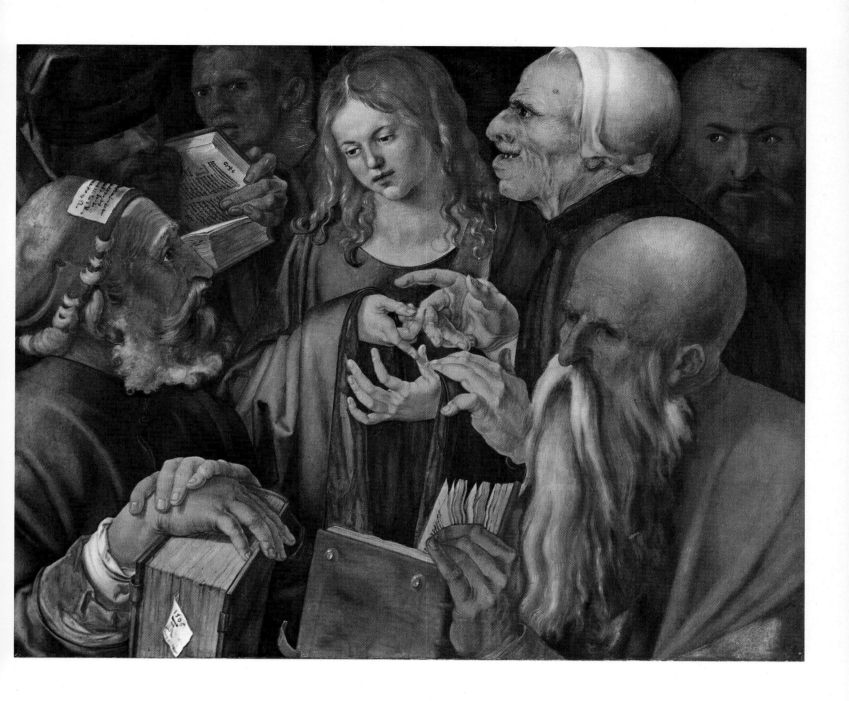

PLATE XXXIII CHRIST AMONG THE DOCTORS Lugano, Thyssen Collection
Whole (80 cm.)

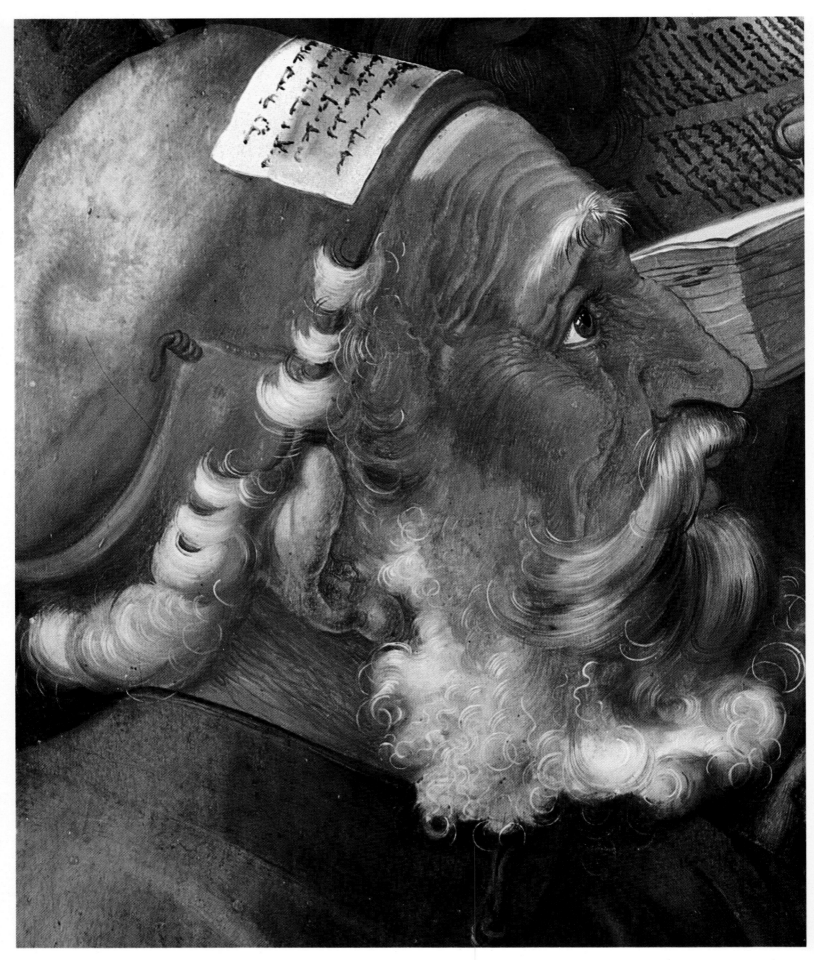

PLATE XXXIV CHRIST AMONG THE DOCTORS Lugano, Thyssen Collection
Detail (actual size)

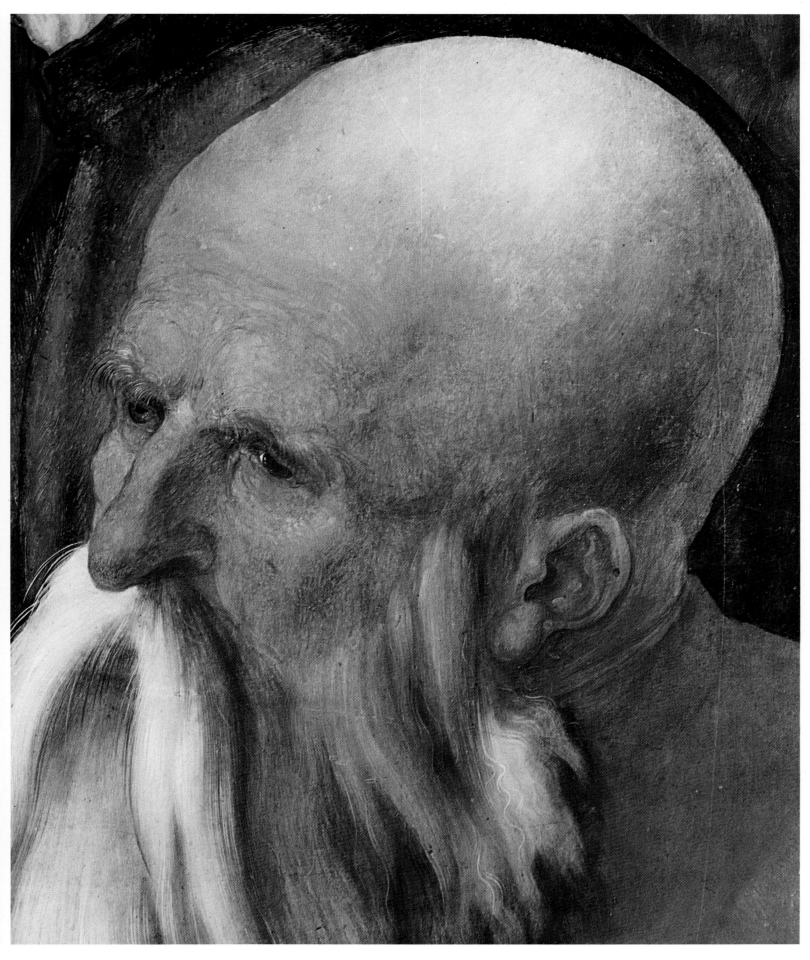

PLATE XXXV CHRIST AMONG THE DOCTORS Lugano, Thyssen Collection
Detail (actual size)

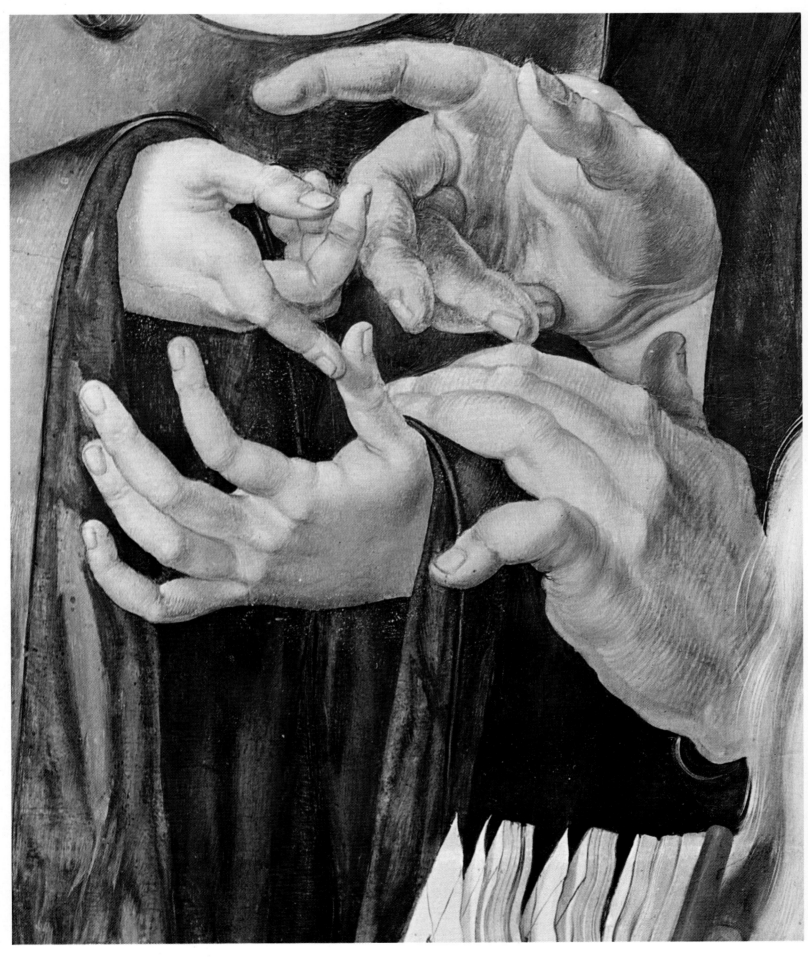

PLATE XXXVI CHRIST AMONG THE DOCTORS Lugano, Thyssen Collection
Detail (actual size)

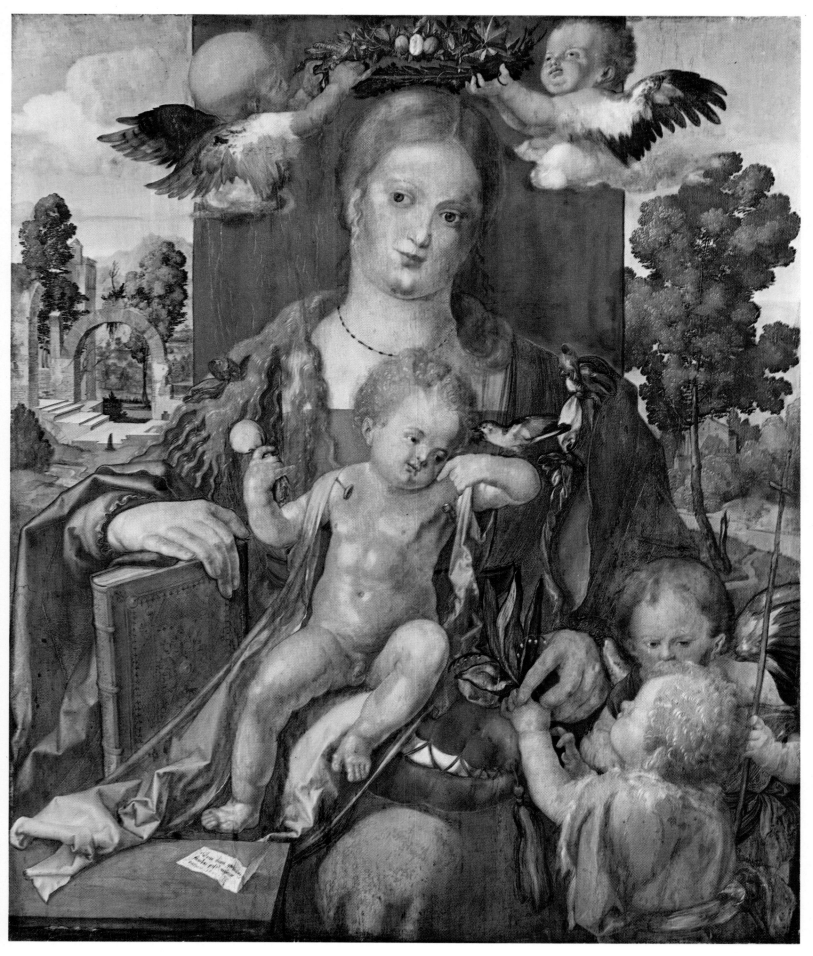

PLATE XXXVII VIRGIN WITH THE SISKIN Berlin, Staatliche Museen
Whole (76 cm.)

PLATE XXXVIII VIRGIN WITH THE SISKIN Berlin, Staatliche Museen
Details (17 cm. each)

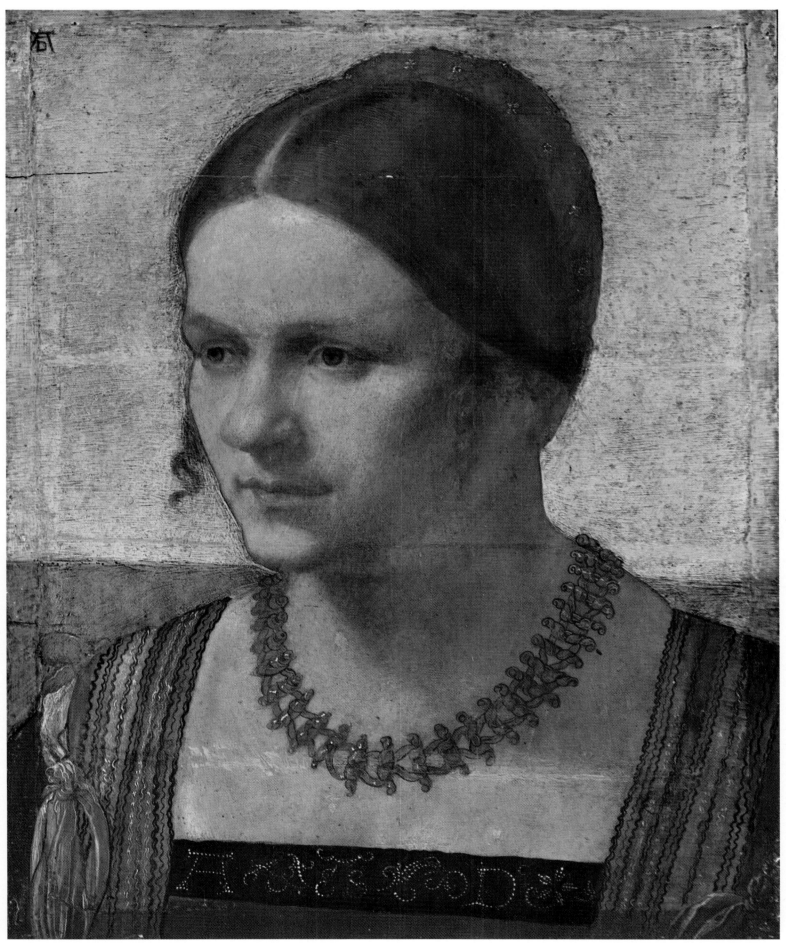

PLATE XXXIX PORTRAIT OF A WOMAN Berlin, Staatliche Museen
Whole (21.5 cm.)

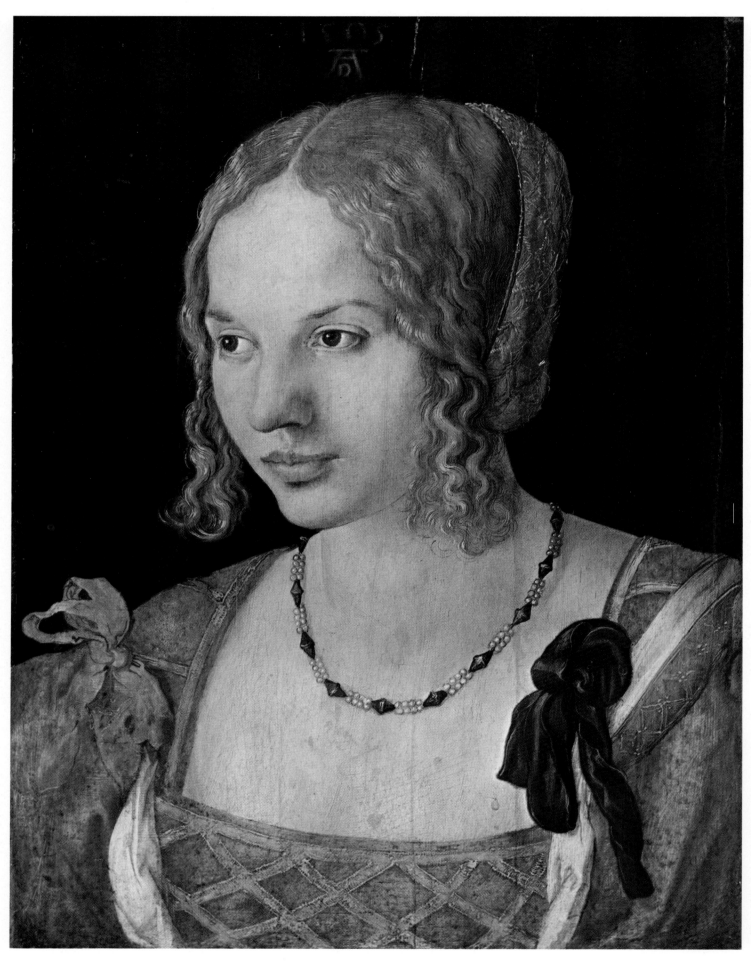

PLATE XL PORTRAIT OF A YOUNG LADY Vienna, Kunsthistorisches Museum
Whole (24.5 cm.)

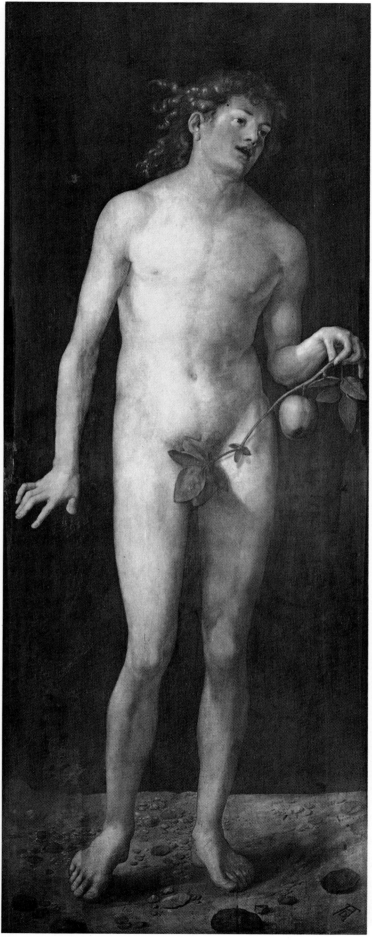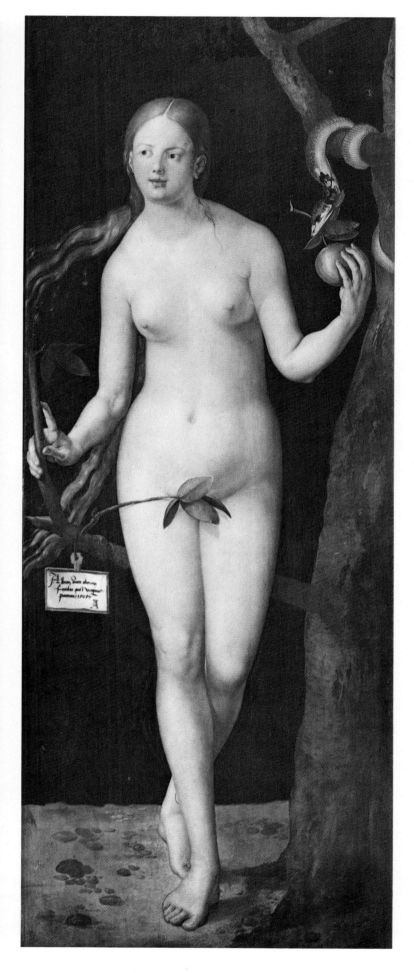

PLATE XLI ADAM and EVE Madrid, Prado
Whole (80 cm. each)

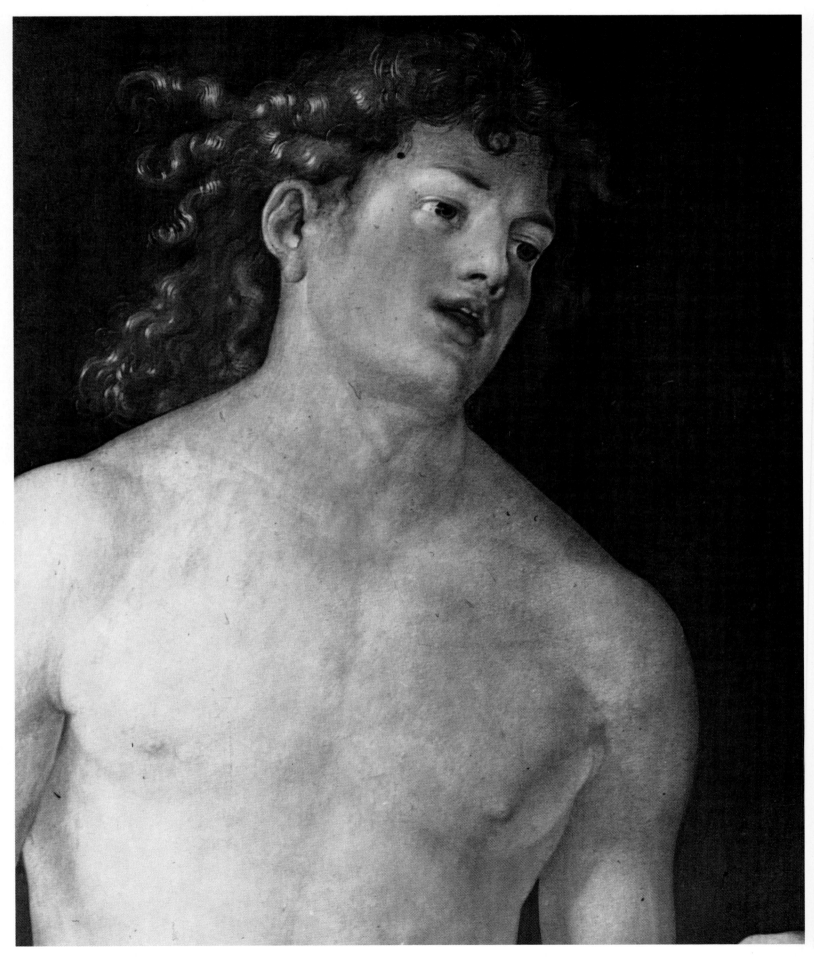

PLATE XLII ADAM Madrid, Prado
Detail (50 cm.)

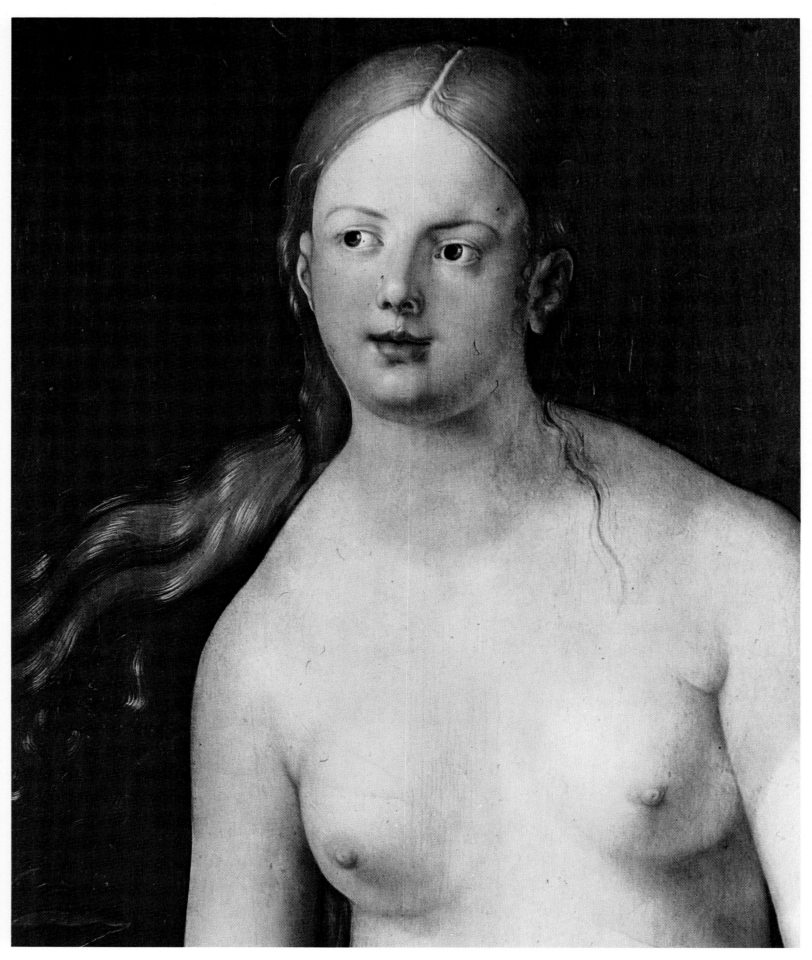

PLATE XLIII EVE Madrid, Prado
Detail (50 cm.)

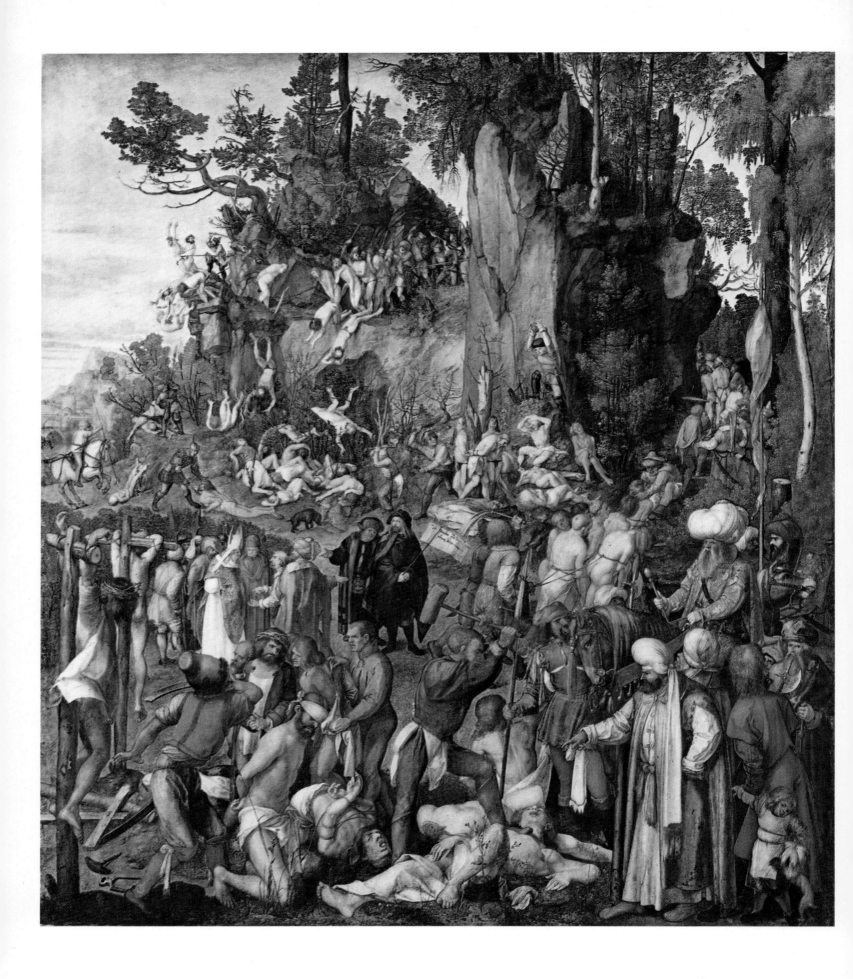

PLATE XLIV MARTYRDOM OF THE TEN THOUSAND Vienna, Kunsthistorisches Museum
Whole (87 cm.)

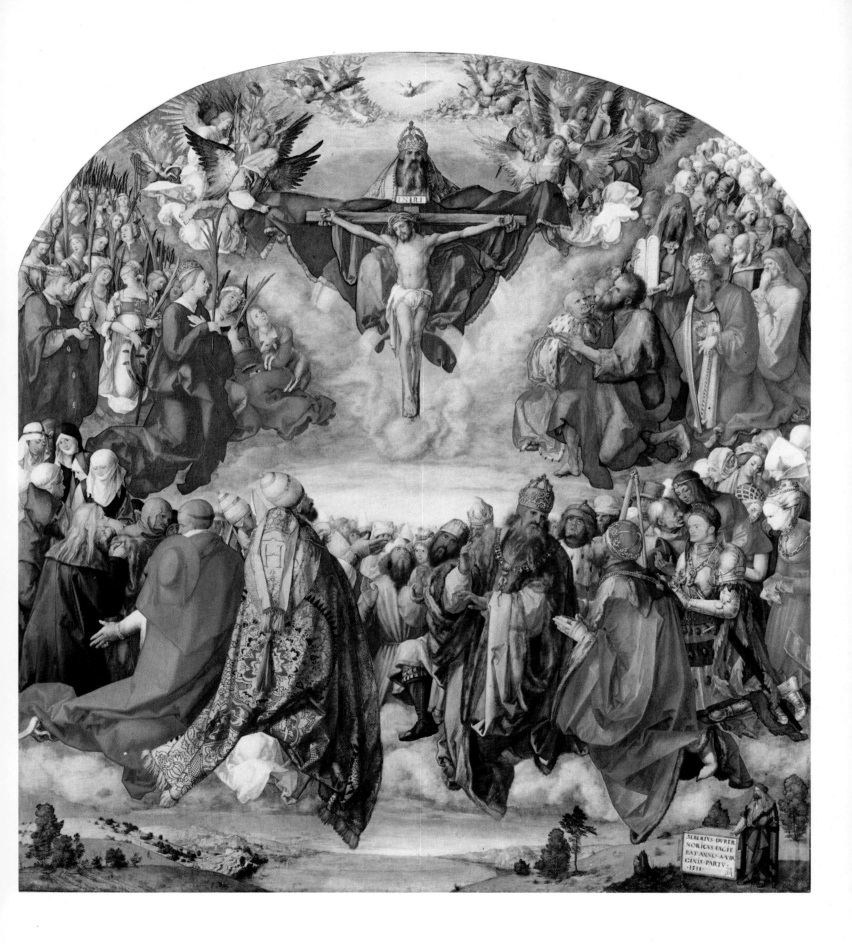

PLATE XLV ADORATION OF THE TRINITY Vienna, Kunsthistorisches Museum
Whole (123.5 cm.)

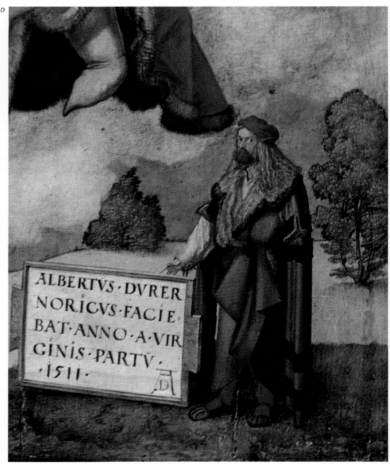

ALBERTVS · DVRER
NORICVS · FACIE
BAT · ANNO · A · VIR
GINIS · PARTV ·
·1511·

PLATE XLVI ADORATION OF THE TRINITY Vienna, Kunsthistorisches Museum
Details (21 cm. each)

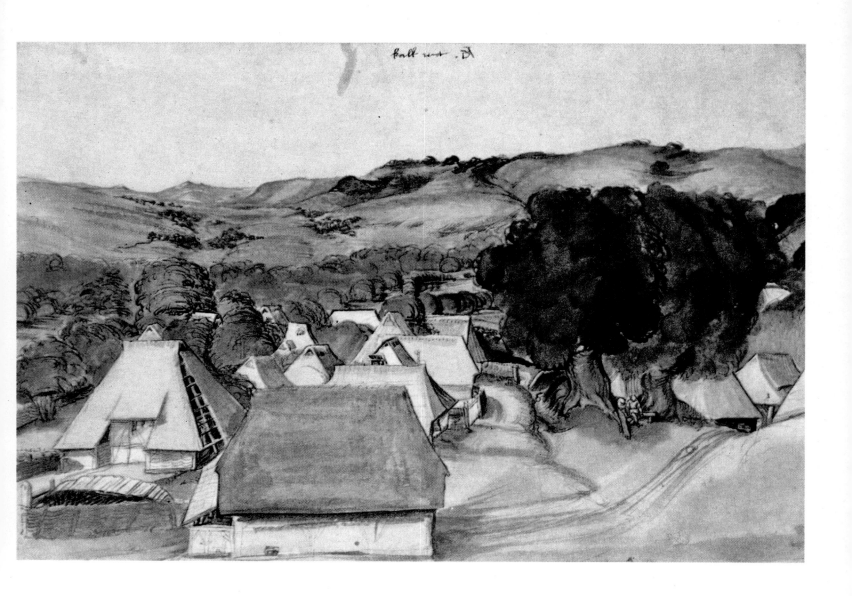

PLATE XLVII VIEW OF KALCHREUT Formerly Bremen, Kunsthalle
Whole (31.4 cm.)

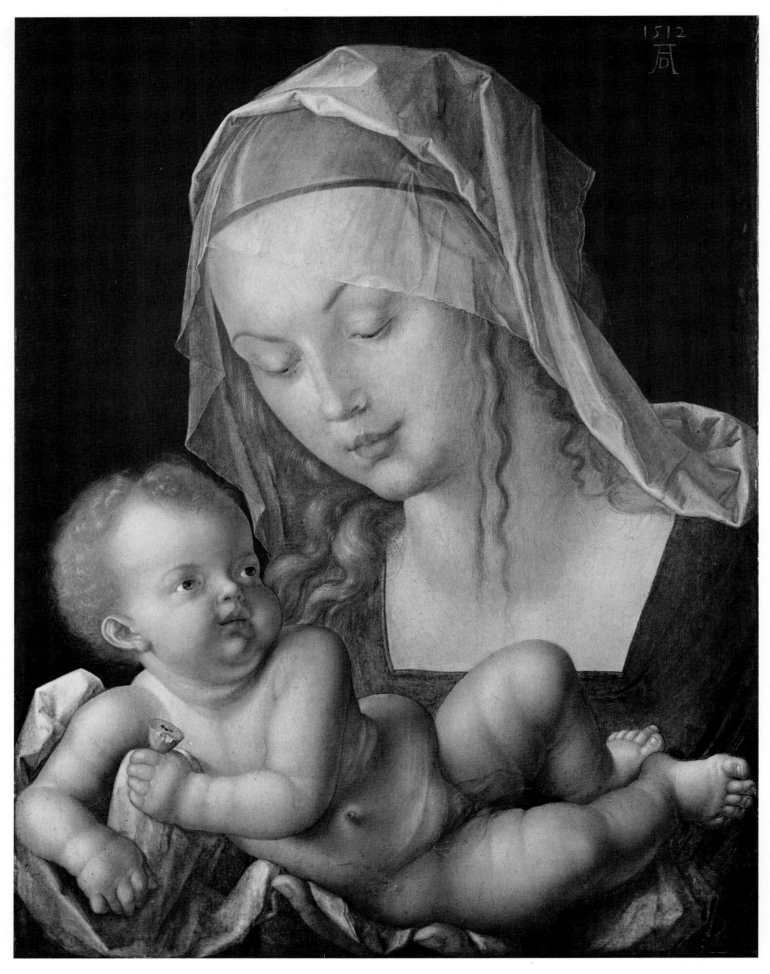

PLATE XLVIII VIRGIN WITH THE PEAR Vienna, Kunsthistorisches Museum
Whole (37 cm.)

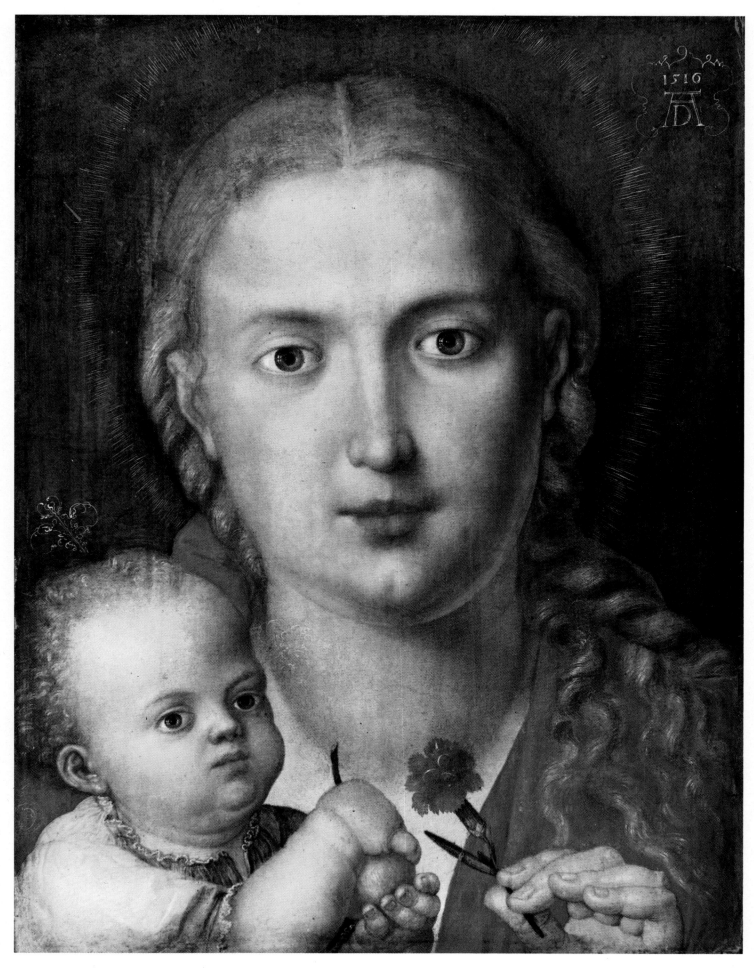

PLATE XLIX VIRGIN WITH THE PINK Munich, Alte Pinakothek
Whole (29 cm.)

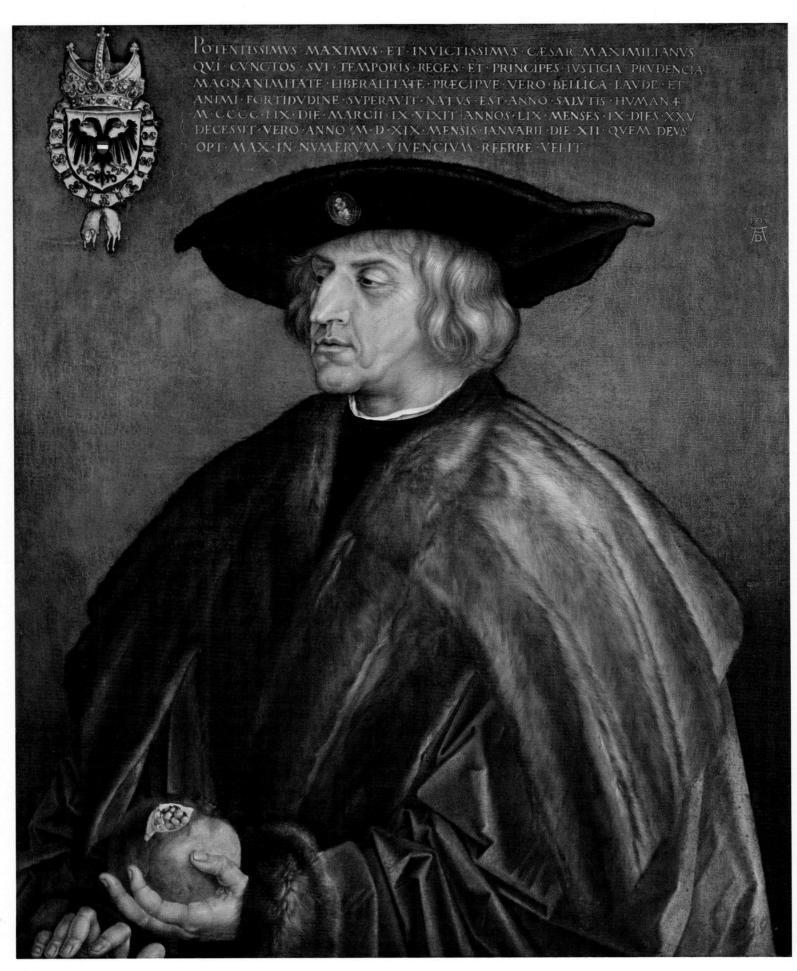

POTENTISSIMVS · MAXIMVS · ET · INVICTISSIMVS · CÆSAR · MAXIMILIANVS
QVI · CVNCTOS · SVI · TEMPORIS · REGES · ET · PRINCIPES · IVSTICIA · PRVDENCIA
MAGNANIMITATE · LIBERALITATE · PRÆCIPVE · VERO · BELLICA · LAVDE · ET ·
ANIMI · FORTIDVDINE · SVPERAVIT · NATVS · EST · ANNO · SALVTIS · HVMANÆ
M · CCCC · LIX · DIE · MARCII · IX · VIXIT · ANNOS · LIX · MENSES · IX · DIES · XXV
DECESSIT · VERO · ANNO · M · D · XIX · MENSIS · IANVARII · DIE · XII · QVEM · DEVS
OPT · MAX · IN · NVMERVM · VIVENCIVM · REFERRE · VELIT

PLATE L PORTRAIT OF EMPEROR MAXIMILIAN I Vienna, Kunsthistorisches Museum
Whole (61.5 cm.)

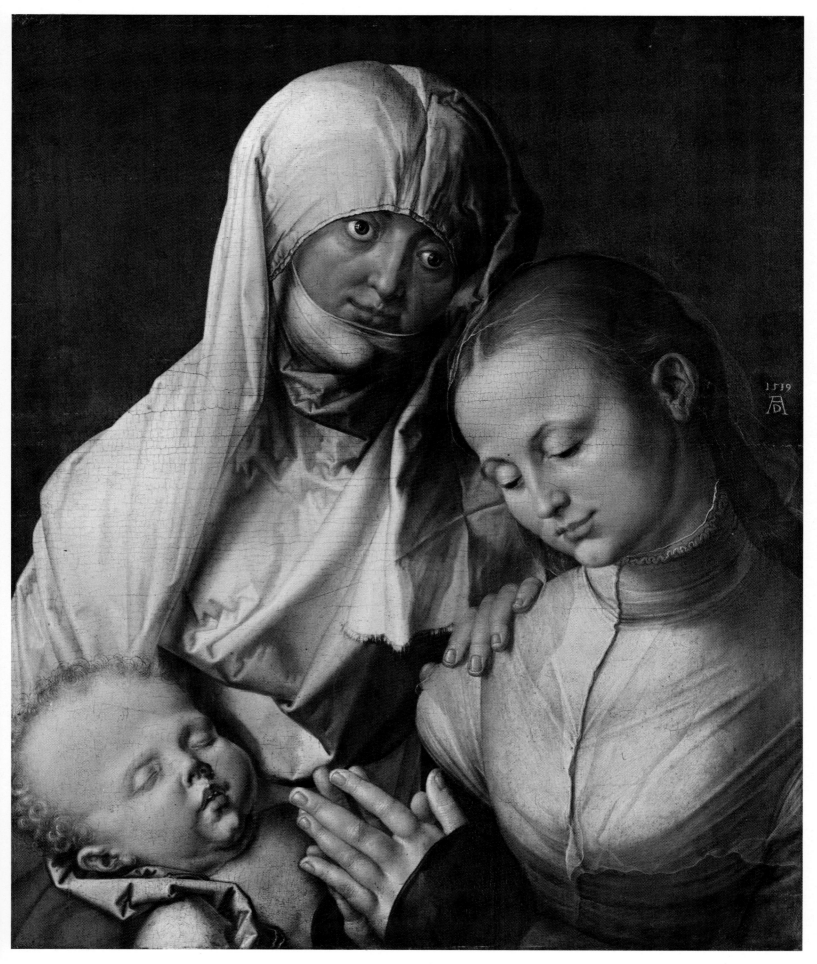

PLATE LI VIRGIN AND CHILD WITH ST ANNE New York, Metropolitan Museum of Art
Whole (50 cm.)

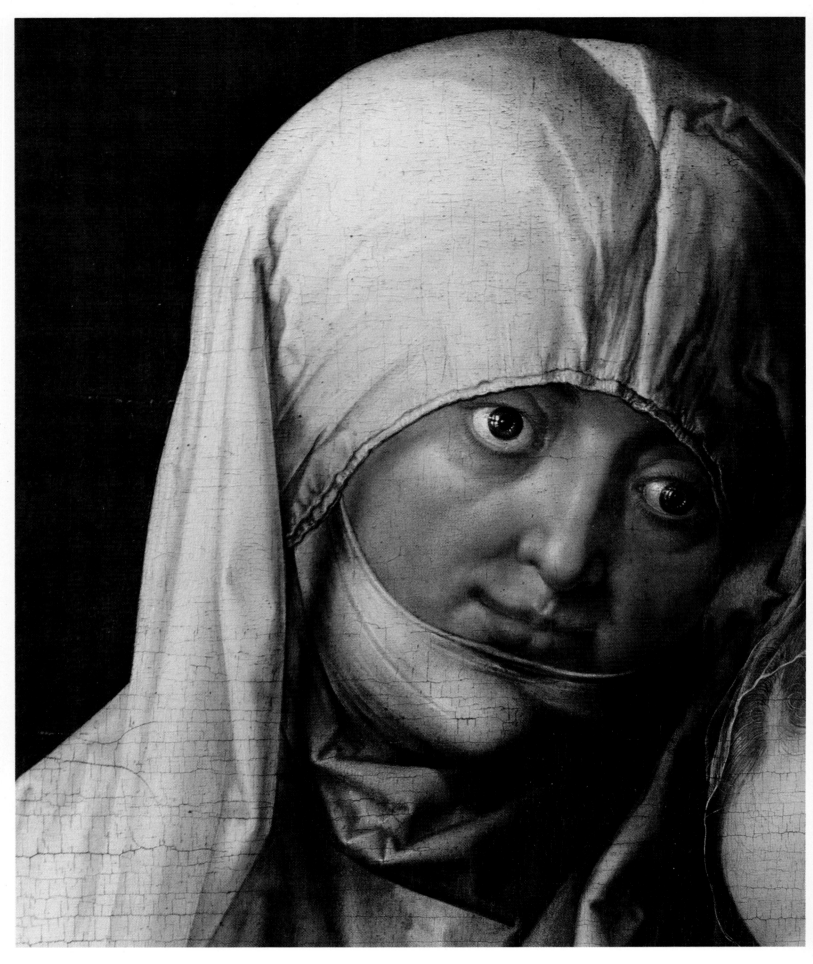

PLATE LII VIRGIN AND CHILD WITH ST ANNE New York, Metropolitan Museum of Art
Detail (actual size)

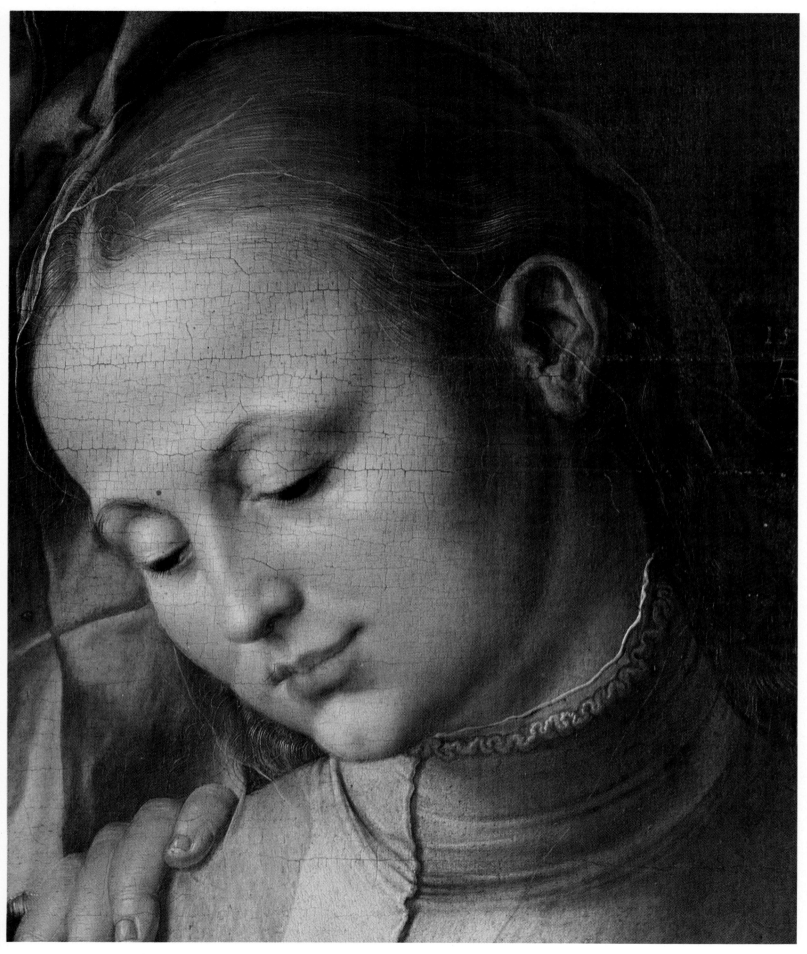

PLATE LIII VIRGIN AND CHILD WITH ST ANNE New York, Metropolitan Museum of Art
Detail (actual size)

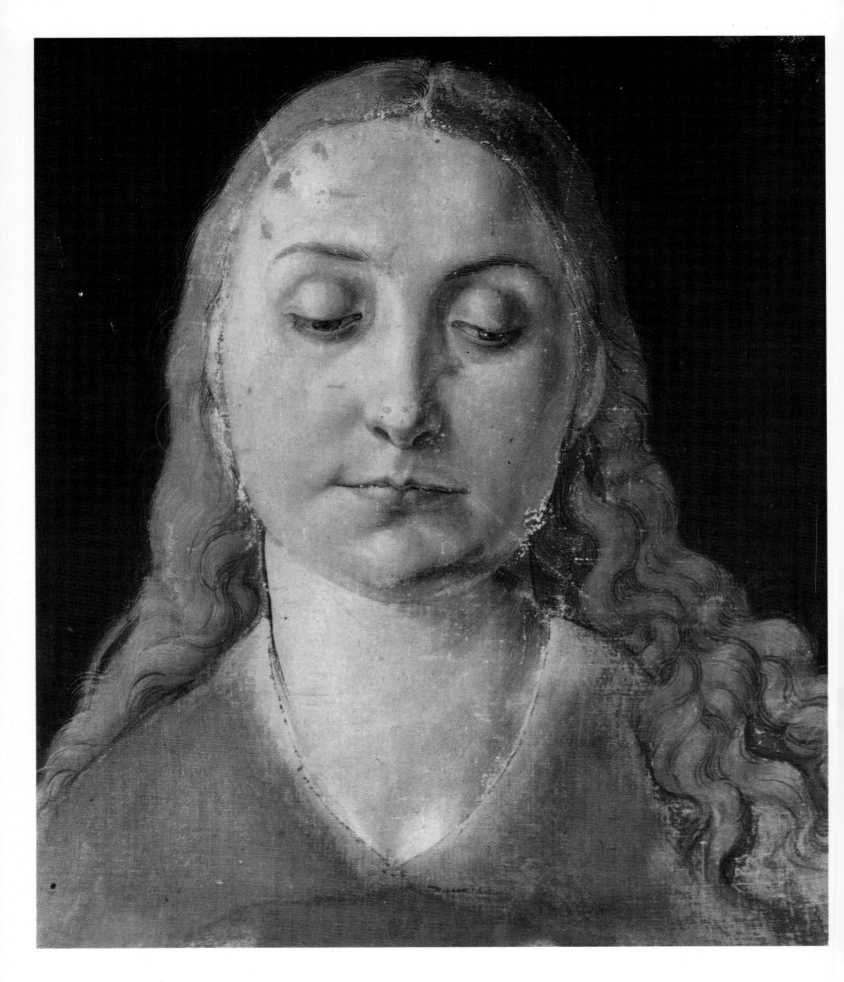

PLATE LIV HEAD OF A WOMAN Paris, Bibliothèque Nationale
Whole (24.5 cm.)

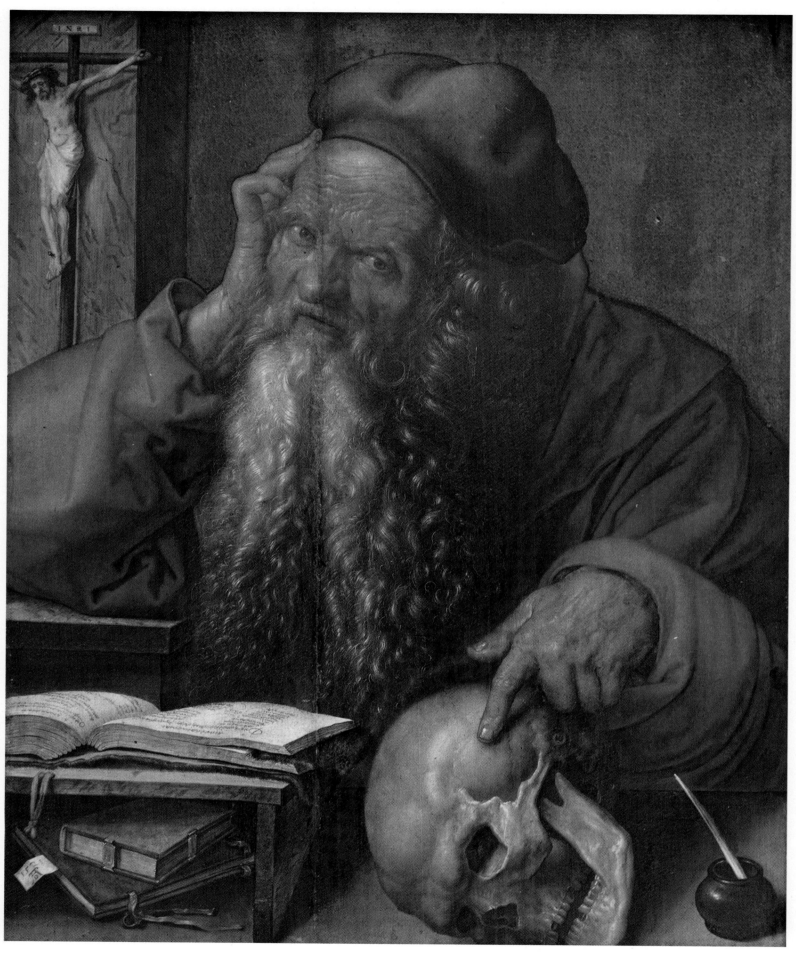

PLATE LV ST JEROME IN MEDITATION Lisbon, Museu Nacional de Arte Antiga
Whole (48.5 cm.)

PLATE LVI ST JEROME IN MEDITATION Lisbon, Museu Nacional de Arte Antiga
Detail (actual size)

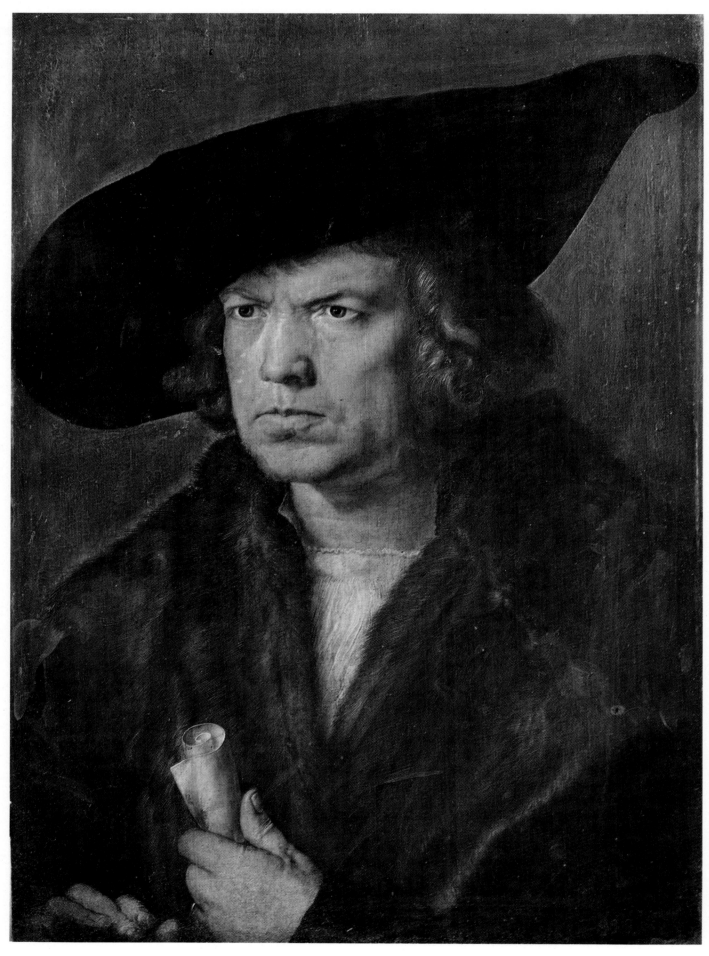

PLATE LVII PORTRAIT OF A GENTLEMAN Madrid, Prado
Whole (36 cm.)

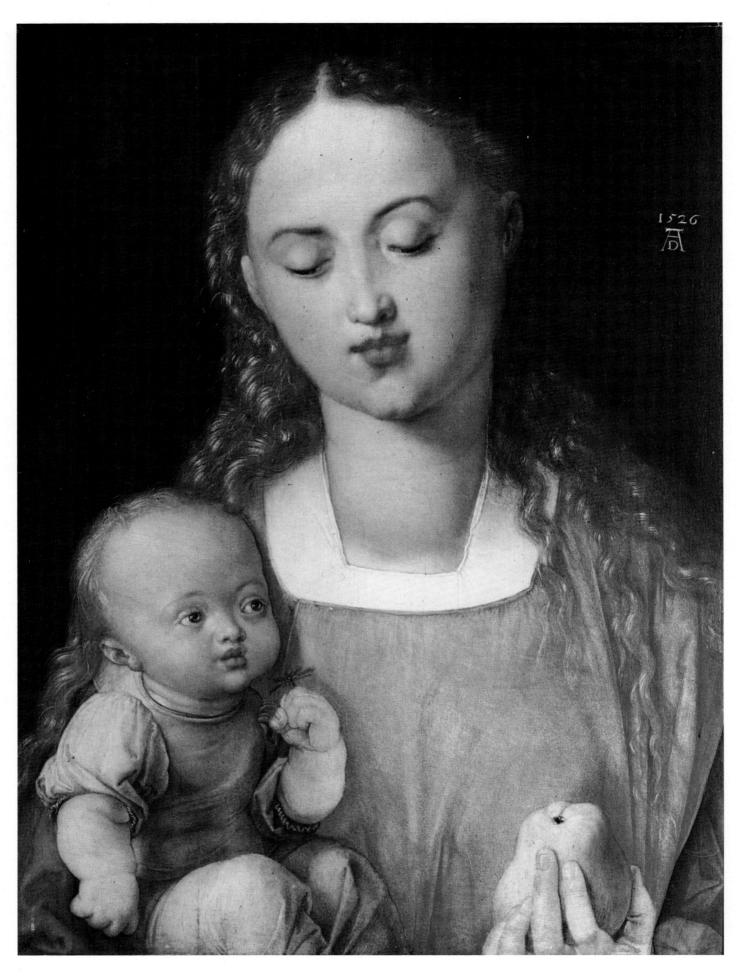

PLATE LVIII VIRGIN WITH THE PEAR Florence, Uffizi
Whole (31 cm.)

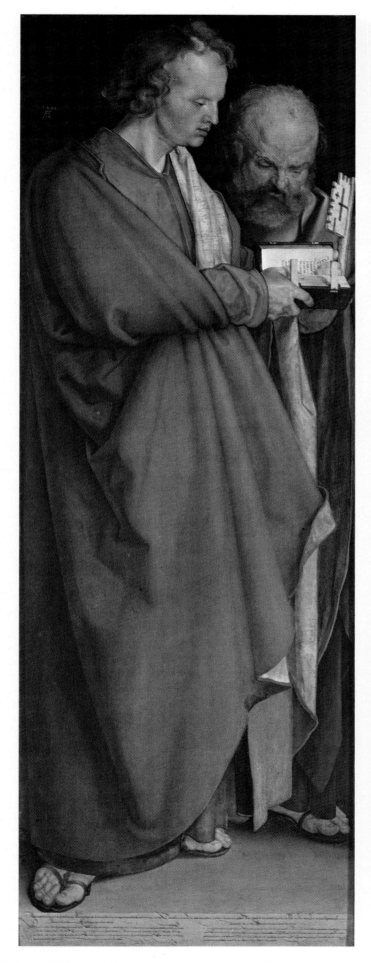
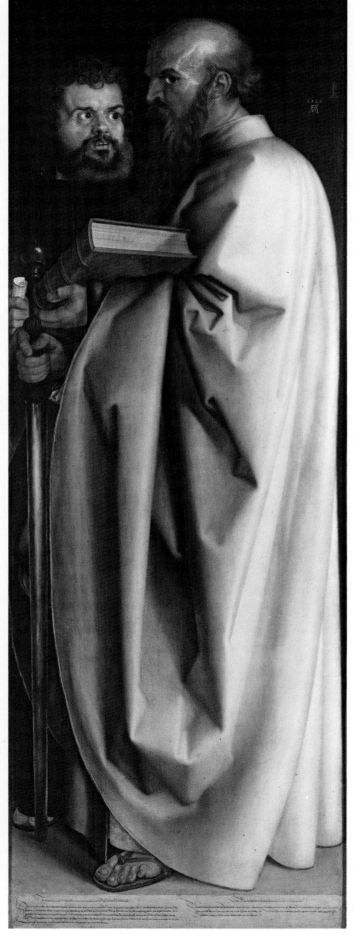

PLATE LIX THE FOUR APOSTLES Munich, Alte Pinakothek
St John and St Peter; *St Mark and St Paul* (76 cm. each)

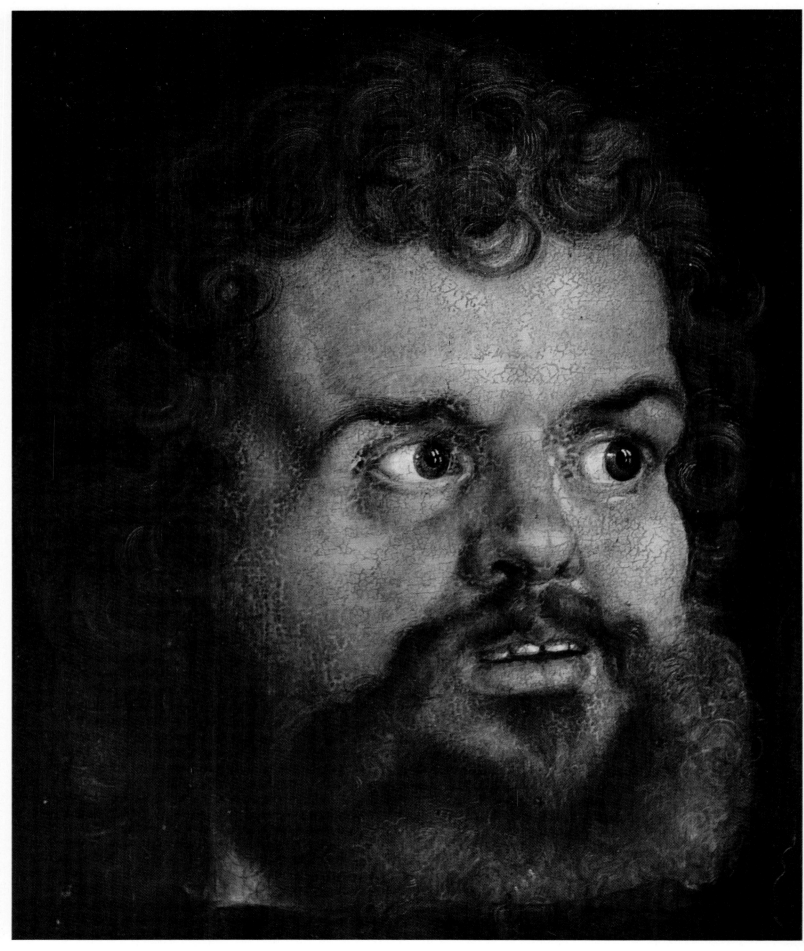

PLATE LX THE FOUR APOSTLES Munich, Alte Pinakothek
Detail of *St Mark* (28 cm.)

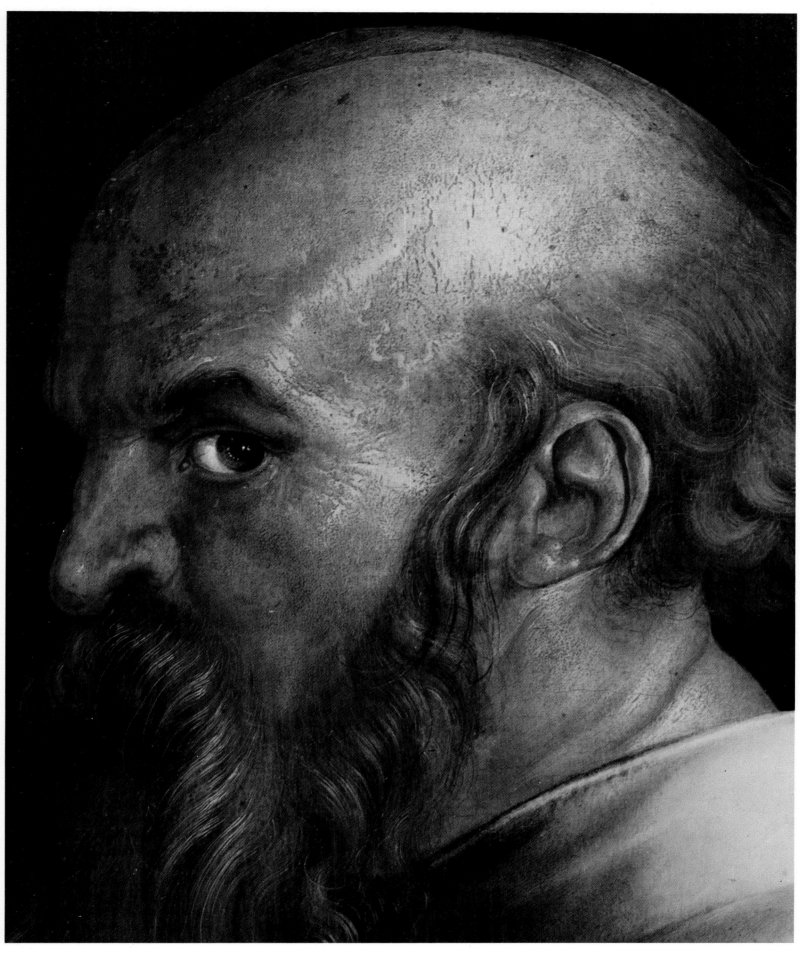

PLATE LXI THE FOUR APOSTLES Munich, Alte Pinakothek
Detail of *St Paul* (28 cm.)

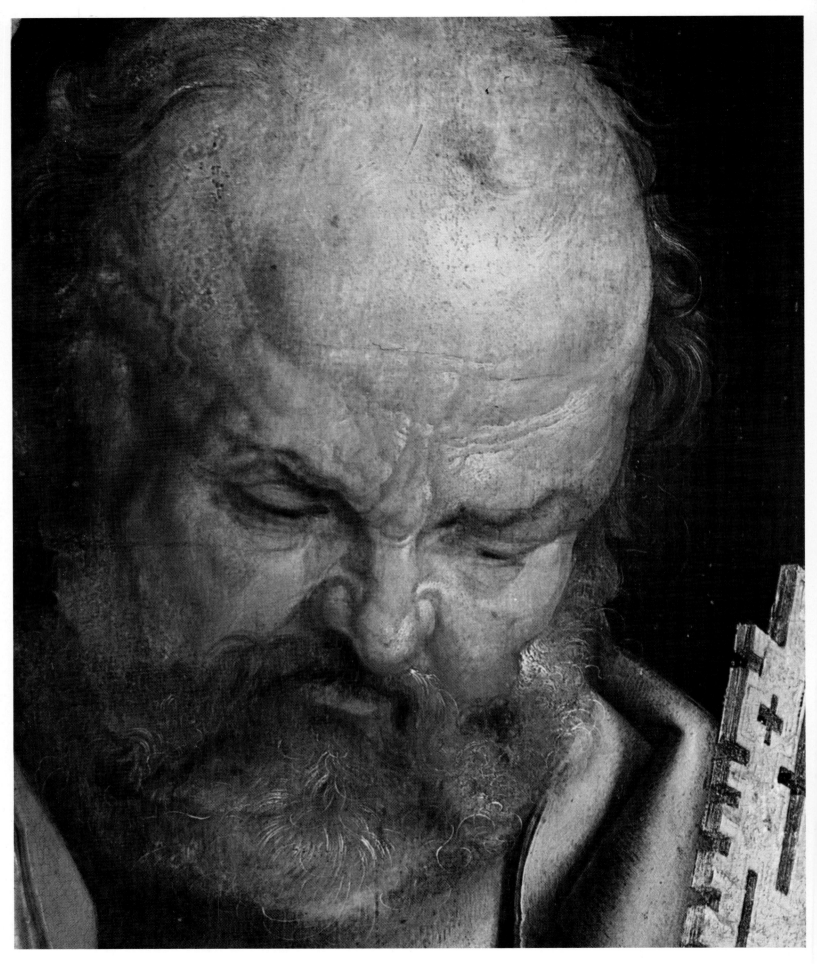

PLATE LXII THE FOUR APOSTLES Munich, Alte Pinakothek
Detail of *St Peter* (28 cm.)

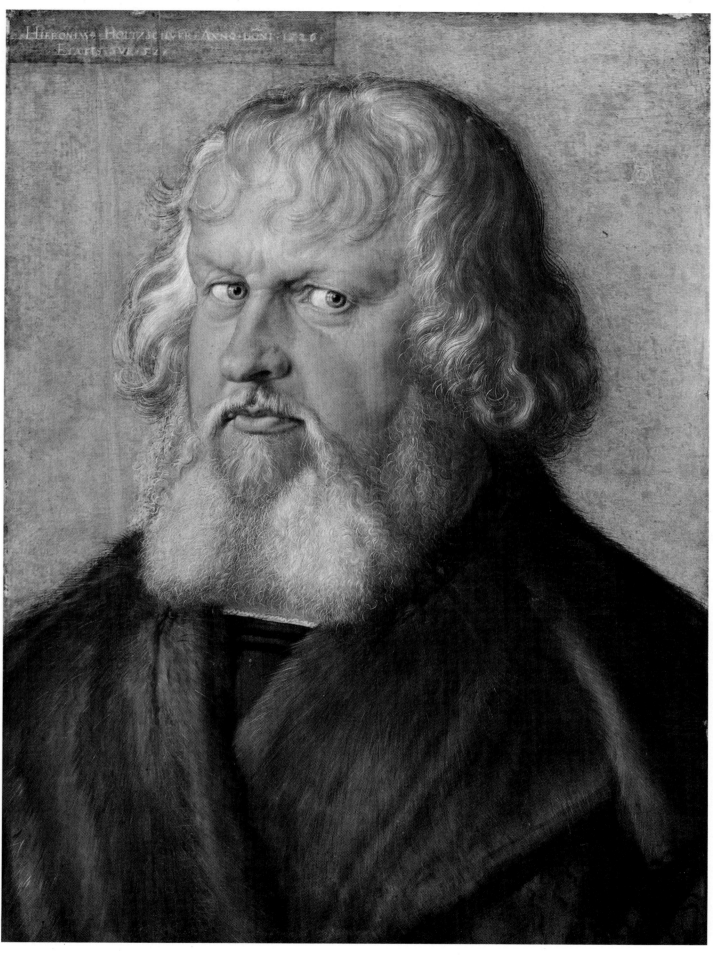

PLATE LXIII PORTRAIT OF HIERONYMUS HOLZSCHUHER Berlin, Staatliche Museen
Whole (36 cm.)

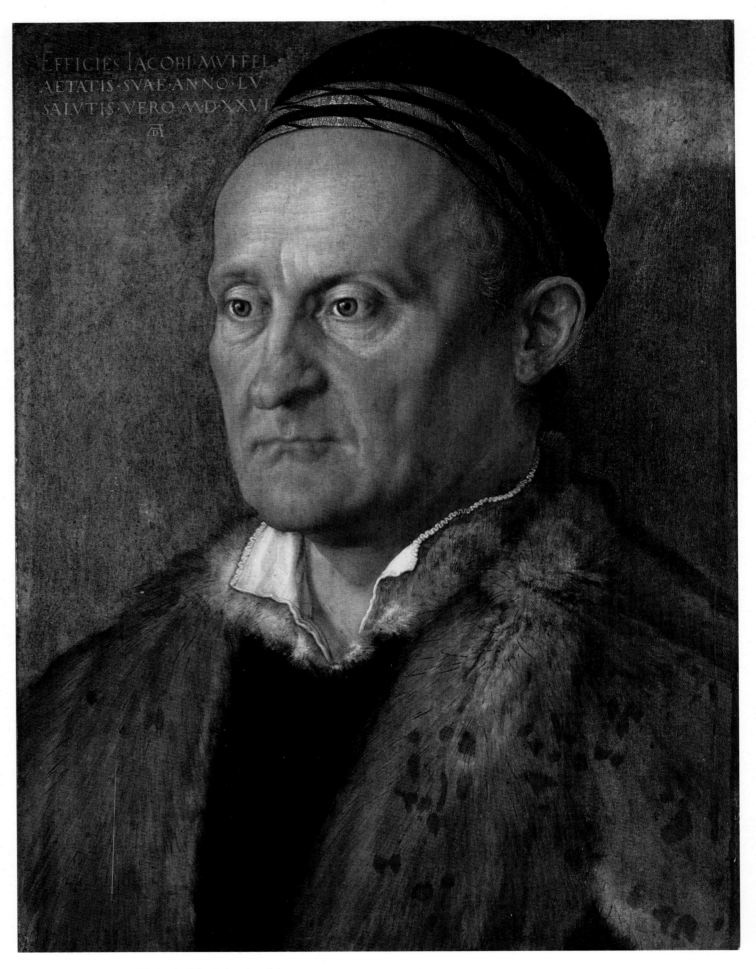

PLATE LXIV PORTRAIT OF JACOB MUFFEL Berlin, Staatliche Museen
Whole (36 cm.)

The works

So that the essential elements in each work may be immediately apparent, each commentary is headed first by a number (following the most reliable chronological sequence) which is given every time that the work is quoted throughout the book, and then by a series of symbols. These refer to: 1) its execution, that is, to the degree to which it is autograph; 2) its technique; 3) its support; 4) its present whereabouts; 5) the following additional data: whether the work is signed, dated; if its present-day form is complete; if it is a finished work. Of the other two numbers in each heading, the upper numbers refer to the picture's measurement in centimetres (height and width); the lower numbers to its date. When the date itself cannot be given with certainty, and is therefore only approximate, it is followed or preceded by an asterisk, according to whether the uncertainty relates to the period before the date given, the subsequent period, or both. All the information given corresponds to the current opinion of modern art historians; any seriously different opinions and any further clarification are mentioned in the text.

Key to symbols used

Execution

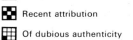

Autograph

With assistants

With collaboration

With extensive collaboration

Workshop

Usually attributed to Dürer

Not usually accepted

Traditional attribution

Recent attribution

Of dubious authenticity

Technique

Oil

Tempera

Watercolour

Support

Panel

Canvas

Paper or similar

Whereabouts

Accessible to the public

Private collection

Unknown

Lost

Additional Data

Signed work

Dated work

Fragment or incomplete work

Unfinished

Without any of the above-mentioned attributes

Symbols given in the text

Bibliography

The literature on Dürer is more extensive and complex than that on any other German artist. The first bibliographic inventory appeared in 1928 (H.W.SINGER, *Versuch einer Dürer Bibliographie*, Strasbourg) which was followed in the same year by a bibliography of Dürer's theoretical writings (H.BOHATTA, *Versuch einer Bibiliographie der kunst-theoretischen Werke Albrecht Dürers*, in *Börsenblatt für den deutschen Buchhandel*, XCV); for the most up to date bibliographical references see E.PANOFSKY's important monograph (*Albrecht Dürer*, Princeton 1943, 1945 and 1948) and J.BIALOSTOCKI (*Albrecht Dürer* in *Encyclopedia of World Art*, Vol. IV, McGraw–Hill, London 1964, which contains an exhaustive list of Dürer studies, grouped according to theme). The following monographs should be noted: M.THAUSING (*Albrecht Dürer, Geschichte seines Lebens und seiner Kunst*, Leipzig 1876 and 1884; French edition 1878; English edition, *Albrecht Dürer*, John Murray, 1882, 2 vols. This is still an essential work); H.WÖLFFLIN (*Die Kunst Albrecht Dürers*, Munich 1905; 6th ed. 1943; English edition: *The Art of Albrecht Dürer*, London 1971); M.J.FRIEDLÄNDER (*Albrecht Dürer*, Leipzig 1921); E.FLECHSIG (*Albrecht Dürer*, 2 vols., Berlin 1928–31); A.NEUMEYER (*Dürer*, Paris 1930); W.WATZOLDT (*Dürer und seine Zeit*, Königsberg 1944, 5th ed.); E.PANOFSKY – in addition to the work already mentioned – (*The Life and Art of Albrecht Dürer*, Princeton 1955 and 1965); F.WINKLER (*Albrecht Dürer*, Berlin 1957); W.BRAUNFELS (*A. Dürer*, Wiesbaden–Berlin 1960); studies of a more general character have included those by G.DORFLES (Milan 1958); M.LEVEY (London 1964); M.BRION (Paris 1966).
Of the catalogues, F. LIPPMANN on the drawings (*Zeichnungen von Albrecht Dürer Nachbildungen*, 7 vols., Berlin 1883–1929. L. followed by a number in the present text refers to Lippmann's catalogue) and the more recent work by F.WINKLER (*Die Zeichnungen A. Dürers*, 4 vols., Berlin 1936–9); the fundamental work on the prints is by J.MEDER (*Dürer-Katalog*, Vienna 1932), but see also S.R.KOEHLER (*A Chronological Catalogue of the Engravings . . .*, Liverpool 1910). A.BARTSCH's (numbers are used to simplify references to the engravings) (*Le Peintre-Graveur*, Vienna 1800–8) – abbreviated as B, followed by the relevant number. For the woodcuts see W.KURTH (*Dürers sämtliche Holzschnitte*, Munich 1927 and 1935; London 1927; New York 1946) and for the engravings C.DODGSON (*Albrecht Dürer*, London–Boston 1926) and R.SALVINI's brilliant study (*Dürer, Incisioni scelte e annotate*, Florence 1964). H.TIETZE and E.TIETZE-CONRAT (*Kritisches Verzeichnis der Werke Albrecht*

Dürers, Augsburg–Basle–Leipzig 1928, 1937 and 1938) is an indispensable study of Dürer's work in all media.
There are innumerable studies of individual works and of particular problems, amongst which the following are worth mentioning: L.JUSTI (*Dürers Dresden Altar*, Leipzig 1904); E.PANOFSKY–F.SAXL (*Dürers Kupferstich "Melencolia I"*, Leipzig–Berlin 1923); M.DVORÁK (*Apokalypse, Kunstgeschichte als Geistesgeschichte*, Munich 1924); H.KAUFFMANN (*Dürers Dreikönig-Altar*, "WRJ" X, 1938 – see list of abbreviations below); A.WEIXLGARTNER (in *Festschrift für Julius Schlosser*, Vienna 1927); F.J.STADLER (*Dürers Apokalypse und ihr Umkreis*, Munich 1929); E.PANOFSKY (*Die "Vier Apostel"*, "MJBK", NF VIII, 1931); H.STEINBART ('ZK' 1951); E.SCHILLING (*Werkzeichnungen zur Grünen Passion*, in *Berliner Museen*, 1954); L.GROTE (*Dürer in Venedig*, Munich 1956); C.KOCK ("ZKW" 1958), J.BIALOSTOCKI ("Opus quinque Dierum": Dürer's "Christ among the Doctors" and its Sources, in *Journal of the Warburg and Courtauld Institutes*, XXII, 1959) K.MARTIN (*Die Vier Apostel*, Stuttgart 1960); E.HOLZINGER ("Essays in honor of Erwin Panofsky", I, New York 1961). The most useful English edition of Dürer's writings is still W.M.CONWAY's (*Literary Remains of Albrech Dürer*, Cambridge 1889).
Among recent books are: Bibliography: M.MENDE (*Dürer-Bibliographie*, Wiesbaden 1971); Monographs and essays: H.HOETINK (*Dürer*, London 1971); C.WHITE (*Dürer: The Artist and his Drawings*, Oxford 1971), E.ULLMANN et al., eds., (*Albrecht Dürer: Zeit und Werk*, Leipzig 1971), R.F.TIMKEN-ZINKANN (*Ein Mensch namens Dürer*, Berlin 1972), J. RICHER (*La Gloire de Dürer*, Paris 1974), P.STRIEDER (*Dürer*, Milan 1979; English edition: London 1982), C.R.DODWELL, ed., (*Essays on Dürer*, Manchester 1979), F.ANZELEWSKY (*Dürer: His Life and Art*, New York 1980; *Dürer: Werk und Wirkung*, Stuttgart 1980; *Dürer-Studien*, Berlin 1983); Catalogues: F. ANZELEWSKY (*Albrecht Dürer: Das malerische Werk*, Berlin 1971) a catalogue of the paintings, W.STRAUSS, ed., (*The Complete Drawings of Albrecht Dürer*, New York 1974), GERMANISCHES NATIONALMUSEUM, NUREMBERG (*Albrecht Dürer 1471–1971*, 1971) quincentenary exhibition; On particular works and problems: W.J.HOFMANN (*Über Dürers Farbe*, Nuremberg 1971), H.T.MUSPER (*Dürers Kaiserbildnisse*, Cologne 1972), H.KAUFMANN (*Albrecht Dürer: 'Die Vier Apostel'*, Utrecht 1972), K. HERRMANN-FIORE (*Dürers Landschaftsaquarelle*, Berne/Frankfurt a.M. 1972); The standard German edition of Dürer's writings is: H.RUPPRICH, ed., (*Dürers schriftlicher Nachlass*, 3 vols., Berlin 1956, 1966, 1969).

Abbreviations

AA: *Art in America*
AB: *The Art Bulletin*
AN: *Art News*
BA: *Bollettino d'arte*
BM: *The Burlington Magazine*
DH: *Der Deutsche Herold* (Berlin)
DM: *Deutsches Museum*
E: *Emporium*
GBA: *Gazette des Beaux-Arts*
JK: *Jahrbuch der preussischen Kunstsammlungen*
JKS: *Jahrbuch der kunsthistorischen Sammlungen in Wien*
JKW: *Jahrbuch für Kunstwissenschaft*
K: *Kunstchronik*
LA: *Les Arts*
MJBK: *Münchner Jahrbuch der bildenden Kunst*
MK: *Monatshefte für Kunstwissenschaft*
MZ: *Mainzer Zeitschrift*
OM: *Oxford Mail*
OMD: *Old Master Drawings*
P: *Pantheon*
PA: *Paragone*
SDK: *Studien zur deutschen Kunstgeschichte*
SM: *Süddeutsche Monatshefte*
SJ: *Städeljahrbuch*
WJK: *Wiener Jahrbuch für Kunstgeschichte*
WRJ: *Wallraf-Richartz-Jahrbuch*
ZBK: *Zeitschrift für bildende Kunst*
ZDVK: *Zeitschrift des deutschen Vereins für Kunstwissenschaft*
ZK: *Zeitschrift für Kunstgeschichte*
ZKW: *Zeitschrift für Kunstwissenschaft*

Outline biography

1455 11 March. According to the family history (written by Dürer in 1524) his father, also named Albrecht (a Hungarian by birth), who was a goldsmith, celebrated his 28th birthday in Nuremberg, where he had settled after travelling across Europe and living for some time in the Netherlands training "with the great masters". Dürer's family was of peasant stock, originally from the Magyar village of Ajtas, but Dürer's grandfather Anton had migrated to the neighbouring town of Gyula and set up as a goldsmith. When Albrecht the Elder arrived in Nuremberg it was a flourishing commercial and industrial city; it was also important for publishing and was the Franconian centre of Humanism. Dürer's father found regular employment in the flourishing workshop of Hieronymus Holper, an influential member of the guild of goldsmiths and silversmiths and one of the four assayers of precious metals to that same body.

1467 6 August. Albrecht, at the age of forty, married Barbara Holper, the fifteen-year-old daughter of his employer. In the course of the next twenty four years she would bear him eighteen children.

1468 8 July. On payment of ten florins to the guild of goldsmiths and silversmiths Albrecht the Elder formally attained the status of master craftsman, a title which had already been designated him. In the same year, for the sum of two florins paid to the corporation of Nuremberg (a tax levied on those whose fortune did not exceed one hundred florins) Albrecht the Elder became a citizen of Nuremberg. It is on this occasion that, for the first time, the name Dürer appears. Dürer is a rough translation of Ajtas, apparently connected with the

Hungarian word *ajto* meaning door (in German *tür* or *dür*), and indeed an open door appears on the family coat of arms. Although contemporary documents refer to Albrecht the Elder as a very active workman it has proved impossible to trace any of his work; the descriptions we have of him from his famous son refer to him only as a man and as a father. On the other hand we have proof of his skills as a draughtsman in the silverpoint *Self-portrait* of 1486 (Vienna, Albertina).

1470 5 December. Willibald Pirckheimer was born in the hereditary home overlooking Nuremberg Market Square; he was later to become the first humanist of that rich and illustrious patrician family.

1471 21 May. In a dependency of the same house, overlooking the Winklerstrasse, which was let out to an artisan's family, Albrecht Dürer was born; he was the third child of Albrecht Dürer (the Elder) and Barbara Holper.

1475 12 May. Following the death of his father-in-law, Albrecht the Elder bought a house (using part of his inheritance), which had formerly belonged to the goldsmith Kraft, situated in the Unter der Vesten (now 493 Burgstrasse). For this he paid two hundred florins and a further one hundred florins on a mortgage in perpetuity. This move contradicts the popular legend that Dürer's celebrated friendship with Willibald Pirckheimer began when they were childhood neighbours in the house on the Market Square. Michael Wolgemut, the most famous contemporary painter and engraver in Nuremberg, lived in the same neighbourhood; so did Schedel, and Sebaldus Frey, the uncle of Dürer's future wife. Anton Koberger, who was Dürer's

godfather, and the most important publisher in Germany, also lived in the area and had his printing works there.

1481–2 Dürer was a pupil at the Latin school of St Lawrence. In 1482 his father was elected a sworn master of the guild of goldsmiths.

1483–6 Dürer made his debut as an artist with the famous *Self-portrait* in silverpoint of 1484, executed while he was working as an apprentice in his father's workshop. In 1486 his father rented a workshop near the town hall for the sum of five florins a year; he wanted his son to become a goldsmith and was at first strongly opposed to the young Dürer's wish to become apprenticed to the painter Michael Wolgemut; however, Dürer eventually overcame parental opposition and began his apprenticeship in Wolgemut's studio on 30 November 1486. He was to remain there for over three years. Works dating from this period include the pen drawing dated 1485 (made whilst he was still in his father's workshop) of the *Virgin with Musical Angels* (Berlin, Kupferstich-kabinett. L.1); *Young Woman with a Falcon* (London, British Museum), which has an inscription indicating that it was executed the day that Dürer entered Wolgemut's workshop (L.208); *Three Lansquenets* (Berlin, Kupfer-stichkabinett. L.2); *Cavalcade* (Bremen, Kunsthalle. L.100) which is dated 1489 and initialled; *The Crucifixion* (Paris, Louvre. L.596) which is undated but probably dateable to 1490; the London drawing *The Lord Blessing;* and *The Ox* (Lemberg, Lubomirski Museum) which is one of the most interesting of these early drawings on account of its powerful rendering. No paintings from this period have survived — even in the form of possible attributions — so it is

impossible to trace Dürer's development as a painter up to the *Portrait of his Father* (Florence, Uffizi) of 1490. Equally it has proved impossible to establish whether he participated in the increased production of woodcuts in Nuremberg between 1488 and 1490. This was a period in which all the painters and engravers in Nuremberg were attempting to compete with Wolgemut and all the best printers with Koberger, the period of the *Schatzbehalter*, the *Neue Weltchronik*, the *Lives of the Saints* and the *Bruderclaus*, and although it would be logical to suppose that Dürer made some individual contribution, no concrete evidence has come to light to support this hypothesis.

1489 30 November. The third anniversary of Dürer's entry into Wolgemut's studio. It is reasonable to suppose, however, that on account of the season and the good relations between the two families Dürer would have stayed in the studio for the winter period until April 1490.

1490 11 April–**1494** 18 May. "When I had finished my apprenticeship", Dürer noted, "my father sent me off. I stayed away for four years, until he called me back again. I left after Easter [11 April] in 1490 and returned home in 1494, after Whitsuntide [18 May]." There is no other evidence from Dürer himself of his travels through Germany on his first and longest stay away from home. It is a matter of conjecture whether he followed his route to the Low Countries; this hypothesis is favoured by Sandrart, and it is true that Dürer's early work seems to be related to the work of Dirk Bouts and Geertgen tot Sint Jans. The first direct reference we have is to his arrival in Colmar, *"peragrata Germania"*, a year and a half after leaving

Nuremberg. There are indirect references to him in a eulogy of Anton Kres written by one Schewal and published in 1515 and in some of Pirckheimer's writing. Dürer's own early drawings and woodcuts throw some light on this period. It appears that the pattern of his journey was essentially conditioned by the necessity of earning a living and that he stayed wherever he could find work.

1492 At the beginning of the year he was in Colmar as the guest of the goldsmiths Kaspar and Paulus and the painter Ludwig Schongauer, the brother of the great painter Martin Schongauer who had recently died. Apparently Dürer had hoped to find him still alive. In the spring he was in Basle as the guest of the fourth Schongauer brother, Jörg. He stayed in Basle for some time and established contacts with the major Basle publishers. The first secure work from this period is a woodcut *St Jerome in his Study*, for an edition of the *Epistolae Beati Hieronymi* published by Kessler in August 1492; it had an immediate success (the original wood block still exists). He also contributed to a series of one hundred and fifty woodcuts for an edition of the *Comedies* of Terence which was prepared by Amerback but not published, for which one hundred and twenty four woodblocks still exist. About four fifths of the forty five woodcuts for *Ritter von Turn* — published by Furter and Bergmann von Olpe in 1493 (Basle) — can be ascribed to Dürer, and he also contributed illustrations to Sebastian Brant's celebrated *Stultifera Navis*, published in 1494 by Bergmann von Olpe.

1493 Towards the end of the year he left Basle for Strasbourg, where, amongst other

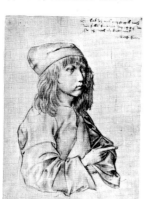 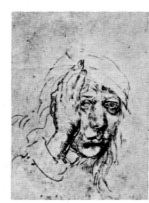 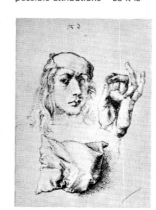 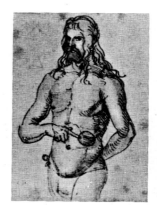 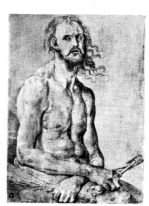

Dürer's self-portraits: (from left) at 13 (1484; silverpoint, 27,5 × 19,6; Vienna, Albertina); at about 20 (c. 1491; pen and ink, 20,4 × 20,8; Erlangen, Universitäts-bibliothek); at 22 (1493; pen and ink, 27,6 × 20,2; New York, Lehman Collection); as a *sick man (c. 1507; pen and ink, 12,7 × 11,7; Bremen, Kunsthalle); as the "man of sorrows" (1522, pen and ink, 40,8 × 29; formerly in Bremen, Kunsthalle). Other self-portraits: see Catalogue nos. 12; 48, 59, 101B, 106, 115, 129, 130, 134 and 176.*

things, he carved two woodcuts for the *Opus Speciale Missarum* (Grüninger?), published in November. The *Self-portrait with Eryngium Flower* dated 1493 (no. 12) was probably painted in Strasbourg. Drawings from this period include *The Promenade* (Hamburg, Kunsthalle); the *Self-portrait* (Erlangen, Universitätsbibliothek) and the *Self-portrait* now in the Lehman collection, New York (formerly in Lemberg, Lubomirski Museum); *The Holy Family* (Erlangen) and the marvellous *Rape of Europa* (Vienna, Albertina).

The French art historian Marcel Brion has attempted to chart the possible itinerary of the whole of Dürer's "bachelor journey": – the first stop was at Nordlingen where the

Swabian painter Friedrich Heslin – a follower of Rogier van der Weyden – was very influential; from there he moved on to Ulm, the artistic centre of the region, where a group of Hans Multscher's followers was working; from Ulm he went to Constance – a city already permeated with Humanism and Italian art (and it was here that the recently deceased Lukas Moser had painted his *Holy Magdalene* cycle). According to Brion, Dürer then went to Basle and only later to Colmar; for some reason Brion ignores the evidence of published books and prints and relies on the works of Conrad Witz. From Basle he went to Colmar and from Colmar to Strasbourg where a meeting with Hans Baldung Grien – a painter of Dürer's

own age – is essential, according to Brion. This reconstruction of the itinerary is probably fairly close to the truth (although Brion takes no account of the Housebook Master) because it relies on the supposition that the journey was intended to widen the young Dürer's pictorial experience.

1494 In May he returned to Nuremberg, where negotiations between his father and Hans Frey for Dürer's marriage to Frey's daughter must have been nearly completed although Dürer himself describes the agreement as concluded only after his return: "When I arrived home, Hans Frey treated with my father and gave me the hand of his daughter Agnes and with her he gave me two hundred florins."

On 7 July the marriage was celebrated; the young couple went to live in Dürer's father's house. In the autumn Dürer left, alone, for Venice, which he reached via the Tyrol, Alto Adige and Trentino (returning by the same route) with brief stops at Mantua, Padua and perhaps Pavia – where Pirckheimer was a student at the University. He may have visited Rome. Although Dürer would already have had some knowledge of Italian art through prints and drawings (some of which he had copied), the impact made on him by the cultural and artistic ambiance of Venice was overwhelming.
1495 In the spring he returned home. From this period date the remarkable series of watercolours of Alpine scenery, and the views of the environs of Nuremberg. Dürer took up his woodcut and engraving activities again; *The Holy Family with Dragonfly, The Penance of St John Chrysostom,* and *St Jerome in the Desert* are all dated 1495.
1496 Frederick the Wise, Elector of Saxony, whom Dürer greatly admired and who was to be his lifelong patron, visited Nuremberg and commissioned a portrait of himself and subsequently two polyptychs for the church of his Wittenberg residence.

The large woodcut *The Men's Bath House* is probably dateable to this year; a pendant *The Women's Bath House* for which there is a preparatory drawing (formerly Bremen, Kunsthalle) was never finally executed.
1497 Preparatory work on the *Apocalypsis cum figuris* and on the paintings ordered by Frederick the Wise; painted the *Portrait of his Father* and the two *Fürlegerin* portraits; executed the allegorical engravings *The Four Witches* and *The Doctor's Dream.*
1498 At his own expense, Dürer printed and published the first of his great books, the

Apocalypsis cum figuris (The Revelation of St John). There are fifteen full-page woodcuts set opposite the text, and a sixteenth was cut in 1511 for the frontispiece to the second edition in Latin. The prints (size 39.2 × 28.3 cms. not including the margins) achieved an unprecedented success and Dürer's name soon became known all over Europe. At the end of this same year he began work on seven of the eleven woodcuts of *The Great Passion* (again on atlas-size paper). The *Self-portrait* in the Prado also belongs to this year.

1499 Executed the *Tucher* portraits and the *Portrait of Oswolt Krel.*

1500 Concentrated on painting. The best known of the *Self-*

Dürer's coat of arms, woodcut by Dürer (1523).

portraits (no. 59), the *Portrait of a Man* which was assumed to be a portrait of Dürer's brother Hans (no. 58), and *The Lamentation of Christ* (no. 61) all in Munich (Alte Pinakothek) and *Hercules Killing the Stymphalian Birds* (no. 60) were all painted in this year. Dürer worked incessantly; he made himself independent and acquired his own workshop. The period is characterised by his numerous activities, which indicate both the astonishing fertility of his ideas and his capacity to realise them; these form the basis of all his future activities.

1501 A fairly uneventful year, although it began with the *St Eustace* engraving and ended with two of his best known engravings, *Nemesis* ("Das Grosse Glück") and *Fortune* ("Das Kleine Glück").

1502 Death of Dürer's father, to whom he had been very close (20 September). *The Young Hare* (no. 75), *The Virgin with a Multitude of Animals* (no. 96) and four of the large engravings of *The Life of the Virgin* all belong to this year.

1503 Executed a series of very striking portraits including the charcoal drawing of W. Pirckheimer; also began the *Jabach Altarpiece* (no. 101, A–D) and painted the *Great Piece of Turf* (no. 97). He was ill, but did not allow this to interrupt the spate of activity.

Portraits of Dürer. (Top row) In a German edition of Vitruvius edited by W. Rivius (1528); wooden model for a medal (c. 1519; Brunswick, Herzog-Anton-Ulrich-Museum); copy (1529) of a medal (1527–8) by M. Gebel (Berlin, Staatliche Museen). (Second row) Woodcut by E. Schön (1527); from a sketch book by J. Sandrart (Munich, Bayerische Staatsbibliothek); copy by E. de Boulonois (after 1629) of a drawing by T. Vincidor (16th century). (Third row) Sandstone head by an unknown artist (after 1550; Antwerp, Fleischhaus-Museum); etching by L. Kilian (1608); engraving by J.W. Heckenauer for the frontispiece of a book dedicated to the memory of Dürer (Goslar, 1728). (Bottom row) Dürer and Raphael Kneeling before the Throne of Art (etching by C. Hoff after a drawing by F. Pforr [c. 1800]); Dürer and Pirckheimer, by E. Steinle (pencil; Leipzig, Museum der bildenden Kunst).

(From left) L. Kilian, *Allegorical Double-portrait of Dürer (etching, 1617). Display (in the centre, Dürer's statue) prepared for celebra-* tions *in honour of Dürer at the Singakademie, Berlin (1828). Jacket of the magazine* Kunstgewerbeblatt *(December 1898).*

1504 His mother, Barbara Holper, moved in with him; she already lived in the same house, but he now presumably became responsible for her until her death. He completed the *Jabach Altarpiece,* and painted *The Adoration of the Magi* (Uffizi, no. 106) and engraved *The Fall of Man (Adam and Eve).*

1505–7 After completing a series of important engravings, including *The Large Horse* and *The Small Horse,* he left on his second trip to Italy (the outbreak of plague in Nuremberg may have encouraged his departure). On both the outward and the return journey Dürer was the guest of the aristocrat Conrad Fuchs von Evenhopen in Augsburg. He may have paid a brief visit to Florence and certainly went to Padua, where his portrait appears in a fresco attributed to Campagnola in the Scuola del Carmine. It was not the young man of 1495, thirsty for art and culture, who arrived in Venice in 1500 but an artist in his first maturity, whose graphic works had already excited the art world, even in Italy. He stayed as a guest of the Fugger family, and was honoured and sought after by the aristocrats and the learned, musicians and humanists alike. He was fêted by the German colony and lived the life of the noblemen amongst whom he now moved. In a letter to Pirckheimer he wrote: "How I shall long for the sun in the cold. Here I am a gentleman, at home I am only a parasite." This second stay in Venice is largely documented by Dürer's correspondence with Pirckheimer, for whom he was collecting valuable objects – in particular Venetian editions of classical books. The letters also indicate that although important local painters were ready to acknowledge Dürer's celebrity as an engraver in wood and copper, they criticised his abilities as a colourist, and it may have been for this reason that he turned down invitations, imagining that the jealous local painters might take reprisals and perhaps even try to poison him.

His altarpiece of 1506 for the German church in Venice, San Bartolomeo, *The Feast of the Rose Garlands,* certainly aroused great interest, and was admired not only by painters but by the Doge, the Patriarch and all the Venetian nobility. The work represents the focal point of his activity in Venice; from it stem other works, like the two female portraits in Vienna and Berlin (nos. 109 & 120) and the portraits of men at Hampton Court, Kroměříž and Genoa (nos. 118, 110 & 119), *Christ among the Doctors,* in Lugano (no. 117) and *The Virgin with the Siskin* (no. 116), and others (e.g. nos. 121 & 122) which may have been painted in Bologna where Dürer went to meet Jacopo de' Barbari. He already knew de' Barbari, either from Nuremberg or perhaps from his first visit to Venice ten years earlier. In Bologna Dürer also met Luca Pacioli whose treatise *De divina proportione* had been published the previous year in Venice. By this stage Dürer's interest in the theory of proportion and perspective was established. It is also just possible that he met Leonardo in Milan.

1507 Dürer returned to Nuremburg in February or March. He painted *Adam and Eve* (no. 123, A & B), Prado. He appears to have abandoned his woodcut and engraving activity temporarily in favour of the study of mathematics; at the same time he made his first rather desultory attempts to formulate an artistic theory. With the money he had earned in Venice he paid off the mortgage on his house.

1508 Completed the *Martyrdom of the Ten Thousand* (no. 129) and worked on the *Heller Altarpiece* (no. 130). Possibly visited Frankfurt.

1509–11 Took up his woodcut and engraving activities again. Worked on a version of *The Small Passion* in copper, and another, rather more complete version in woodcut which was published in 1511 in thirty seven parts. *The Great Passion,* partially published in single sheets in 1498, was completed and reprinted; *The Adoration of the Magi, The Holy Family, The Mass of St Gregory, St Jerome* and *St Christopher* were issued as separate prints. On 11 June 1509 he acquired a house on the Zistelgasse, still known as Dürer's House. The following year on 15 January he made a payment to the Treasury Offices, thus releasing his house from the endowment, which was now looked after by the Treasury.

The Adoration of the Trinity (no. 134) of 1511 marked the completion of the decoration of the chapel of the Zwölfbrüderhaus.

1512 Worked on the portraits of *Charlemagne* and *Emperor Sigismund* (nos. 140 & 141); painted *The Virgin with the Pear* (no. 136); completed the engraved *Small Passion* and executed the beautiful drypoint *St Jerome in the Desert,* which is very Italianate in appearance. He probably established contact with the Emperor Maximilian I for the first time. 3 June he bought, for ninety florins, from one Bauer, the Tiergärtnertor which adjoined his house.

1513–4 Apart from some watercolours, a well known engraving of peasants and the long preparatory work for the *Triumphal Arch of Maximilian I,* the period is dominated by

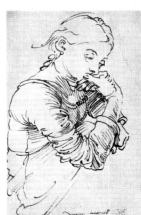

(Above, from left) Self-portrait by Dürer's father (silverpoint; Vienna, Albertina). Drawings by Dürer: his mother (1514; Berlin, Staatliche Museen); (below) his wife Agnes as a young woman (Mein Agnes, 1495; Vienna, Albertina) and as an older woman (1521; Berlin, Staatliche Museen).

three masterpieces of engraving: *The Knight, Death and the Devil* of 1513, *St Jerome in his Study* and *Melencolia* of 1514; the three works are similar in that they all employ a complex symbolism, and are of an unusually fine execution. In 1514 Dürer's mother, Barbara Holper, died; the marvellous portrait drawing of her (Berlin, Staatliche Museen) was made two months before her death.

1515 Executed the well-known woodcut *The Rhinoceros,* as well as several charming watercolour drawings of animals for *The Prayerbook of Maximilian I,* which was printed on vellum and decorated with marginal illustrations in pen and coloured inks by Dürer; these drawings show a unique freshness and inventiveness. He also began work on the huge woodcut *The Triumphal Arch of Maximilian I* for which there are ninety two prints; joined up these make a total print of 341 × 292 cm.; the composition consists of ten square metres of awkward, heavy, boring architecture, embellished with statues, coats of arms and trophies, garlands, ornamental scrolls, plaques and portraits, carved and printed by a team of artists and craftsmen under Dürer's supervision. The motley confusion of the assembled disparate parts made Dürer detest the whole undertaking. On 5 September the Emperor settled an annual pension of one hundred florins on Dürer as payment, to be paid by the city of Nuremberg.

1516 He painted *St Philip* and *St James* – both in the Uffizi – (nos. 144 & 145), *The Virgin with the Pink,* Munich (no. 146), the *Portrait of Michael Wolgemut,* Nuremberg (no. 147), and the *Portrait of a Clergyman,* Washington (no. 148); the famous engravings of a rather ornamental character like *The Desperate Man* (which contains a possible portrait of Michelangelo) and the *Sudarium Spread out by an Angel* also belong to this year.

1517 Only a few charcoal and watercolour drawings are worthy of note.

1518 He painted *Lucretia,* Munich (no. 152), and *The Virgin in Prayer,* Berlin (no. 153). He also made a first, extraordinarily vital, sketch of *The Triumphal Procession of Maximilian I;* this was later elaborated in a sequence of twenty four bound woodcuts which depict eighteen chariots designed in a bizarre baroque manner with futuristic mechanical parts, separated by groups of infantrymen and cavalry. Although the whole operation was carried out under Dürer's supervision by excellent carvers and the work has an authentic quality to it, Dürer himself apparently did not work directly on it at any stage. *The Emperor's Triumphal Chariot,* which consists of eight bound woodcuts, is, however, by Dürer; it

(Left, from top) Note by Dürer on Euclid, published in Venice in 1505, frontispiece of the first edition of Dürer's treatise on proportions (Nuremberg, 1528). (Right, from top) "Historical divertimento" on the life and works of Dürer and Raphael, published by G. W. Knorr (ibid., 1738); invitation (lithograph by J. G. Schadow) to the Dürer celebrations held in Berlin, of 18 April 1828.

(Top) Dürer's house in Nuremberg, c. 1900.
(Bottom) Monument to Dürer (by C. Ranch) in Nuremberg.

was only published in 1522, although it was evidently printed earlier. His payment for this, in addition to the life pension, was two hundred florins, to be paid, once again, by the city of Nuremberg, but in fact he was never paid.

Between 1517 and 1518 he visited Bamberg, briefly, and .then went to Augsburg. In 1518 he acquired his brother Endres's share of their father's house.

1519 12 January the Emperor Maximilian died and, whilst Dürer was away in Switzerland with Pirckheimer, the municipality cut off his pension, which had terminated automatically with the death of his patron. Dürer returned to Nuremberg only in July, and attempted, unsuccessfully, to get his pension renewed; the Treasury suggested that he should ask Maximilian's successor Charles V to renew it and accordingly he travelled to Antwerp in 1520.

The two portraits of *Maximilian* (nos. 157 & 158), *The Virgin and Child with St Anne* (no. 156) and the engraving of *Cardinal Albrecht of Brandenburg* (B.102) are all dated 1519.

1520 After making a propitiatory pilgrimage to the Sanctuary of the Fourteen Saints — the most famous sanctuary in Franconia — Dürer left on 15 July for Antwerp. For the first time his wife accompanied him, together with her maid Susanna. The trip was a total success and Dürer made numerous excurions to other parts of the Low Countries, which he recorded

in his diary (*Tagebuch der niederländischen Reise, 1520–21*), using Antwerp as his base. In his diary he also recorded his observations on the artists he met; it contains only brief references to the paintings he had seen, whereas there are long descriptions of celebrations of one sort or another, and of the fairs and carnivals in Antwerp.
He details his purchases, his encounters with people, sketches for portraits, rare or bizarre objects, collections he has seen, corals, Indian materials, shells, and rare Aztec curios.

In the summer Dürer left Antwerp for Malines, where Lady Margaret of Austria, the daughter of Maximilian and Governor of the Low Countries, lived. He offered her the portrait of her father (no. 157) which she refused, perhaps on the grounds that she had already promised (to van Orley, her own painter) the manu-

script of a theoretical treatise by Jacopo de'Barbari which Dürer wanted. Later, Dürer visited Brussels, and on 23 October he was in Aachen for the coronation of Charles V. The Emperor eventually ratified Dürer's pension on 15 November of the following year. Soon after his return to Antwerp from Aachen and Cologne, Dürer left once more, curious to see a whale which had been reported stranded by high seas on a beach at Zieriksee in Zeeland, but by the time he arrived it had been washed away again. It was in Zeeland that he was attacked for the first time by an illness which kept him in Antwerp for most of the winter and which was to prevent him from enjoying a trip to Brussels with the King of Denmark and other guests invited by the Emperor.

1521 In the middle of the year Dürer returned to Nuremberg from Antwerp. During his stay

in the Low Countries he had executed several portraits, mostly in chalk or charcoal. Amongst the best of these are the portraits of *Jobst Planckfelt and his Wife*, the portrait of *Lorenz Sterck*, and one of an unknown youth; besides these he made a number of watercolour drawings of animals and the Lisbon *St Jerome* (no. 169). Back in Nuremberg he resumed much the same routine as before in his house on the Zistelgasse; he worked incessantly, although he was much weakened by the illness he had contracted whilst he was away. He devoted more time to his scientific interests and made plans to write a theoretical treatise on art; the notes still exist, showing his researches into proportion and perspective and his studies of urbanisation and fortification.

1523 He may have completed *The Man of Sorrows* (no. 176); he engraved the magnificent *Portrait of Cardinal Albrecht of Brandenburg in profile* (B.103).

1524 He painted the striking *Portrait of a Gentleman* in the Prado (no. 179) and made the last engraving of *Frederick the Wise, Elector of Saxony* (B. 104).

1525 Dürer's first theoretical work appeared: in Nuremberg a treatise on geometry entitled *Underweysung der messung dem Zirckel und richtscheyt in Linien, Ebnen und gantzen Corporen.*

1526 The last major works followed one after another: the portraits of *Muffel, Holzschuher* and *Kleberger* (nos. 183, 184 & 185). *The Virgin with the Pear* (no. 182) and *The Four Apostles* (no. 181, A–B). On 30 April the mortgage owed to the Tuchers on the house bought in 1509 expired.

1527 Dürer painted the large grisaille *The Bearing of the Cross* (no. 187); his treatise *Etliche Underricht zu Befestigung der Stett, Schloss und Flecken* (On the Fortification of Cities, Castles and Towns) was published in Nuremberg with a dedication to King Ferdinand of Hungary.

1528 6 April. Albrecht Dürer

died. His remains lie beneath a large commemorative tablet in the cemetery of the church of St John in Nuremberg. On the bronze plaque is an inscription by Willibald Pirckheimer: "Me Al. Du./Quicquid Alberti Dureri mortale/fuit sub hoc conditur tumulo./Emigravit VIII Idus aprilis/MDXXVIII." A few months after his death, the third of Dürer's theoretical treatises, that on proportion, was published in a double edition in both German and Latin, entitled *De simmetria partium in rectis formis humanorum corporum libri* (in German *Hierin sind begriffen vier Bücher von menschlicher Proportion*).

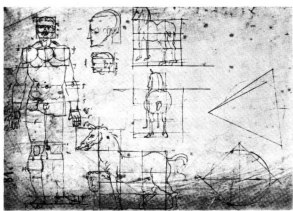

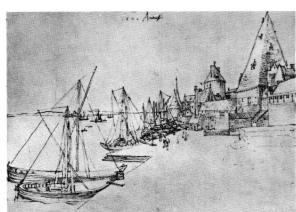

Studies by Dürer (1505) in Vitruvian geometry. The harbour at Antwerp, in an autograph drawing of 1520 (Vienna, Albertina).

Catalogue of works

In the last quarter of the fifteenth century Nuremberg was one of the richest, most active, free and sophisticated cities in Germany, where bankers, businessmen, merchants and artisans all prospered with equal rights and responsibilities. Figures such as the humanist Schedel, who collected paintings, drawings and prints of the monuments of antiquity, the poet Celtis, the astronomer Walther, the cosmographer Regiomontanus and the navigator Behaim were the most eminent representatives of this society. But people such as the Tuchers, the Stromers and the Pirckheimers, who were all versed in Latin and Italian and some of them in Greek, and above all Koberger, are equally representative. The last mentioned was the most important publisher in Germany: he owned forty printing presses and employed one hundred workmen, and he was a friend of the goldsmith Albrecht Dürer the Elder, with whom he discussed Latin literature and accounts of modern travels. But in Nuremberg, as elsewhere, developments in the spheres of science and literature were not parallelled by a similarly enlightened advance in the visual arts. Art was still Gothic, anchored to the style which reached its climax at the end of the century. Throughout Northern Europe not only the style but the attitudes which formed it remained essentially Gothic: man was not yet conceived as the centre of the universe. In Italy the Renaissance had evolved naturally out of the past. But in Germany it had a disturbing effect which was never entirely erased. German traditions, aesthetics, taste and feelings were, and remained, essentially Gothic: certainly the Mediterranean Renaissance was seen as something to be aspired to, studied, imitated, envied, and even loved, but as something to be learned about rather than experienced, as appealing to the intellect and not to the heart. Thus Germany clung to her traditions and remained cut off from the Italian Renaissance, despite valiant and often radical efforts to bridge the gap. Dürer's fame rests on the quality of his farsighted contributions to this cause.

He was the first German artist to have a reputation which, during his own lifetime, spread beyond his own country, whose engraved work was known, sought after, imitated and even plagiarised while he was still working in his native town, whose name was known to artists, humanists and publishers from Amsterdam to Venice. That Dürer's name

was known throughout the art world was due almost solely to the impact of a handful of prints. Vasari wrote of him: "If this remarkable man, so industrious and so universal, had been born a Tuscan and had been able to study the things in Rome as we have done, he might have been the best painter of our land, just as he was undoubtedly the most remarkable and famous of the Flemings." And how multifaceted was his work — almost 1,000 drawings, 250 woodcuts, about 100 engravings and some 70 paintings are all evidence of an output which has, for the most part, survived. In addition, he published three treatises, on proportion, on fortification, and on human proportion. He was more than a mere painter and engraver; he tackled problems of mathematics and engineering as well as questions of theory and of linguistic purity. He is the only German artist of his century whose complex output can be compared both in its nature and in its quality with that of the great contemporary Italian artists.

But if we are to see Dürer as a modern man, as an innovating artist, we must look at the constituent parts of his genius, the paradoxes, contradictions and conflicts which go to form it, before turning to the works. He was the child of a problematic age. He was not an artist who, having discovered a language and style of his own, could move from strength to strength: he was, rather, a poet and a craftsman who found it necessary to resolve conflicting impulses in himself. He was dependent on the cultural traditions of his native land, and his art developed through an apprenticeship with the longstanding traditions of the craftsman-artist. He learned to handle the burin and the decorative arabesque which was first drawn and then incised or elaborated on the metal or silver. At the same time he mastered the principal craft of Wolgemut's workshop, the woodcut. Thus he was tied to a tradition which was largely secular in origin, which generations of skilled artists had developed into an expressive and pictorial means perfectly attuned to the final flowering of the medieval world in the international Gothic style. But he was, as well, a "new" man, a humanist who responded to the lure of the Italian Renaissance as, in the wake of the bankers and merchants, the Italian air came wafting across the Rhine. In Germany there had already been a reawakening of interest

in the classical and humanistic world; but this was something more profound, a way of life, an economy, a society which could replace the existing one, an attempt to break down constricting tradition and to inject new life into culture and modes of thought, into taste and manners of expression. It was in answer to this challenge that Dürer made his first journey to the South, for which his mind and spirit had so long been prepared. What he discovered was a new conception of space, conditioned by perspective and proportion, which had raised art to the dignity of a science and made of the artist a gentleman versed in the liberal arts. From this moment onwards Dürer devoted all his energies not only to applying these new principles to his own art, but to understanding them thoroughly, and analysing and expounding the theory behind the new concepts of space and of the world. And yet, in spite of his seemingly limitless response to the fascination of the Renaissance, to its ideas of space, form, composition, articulation, and colour, he remained firmly rooted in the Gothic tradition. Moreover, he was able to resolve these contrasting elements in a synthesis which transcended the purely formal level. Dürer never accepted anything unquestioningly: he made a conscious choice, and the new found extension of his expressive range, combined with his absolute mastery of the media, allowed him to dominate appearances and to express them formally with maximum impact. When he allowed his quite remarkable powers of expression free reign, fantastic and visionary works such as the medieval *Apocalypse* (B. 60—75), the astrological *Melencolia* (B. 74) and the *Four Apostles* (no. 182 A—B) resulted; when held in check by objective study, he attained the perfect naturalism of the *Fall of Man* (B. 1), the classic portraits, and the *Adoration of the Magi* (no. 106). But in every case the two expressive poles represented by the Gothic tradition, with its attention to detail, and the Italian Renaissance, with its breadth and assurance, are fused.

It might be argued that if all Dürer's prints had been lost he would still be a great artist; but his greatness lies first and foremost in his prints and engravings, although he was undoubtedly a great painter as well. He was born into the tradition of the woodcut and the engraving; he became a painter without the latent instinct which marks a

Grünewald or an Altdorfer. His inherited visual world was made up of infinitely subtle shades of grey on white. It was Dürer's delicate monochrome prints, alone, that broke down the barriers of German artistic isolation; they were of course influenced by the Italian Renaissance, but they brought about the Renaissance in Germany and dominated the style of European art, long after Dürer's death, up to the end of the sixteenth century. One aspect of his graphic art has often been dwelt on: whereas he executed all his own engravings (including some etchings and occasional dry-points) and had handled the burin since childhood, he did not actually carve the woodcuts himself; although he drew the design directly onto the block the carving was left to assistants. But we must assume that Dürer's mastery of all the technical aspects of the craft would have enabled him to maintain a constant supervision and control of the ware. His woodcuts show technical innovations which would be otherwise inexplicable, as well as, on occasion, an astonishing power and delicacy. It was certainly Dürer and not his craftsmen who achieved the intense lyricism of the visionary of Patmos in the fifteen large blocks for the *Apocalypse* (B. 60—75) as is illustrated by the *Four Horsemen* (B. 64), the *Opening of the Sixth Seal* (B. 65), *St Michael Fighting the Dragon* (B. 72), *St John before God and the Elders* (B. 63), the *Hymn of the Chosen* (B. 67), and the *Four Angels Holding the Winds* (B. 66). Behind the hallucinatory images lurks the shadow of the Middle Ages, embodied in the graphic medium itself, but the breadth and articulation of the prints is inspired by the Renaissance, and in them Dürer has resolved the stylistic confrontation, producing his first masterpieces. The first prints of the *Large Passion* (B. 4—15), which date from the same period, are equally powerful in their effect. Eight years later, however, the dynamic elements were refined and channelled into an elegant play of line and texture, delicately and rhythmically evolving light, atmosphere and space. In fact, in the *Angel Appearing to Joachim*, the *Meeting at the Golden Gate*, the *Birth of the Virgin*, the *Presentation of the Virgin in the Temple*, the *Visitation*, the *Flight into Egypt* and the *Sojourn of the Family in Egypt* (B. 78, 79, 80, 81, 84, 89 & 90, Dürer achieved a sublime quality which is not present in either the thirty six woodcuts of the *Small Passion* (B. 16—52) and in those remaining of the *Great Passion* (B. 4, etc.) or in any of the rightly famous separate prints like the *Decapitation of St John the Baptist* (B. 125), the *Mass of St Gregory* (B. 123), *St Jerome in his Study* (B. 114) and *in the Cave* (B. 113), *St Christopher* (B. 103), and the evocative *Penitent* (B. 119) (which is a disguised self-

portrait), the over-praised *Rhinoceros* (B. 136), and the majestic *Trinity* (B. 172).

In the interval which separated his two journeys to Italy, between the ages of twenty four and thirty four, Dürer created his most famous engravings; in them he allied qualities of imagination, of composition and brilliant technique, achieving a fusion between Northern tradition and borrowings from Pollaiuolo, Mantegna and Jacopo de' Barbari. One is astounded, in the work of this period, at the way Dürer can suggest an almost invisible hair by an imperceptible modification of the burin stroke, or how, with the effect of a brushstroke, he can suggest rustling drapery. The sheer variety and range of expression, subtle but precise, are breathtaking. Some prints, like the *St Eustace* (B. 57), mark the end of an era, whilst others, such as the *Fall of Man* (B. 1), translate antique traditions of proportion into a new beauty. In the *Holy Family with the Grasshopper* one is almost astonished by the tentative strokes, seemingly groping for the subtlest effect, while in the *Virgin with the Monkey* (B. 42) the monkey's baleful expression and the lively treatment of its fur and features contrasts notably with the mother's mood of serene contemplation and the river slipping quietly past. Far removed from this masterly evocation of tranquillity are the tortured asceticism of *St Jerome in the Desert* (B. 59), the pathos of the *Penitent St Chrysostom* (B. 63) and the strident anguish of the *Prodigal Son* (B. 28) expressed, but not exaggerated, by the accompanying landscape backgrounds. In the *Four Witches* (B. 75) Dürer falls back on an almost medieval treatment of the female body to express that synthesis of beauty and depravity which is the matter of erotic fantasy. In the *Doctor's Dream* (B. 76), however, the lure of Venus and the Devil totally fails to rouse the dreamer from his torpor. Innumerable attempts have been made to explain the meaning of these mythological subjects, as well as those of *The Sea Monster* (B. 71) and *Hercules* (B. 73), but they can also be considered purely as studies of the human body. There is, for instance, a precise reference to a poem of Poliziano for the subject matter of *Nemesis* (B. 77) but the nude can also be referred to Dürer's study of the human form which culminates in the *Fall of Man* (B. 1). Here the Adam and Eve could almost be Apollo and Diana, curiously out of place in a German medieval forest, full of strange animals — some real, some allegorical; but the elegant statuesque harmony of their bodies monopolises our attention and makes of this print almost an icon to the new world of the Renaissance. One could scarcely imagine a greater contrast between this and the *St Eustace* (B. 57) where the exquisite elegance of the forms is subsumed by

the wealth of detail: five dogs, a Pisanellesque stag and a horse vie with one another in a virtuoso, quivering tension of line to which the eye is irresistibly drawn by the dark, brooding lake with its white swans. Equally atmospheric are *The Offer of Love* (B. 93), which contains one of the most realistic horses ever drawn by Dürer, *Young Woman Attacked by Death* (B. 92) – which is similar in theme to the *Promenade* (B. 94), *The Nativity* (B. 2) and the famous *Small Horse* (B. 96) and *Large Horse* (B. 97), and other smaller but no less well known engravings.

With the fifteen plates for the *Small Passion* and some others, we enter the second great phase of Dürer's graphic art between 1507–12. It began with *St Jerome in the Desert* (B. 59), followed by the *Holy Family* (B. 43) in which he attempted new effects through the distribution of light; in the *Coat of Arms with a Cock* (B. 100) the detail becomes completely self-indulgent; finally there are the three great masterpieces: *The Knight, Death and the Devil* (B. 98), *St Jerome in the Desert* (B. 60) and *Melencolia* (B. 74), which share a network of conceptual associations. Perhaps these three prints mark the zenith of Dürer's art: the symbols refer to astrology and alchemy and seem to be used to give us a spiritual self-portrait; they chart the artist's dreams and aspirations, his fears and resolutions, the passion involved in creation, and finally the impotence of creation itself. The figure of Melencolia seems to tell us that absolute knowledge is for ever out of reach; that absolute creation, that ultimate truth, are unattainable; but the artist-hero will continue, his pace unfaltering, in his search for the ultimate truth. This then is the theme, reflecting the doubts and contradictions of the modern soul. The triptych attains a new height in the graphic expression of proportion and beauty: the Verrocchiesque horse, the play of dappled light on the study walls, the relaxed prone animals, the palpable quality of the objects and their textures, are all evidence not only of an extraordinary, unparalleled technical virtuosity but of the consistency with which Dürer, in a unique way, developed his theme.

The critical catalogues of Dürer's work, from Lippmann's classic study to those of the Tietzes, Winkler and Panofsky, do not include the watercolours and gouaches amongst the paintings, but group them with the drawings. Quite apart from the fact that there is no reason why a watercolour should not be judged by the same criteria as an oil tempera painting, this distinction has excluded some of Dürer's most perceptive and poetic works from serious consideration. There are watercolours in which his mastery of line and colour and his almost impressionistic treatment of

light and shade, of tone and hue, are so complete that they would put to shame the work of the landscape painters of three centuries later. The small sketches which he painted, when he was twenty four years old, on his way home from Italy, and after his return in the surroundings of Nuremberg, convey the whole of Dürer's lyrical poetry. One might claim that they possess only a documentary value, that they would have been unknown to his contemporaries – hidden away as they were in his sketchbooks – and that they would simply have been intended as mnemonics for his full scale paintings. Obviously this is true, but they transcend the function of mere preparatory sketches and reveal a dialogue between the artist and nature in the way they capture the feeling of a particular time and a particular light with their subtle colouring. Indeed, some of them, like the *House on an Island* (no. 29), the *Pond in a Wood* (no. 36), and *Alpine Road* (no. 25), are transfigurations or transpositions of nature which achieve a quality one would today call lyrical surrealism. There is nothing Northern about them: the limpid, transparent colours are Venetian, the skies are Bellinian, and the landscapes reminiscent of Cima or Carpaccio; but there is nothing derivative about them. Dürer is a poet here, rather than a "Gothic" or "Renaissance" artist; he uses nature as a means of self-expression and transcends the limits of the medium, of style and of his period, to arrive at the most direct interpretation of nature ever achieved by a European artist.

In the *Self-portrait* made when he was an apprentice goldsmith in his father's workshop, the young Dürer tentatively but courageously experimented with the unfamiliar silverpoint in place of his accustomed technique of the engraver's burin on metal. Here the child prodigy turned his restless curiosity from the world about him and fixed his penetrating gaze on himself as the centre of this world.

Dürer is the man of the self-portraits. There is a whole series of drawn and painted self-portraits as well as numerous representations of himself in his major works. They provided an outlet for study, self-criticism and self-analysis, and a means of assessing his energies, his ideas and his fantasies, as well as fulfilling a purely representational function. They run from the young boy searching for knowledge, through the exuberant or thoughtful images of the young artist (in the Erlangen and Lehman Collection drawings) to the earnest twenty-year-old (no. 12), the confident, resolute and slightly condescending artist-*gentiluomo* (no. 48) and finally, two years later, to the philosopher-Christian, the man-Christ who bears upon him both his own sins and sorrows

and those of the world (no. 59). Soon after this his features appear in the figure of the musician mocking Job in the *Jabach Altarpiece* (no. 101 B); he is present in the *Adoration of the Magi* (no. 106) as the most resplendent of the kings, and his hypnotic gaze goes almost unnoticed, paled by the effulgent colours, in the *Feast of the Rose Garlands;* he reappears again in the *Martyrdom of the Ten Thousand* (no. 129), and as an almost prophetic figure in the *Coronation of the Virgin* (the *Heller Altarpiece*) (no. 130) and at the foot of the *Adoration of the Trinity* (no. 134). Finally, if we leave the drawings and minor engravings to one side, there is the tragic figure of the *Ecce Homo* of 1523, of which, besides one print (B. 22), a probable but almost unrecognisable original has come down to us (no. 176). What quirk of character induced Dürer to return time and again to his own features, in an age when self-portraits were unusual? And why, contemporary with the austere and amost frightening, but vivid and real Prado *Self-portrait* painted just before the exuberant, smiling image in the *Jabach Altarpiece*, did he depict himself with such disconcerting effect in the Munich *Self-portrait* which, despite the intended hieratic significance of the pose, conveys such a disturbing mood? In all the self-portraits, even in those in which the figure is subsumed in a larger composition, there is always a posed, ritual element, almost as if he desired, perhaps unconsciously, to assume the role, the attitude he instinctively felt was demanded of him, and which he expressed in a considered gesture, a theatrical pose.

This quality is not present in the portraits of other people; they are always represented in traditional poses, shoulder-length portrait figures set against a plain background, sometimes enlivened by a curtain, a window ledge or a window framing a landscape view. They employ a formula which is acceptable, if not entirely conventional; they portray his fellow countrymen – mostly small-time officials and unknown bourgeois, with the exception of the historical portraits of *Frederick the Wise* and the *Emperor Maximilian* (nos. 40, 157 & 158). In these latter he could have attempted a courtly or heroic style of portraiture, but he did not. It was only twenty years later, in the portrait of *Maximilian I* (Vienna), that he achieved any real feeling, or understanding, of majesty, or "*Virù*" as the Italians would say. Otherwise he was less interested in conveying the status of the man and more concerned with the difficult and more direct problem of the man himself, searching for the real features, the character and the soul. In his bourgeois portraits, Dürer isolates his sitters from their everyday context, their preoccupations and com-

mitments, and probably removes their opinion of themselves and of others; he analyses or interprets them so as to arrive at the hidden, perhaps unconscious, essence of each character, and to capture the soul which illuminates even the humblest face. Thus he discovers in or endows on each of these financiers or prosperous merchants, men of solid traditions, a moral nobility, a vital intimate energy, a curious empathetic quality which transforms them into real people, into symbols and representatives. His brushwork is meticulous and detailed, modifying the incisive drawing, and his use of colours is controlled, suggesting a vibrant, electrically charged vitality beneath the painted features. But his best portraits are in black and white. His drawn portraits alone can be compared with contemporary Italian portraiture: this is true of the Pirckheimer, Hieronymus of Augsburg, Lucas van Leyden and van Orley portraits – several artists, that is – (only the portrait of Wolgemut is in oils, no. 147). Furthermore, these create a new dimension in the art of engraving: they are of a quality and technique which, particularly in the woodcut medium, have never been equalled.

The documentary evidence presents Dürer as a man who treated himself rigorously: he retained his craftsman's integrity, but at the same time was cultured and sociable, capable of creating enduring and intimate friendships. Like Raphael he was influenced by almost all the important artists of his time, both German and Italian, from Schöngauer to Baldung Grien, from Carpaccio to Bellini, Pollaiuolo to Mantegna, but he blended his sources with his own creative inventions. His technical skills derived from his training as a goldsmith, developed in the craft of the engraver, and remained with him until his death, increasing in confidence and delicacy as his imagination grew in breadth. And yet the artist who is first revealed in the little silverpoint *Self-portrait*, who gave us his *apologia* in the *Melencolia*, and whose supreme offering to the world was the *Four Apostles* (no. 181 A–B), was a solitary

1

man, and his work has remained isolated: none of his pupils or his followers penetrated its secret.

1 ⊞ ⊗ 26,1×17,2 1484? ⊟ ⦂

Portrait of a Boy
Stettin, Muzeum Pomorza Zachodniego
The portrait was discovered stuck inside a book of accounts of Philip II of Pomerania which was given to the Pomeranian Historical Society in 1888. According to the frontispiece the volume was compiled in 1617, and evidently included this miniature. The museum director, F. Henry, attributed the work to Dürer, and the similarity of the face with that in the magnificent *Self-portrait* in the Albertina of exactly this date (1484) seems convincing. However, Henry's view that the work should be dated to the beginning of Dürer's apprenticeship to Wolgemut is less convincing as the painting is inscribed with the date 1484. The present condition of the painting makes it difficult to determine whether it is an original of 1484, or a copy. It is also difficult to decide whether this is a self-portrait by Dürer or a portrait by some other artist; the crude technique is quite unlike the technique of Dürer's authentic early work. The Tietzes' hypothesis (1928) is that this is a sixteenth-century copy of an original of 1484. Panofsky tends to agree with the Tietzes but raises the doubt that it could be the work of another local painter.

2 ⊞ ⊗ 29×42,3 *1489–90* ⊟ ⦂

Cemetery of St John's Church, Nuremberg
Formerly Bremen, Kunsthalle
Watercolour and gouache on vellum. Autograph inscription "Sant Johans Kirche" at the top, and a monogram added at a later date in brighter paint. The painting was stolen, together with several other works by Dürer in the same museum, and has now disappeared altogether. Dürer scholars are now generally agreed that this is the earliest surviving work by the artist. Although the drawing is rather naively composed, it is drawn with an overall precision and coloured in a limited range of greens and blues. The compositional and colouristic weaknesses are too obvious for Brion's dating of 1494 to be convincing. Furthermore, the evident influence of Franconian painting, which inspired Dürer's predilection for landscape, makes the date proposed by Ephrussi (1882) of about 1505–6 and Haendke (1899) of after 1506 seem quite absurd.

3 ⊞ ⊗ 28,6×42,6 *1489–90* ⊟ ⦂

Wire Drawing Mill (Trotszich Mull)
Berlin, Kupferstichkabinett

The monogram has been added at a later date in brighter paint. Similar to no. 2 (this is also watercolour and gouache on vellum), but more refined chromatically, which would suggest a slightly later date; other factors would again suggest a later date. According to Mitius (K 1912) it is a view of the Pegnitz valley painted immediately before or after Dürer's "bachelor journey". However, in view of the links

Grünling Collection and entering the van Beuningen Collection. The Tietzes (1928) and Panofsky (1948) linked it stylistically with no. 4. Haendke, however, assigned it to 1506.

6 47×39 *1490

A. Portrait of Dürer's Father
Florence, Uffizi
Signed with monogram and dated near top left corner. Painted on the eve of Dürer's

appears in conjunction with that of her husband — even when there is no portrait of Barbara Holper herself.

B. Coats of Arms
Back of no. 6 A. See note.

7 59,5×71,9

The Raising of the Cross
Frankfurt, Städelsches Kunstinstitut

4

between this group of four watercolours (nos. 2, 3, 4 & 5) and traditional Franconian methods, the date suggested by the Tietzes (1929) and Panofsky (1948) of 1489–90 seems more acceptable. Haendke (1899) dated it to 1506–10. Bock (1921) and others have dated it circa 1494.

4 34,3×27,9 *1489-90*

Three Lime Trees
Formerly Bremen, Kunsthalle. Watercolour and gouache on vellum. For present whereabouts see no. 2. The three trees may be those in the garden behind the apse of the Church of St John, or perhaps those in the enclosed orchard *The Wire Drawing Mill* (no. 3). This very simply composed watercolour gives far more of an impression of freshness and spontaneity than no. 2. Ephrussi (1882) and Haendke dated it 1506.

5 34,3×26,7 *1489-90*

Lime Tree on a Bastion
Rotterdam, Boymans-van Beuningen Museum.
Like no. 4, watercolour and gouache on vellum. Known to have passed through various hands between leaving the

departure on his "bachelor journey", at the end of his three year apprenticeship to Michael Wolgemut. It is the first panel painting securely attributed to Dürer. His later addition of the coats of arms of both the Dürer and Holper families, on the back of the panel, has suggested (Friedländer, 1921) the possibility that this was originally part of a diptych with a portrait of Dürer's mother, Barbara Holper (the latter now lost, according to Friedländer); however, this is pure hypothesis. Panofsky (1948) pointed out that the Holper coat of arms often

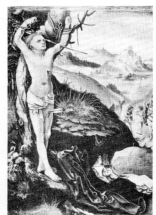

5

Formerly in the Hohenzollern-Sigmaringen Collection, where it was traditionally ascribed to Wolgemut. According to Panofsky it would have been painted in Nuremberg *c.* 1490 using the same sources as are evident in Dürer's work of around this date; this does not mean that the work should necessarily be attributed to Dürer. Rieffel (SJ 1924) attributed it to the school of Schongauer; Winkler (ZK 11), like the Tietzes (1938), was of the opinion that it was not by Dürer, for stylistic reasons.

8 29,5×21

St Sebastian
Berlin, Staatliche Museen
Together with no. 8 B this depicts the martyrdom of St Sebastian. The panels probably formed the front of a triptych, rather than one painting now divided into two. Both have been attributed to Dürer largely on account of the horseman in the background of the left hand panel who appears in reverse in a Dürer drawing of *The Cavalcade*, dated 1489 (L. 100) (formerly Bremen, Kunsthalle). Obviously the unknown painter of these panels and Dürer both took the motif from the Housebook Master — Dürer probably using a lost drypoint, which would explain the reversal of the pose. Baldass (P 1928) has attributed it, with good reason, to Hans Baldung Grien in his period under the influence of both the Housebook Master and Schongauer.

Archers, Crossbowmen and Horsemen
Berlin, Staatliche Museen
See notes to 8 A.

9 11,8×9,3 1492

Infant Saviour
Vienna, Albertina
Miniature on vellum. Monogram and date in red, of doubtful authenticity. Painted in pale shades of violet, green and gold. Weisbach (1906) and Römer (JK 1926 & 1927) stress its dependence on Schongauer.

10 36,8×27 1492-93?

City Square
Vienna, Albertina
Panofsky (1948) interpreted the subject as the courtyard of a castle; he dated the watercolour circa 1490. The Tietzes (1928) interpreted the subject as an enclosed square in a town, but did not consider that it was painted by Dürer. Various scholars have identified it as the courtyard of the Hofburg at Innsbruck, but we should need definite proof that Dürer visited Innsbruck on his travels through Germany. 1492–3 would seem a plausible date for this, and in fact it should probably be dated, on stylistic grounds, sometime between

6 A

6 B

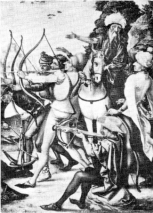

9

1490 (see nos. 2 & 3) and 1483, that is to say rather earlier than his first journey to Italy. If the location is not Innsbruck, it would be a square in some Franconian city, as the assortment of buildings in this watercolour (and the following one, with which it is closely connected) would suggest. It is difficult to agree with the Tietzes that this pair of drawings is not by Dürer, as they are very delicately handled. Panofsky's observation that it is impossible to link them stylistically with the most famous view of Innsbruck (no. 27), which Dürer painted on

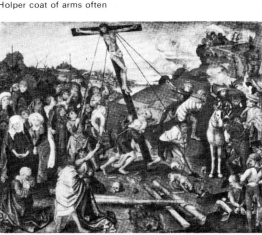

7

8 A

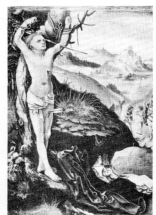

8 B

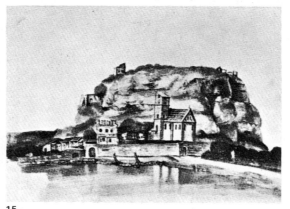

10

15

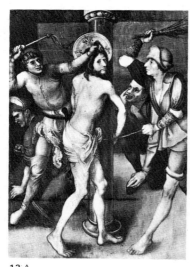

11

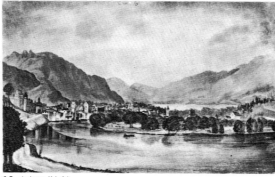

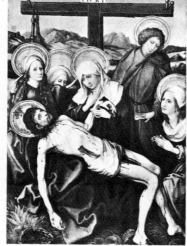

16 (plate IV A)

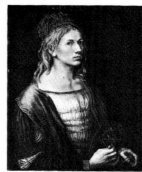

delicate, and the colour is complemented by clear cut, precise contours. At the same time, the unwavering gaze and almost arrogant frown give the portrait an air of toughness. According to Thausing (1884), the painting, which was originally on vellum, was transferred to canvas and restored in about 1840 by Erasmus Engerth when it was in the possession of Dr Habel of Baden.

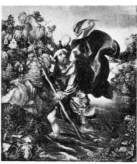

12 (plate I)

Scenes from the Life of Christ, and St Dominic
(The St Dominic Altarpiece)
Darmstadt, Hessisches Landesmuseum
A group of six fragmented panels which have been attributed to Dürer. It has not, however, been securely established that they belonged to the same altarpiece. Differences in technique, support, iconography and style are discernible in the various panels, but they all derive from the influence of the Housebook Master and Schongauer. According to Panofsky (1948) *The Flagellation* and *The Lamentation* belong together and are markedly different from the other four panels which form a more or less homogeneous stylistic group. Scheibler, Rieffel and Schmid attributed them to the school of Schongauer, whilst Bock and Wechtlen favoured Grünewald. Pauli (ZBK 1912) argued persuasively, with detailed if not always convincing analyses, that the paintings are by

14

his return from Venice, is certainly correct.

11 33,5×26,7 1492-93?

City Square
Vienna, Albertina
This is the same square or courtyard as that in no. 10, but seen from the other end. Both views must have been taken from windows overlooking the square. The clouds are evidently a later addition and do not blend with the rest of the composition.

12 56,5×44,5 1493

Self-portrait (with Eryngium Flower)
Paris, Louvre
Formerly in the Felix Collection in Leipzig and the Goldschmidt Collection in Paris. Dated 1493 and inscribed "My sach die gat/ Als es oben schtat" ("My affairs shall go as ordained on high"). The eryngium flower – a symbol of conjugal fidelity suggests that the painting may have been intended as a betrothal token for Agnes Frey.

It was painted during Dürer's "bachelor journey" through Germany. Three important early self-portrait drawings precede the painting (see page 83). They are: a) *Self-portrait, aged thirteen* of 1484 in the Albertina, Vienna; b) *Self-portrait, c.* 1491, in the Univeritätsbibliothek, Erlangen (on the back of a *Holy Family*); c) *Self-portrait* of 1493, in the Lehman collection, New York, which was executed the same year as the painting. The handling of the painting is

Dürer, assigning them to 1492–3. Friedländer (1921) accepted them as authentic, but with some reservations, and dated them 1497, whereas Röttinger (1926) accepted both the attribution and the 1492–3 date. Bock (in the Museum Catalogue, 1914) attributed the works to the Master of the St Dominic Legend; he assumed that *The Betrayal* and the three *Scenes from the Life of St Dominic* were by the same hand, or at least from the same

13 A

13 B

13 C

13 D

13 E

13 F

workshop, and that *The Flagellation* and *The Lamentation* came from the same source but belonged to a different polyptych. Winkler (1936) claimed that the provenance of the paintings from Strasbourg was established: if this is the case, it might be assumed that Dürer had a hand in the better examples (the St Dominic scenes) during the period of his activity in Strasbourg (1493–4) but it would be difficult to isolate his personal contributions. Panofsky's thesis that Dürer did in fact collaborrate on these pictures but that his hand is indistinguishable from that of others seems to be the most acceptable theory. The Tietzes (1927) rejected the attribution to Dürer altogether.

13 ⊞ ⊕ 113×79 1493-94? ▢ ⁝

A. Flagellation

13 ⊞ ⊕ 113×79 1493-94? ▢ ⁝

B. Lamentation of Christ

13 ⊞ ⊕ 80×113 1493-94? ▤ ⁝

C. Betrayal
Transferred to canvas from original panel and cut down.

13 ⊞ ⊕ 95×78 1493-94? ▤ ⁝

D. Death of St Dominic
Canvas on panel (fragment).

13 ⊞ ⊕ 79×112 1493-94? ▤ ⁝

E. Assumption of St Dominic
As above; cut down.

13 ⊞ ⊕ 56×111,5 1493-94? ▤ ⁝

F. Coronation of St Dominic
As above.

14 ⊞ ⊕ 46×36 *1494* ▢ ⁝

St Christopher
Dessau, Gemäldegalerie
The attribution to Dürer is controversial. The Tietzes (1928) considered it to be an early work (1494) inspired by a drawing – now lost, but known through two almost identical copies, one at Brunswick and the other at Erlangen. The composition and colour are reminiscent of the Housebook Master (particularly the altar panels of *c.* 1487 in Nuremberg). Panofsky (1948) agreed that the picture is based on a lost drawing possibly by Dürer but thought that the painting was by another hand.

15 ⊞ ⊕ 16,8×20,2 1494? ▢ ⁝

The Doss Trento (Trintperg)
Basle, R. von Hirsch Collection
Watercolour and gouache. Inscribed in Dürer's hand "Trintperg". View of a mountain ridge at Trent and the church of Sant'Apollinare.
From the stylistic point of view – as the Tietzes have sug-

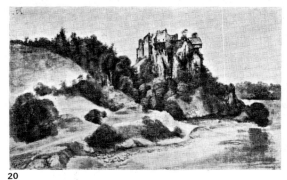

20

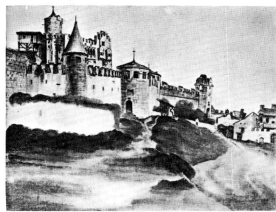

23 (plate IV B)

gested – we must assume that it was painted on the journey to Italy, in which case it is unusual. It appears to be more carefully drawn and less expressive than the watercolours of 1495. Dorner, Winkler and Panofsky all dated it to the return journey from Venice in 1495.

16 ⊞ ⊕ 23,8×35,6 1494? ▤ ○ ⁝

View of Trent
Formerly in Bremen, Kunsthalle For present whereabouts see no. 2. (facsimile in British Museum). Watercolour and gouache. Inscribed "Trint" by Dürer; monogram added later. Although the landscape is painted fairly sketchily, and the course of the River Adige was changed in the nineteenth century, the outline of the town has remained more or less unaltered and it has thus been possible to establish the spot from which Dürer made this sketch. The Tietzes (1928) dated it to the end of 1494; Meder agreed that it was executed on the way to Venice.

17 ⊞ ⊕ 12,6×17,2 1494 ▤ ⁝

Lion
Hamburg, Kunsthalle
Miniature (gouache on vellum, heightened with gold). Monogram and date in gold. Painted in Venice, but evidently not from the life in spite of the attempted naturalism. The model for this was, as Panofsky

says, the Lion of St Mark's, of which there are numerous contemporary paintings and drawings.

18 ⊞ ⊕ 26,3×35,5 1495 ▢ ⁝

Sea Crab
Rotterdam, Boymans-van Beuningen Museum
Watercolour and gouache. Acquired by van Beuningen from the Béhague Collection in Paris. Sketched from the life, during the artist's stay in Venice. Published by Winkler J K L) and generally agreed to date from 1495. The Tietzes thought that it might have been intended for a *Horolographia*. The references to the great Italian painters of animals such as Giovannino de'Grassi, Pisanello and Leonardo seem fairly obvious.

19 ⊞ ⊕ 24,3×43 1495 ▤ ⁝

Lobster
Berlin, Kupferstichkabinett
Watercolour and gouache. Executed during the first stay in Venice and, like no. 18, evidently drawn from the life, judging at the realistically observed detail.

20 ⊞ ⊕ 15,4×25 1495? ▤ ○ ⁝

Ruined Castle on a Rock
Formerly Bremen, Kunsthalle
Watercolour and gouache. The monogram may not be authentic. Formerly in the Grünling Collection. For present whereabouts see no. 2. Rusconi

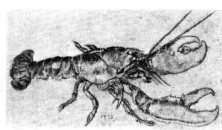

21

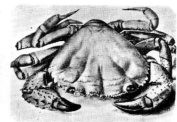

22 (plate VI A)

(1936) identified the castle as the Castello di Segonzano, and consequently assigned the watercolour to the homeward journey from Italy. Zink, on the other hand, (P 1942) identified it as a view of the Castle of Prunn in Franconia. Panofsky (1948) considered that the identification of the locality as Segonzano was rather questionable; he dated the watercolour after 1495, but not later than 1500.

21 ⊞ ⊕ 19,1×13,9 1495? ▤ ⁝

Castle in the Alps
Berlin, Kupferstichkabinett
Watercolour and gouache. Inscribed "Ein Welsch Schlos". The monogram may not be authentic. Rusconi identified it as a view of the Castello di Segonzano and related it to the drawings L. 108 (no. 20) and L. 301, which are both authentic. The Tietzes considered it a workshop copy, with a fake monogram and inscription, but this view is unacceptable although the work is rather crude in appearance because the main outline has been overworked in pen. According to Panofsky this is an authentic work, and should be dated 1494-5.

22 ⊞ ⊕ 22,1×22,1 1495 ▤ ⁝

View of Arco
Paris, Louvre
Watercolour and gouache. Painted during the return.

journey from Verona to Trent. The inscription "Fenedier Klawsen" is in Dürer's hand but the monogram appears to have been added by a later hand; there is possibly a faint pen outline. The square format and the intentional suppression of the distant mountain landscape indicate that Dürer's main interest was in the fortified rock itself, at the mouth of the Sarca valley; this is the focal point of the drawing, thus it is not, as the Tietzes (1937) claimed, an example of his naive conception of landscape. Beyond the chalky yellow hump in the foreground, and beyond the middle ground of fields, pastures and clumps of trees, the small town is seen, perched on the rocky spur; everything is drawn in the sharp relief of a clear dawn light. It has been suggested that this and no. 23 (of the same date) were done for Dürer's treatise on the fortification of cities, castles and towns which he published in 1527, but it seems highly unlikely that such early drawings as these should have been intended as documentary illustrations for the work in question. At this stage Dürer's interest in military engineering is not yet apparent; here he is obviously interested in the compositional and pictorial qualities offered by the scene. Moreover, the defensive strength of both Arco and the castle of Trent had already been broken down by this time. The Tietzes (1937) related this to a detail in Mantegna's *Martyrdom of St James* in the Church of the Eremitani, Padua, which accords with a dating to the return journey.

23 ⊞ ⊕ 19,8×25,7 1495 ▢ ⁝

The Castle of Trent
London, British Museum
Inscribed "trint" at the top in Dürer's writing. The foreground slope is loosely sketched in; by contrast the castle battlements are drawn in precise detail. The fortified castle was for centuries the political, administrative and even religious nucleus of both the city and the surrounding region. This watercolour has an expressive quality which distinguishes it altogether from the landscape watercolours made on the return journey from Venice. The Tietzes dated it to the end of 1494.

24 ⊞ ⊕ 14,1×14,8 1495? ▤ ○ ⁝

Trees on the Ridge of a Hill
Berlin, Kupferstichkabinett
Watercolour and gouache. According to Rusconi (1936)

17

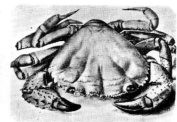

18 (plate III)

19

91

24

25

26 (plate V A)

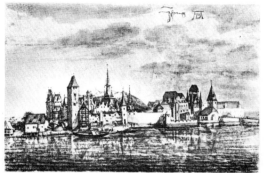

27 (plate V B)

28

29

monogram added later. The Tietzes (1928) related it to the engraving *St Jerome in Penitence* (B. 61) and dated it *c.* 1495-6. Ephrussi dated it 1510; Colvin, after 1506; Haendke, after *c.* 1506. The spontaneity and vividness of the brushwork would suggest 1495-6 as the most likely date.

31 19,8×30,6 1495-96
Quarry
Bremen, Kunsthalle
Pen drawing, with watercolour washes. Inscribed "Steinpruch" in Dürer's writing; the monogram was added at a later date and has faded. Comparable to no. 30 in subject matter. The Tietzes dated this—like no. 30—1495-6.

32 8×17,8 1496-97
Franconian Landscape
Paris, Louvre
Watercolour and gouache. The Tietzes dated this picturesque view to 1495-6, because of its stylistic and technical affinities with the exquisite *View of Nuremberg* (no. 42). Panofsky denies Dürer's authorship. Probably painted after his return from Italy, *c.* 1496-7.

33 29,5×19,6 1495-97*
Pine Tree
London, British Museum
Watercolour and gouache. This may have been intended as an illustration for a botanical manual; it may also have been a preparatory study for other watercolours of the Nuremberg area. Panofsky (1948) dated it 1495-7; the Tietzes (1928) suggested 1499-1500.

34 23,3×19,7 1495-97
Quarry
Milan, Biblioteca Ambrosiana

the locality is in the vicinity of Segonzano. The ridges of the mountains beyond the valley are faintly visible. The Tietzes (1928) related it to the *Ruined Castle on a Rock* (no. 20) and dated it to the end of 1494. According to Panofsky it belongs to 1495. Ephrussi (1882) dated it to Dürer's second Italian journey.

25 20,5×29,5 1495
Alpine Road
Escorial (Madrid)
A view of the Val d'Isarco, between Chiusa and Ponte Isarco (Rusconi, 1936). Panofsky and the Tietzes dated it 1495. It is a delightful example of *plein-air* painting.

26 21×31,2 1495?
Alpine Landscape (Wehlsch pirg)
Oxford, Ashmolean Museum
Watercolour and gouache. Formerly in the Chambers Collection. The inscription "Wehlsch pirg" the name by which the painting is generally known) is usually accepted as authentic. The range of mountains, seen here in the clear dawn light, lies to the west of Trent, in the Cembra valley near Segonzano. The locality was identified by Rusconi (1936) who dated the watercolour 1494 on account of the autumnal scenery. Panofsky, however, dated it to the spring of 1495. The Tietzes dated it 1507, i.e. to the return journey from Venice on the second Italian journey. The stylistic affinities between this exquisite watercolour and others belonging to the first Italian journey make the 1507 date suggested by the Tietzes seem very improbable, and Rusconi's claim that this is definitely an autumnal scene is not particularly convincing, as the muted rather mellow colours of this watercolour are equally characteristic of the late spring in the Trent region. It is an enchanting composition, beautifully balanced and delicately handled.

27 12,7×18,7 1495
View of Innsbruck
Vienna, Albertina
Bears the inscription "Isprug" in Dürer's hand. The monogram was added later and is in brighter paint but it too is probably autograph. This watercolour is smaller than others like it, but it is highly finished. It is assumed to have been painted on the journey to Italy and the Tietzes accordingly dated it to the end of 1494, but, as Rusconi (1936) has pointed out, the vegetation is more typical of spring, so it would be possible to date it to the return journey (i.e. of 1495), which would fit the more subtle character of the painting. A strip of land is enclosed between the sky and the water; the crystalline transparency of the washes of colour are so expressive of atmospheric effect that this watercolour could only have been painted after Dürer's visit to Venice, when he had assimilated his Venetian experience.

28 37,2×26,6 1495*
Ruined Alpine Hut
Milan, Biblioteca Ambrosiana
The monogram and 1514 date are not authentic; they may have been added by Hans von Kulmbach. According to Kuhrmann (Catalogue of the exhibition *Zeichnungen der Dürerzeit,* Munich, 1967), the delicate atmospheric washes of colour and carefully controlled tonal gradation are typical of Dürer's watercolour style after his trip to Venice. Both the Tietzes (1928) and Stadler (1929) rejected the work; Winkler (1929 etc.) accepted it as authentic and dated it 1495; Flechsig (1931 and Degenhart-Kuhrmann (1967) accepted it; Panofsky considered the attribution questionable, but proposed a date of 1494-5, if genuine.

29 21,3×22,2 1495-96
House on an Island in a Pond
London, British Museum

Watercolour and gouache; inscribed by Dürer "Weier Haws"; the monogram is spurious. The subject has been identified as a pond formed by the damming of the River Pegnitz near Nuremberg; the small house is popularly supposed to have been a refuge for city councillors in times of unrest. F. Frommau (*Nürnberger Schau,* 1941) identified it as the Haller Weiherhaus. The subtle, muted colouring, and the contrast between the calm, reflective, shimmering water and the threatening clouds make this a particularly striking work. Parts, for instance the boat, are carefully finished. The Tietzes (1928) dated it 1494, i.e. before the first Italian journey. Wölfflin (1905) dated it *c.* 1500.

30 29,2×22,4 1495-96
Quarry
Formerly Bremen, Kunsthalle
For present location see no. 2. Watercolour. Inscribed "Steinpruch" in Dürer's writing;

92

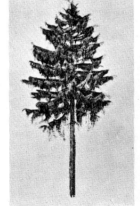

31

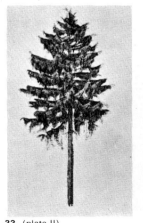

33 (plate II)

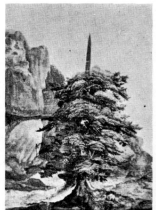

35

Inscribed at the top "Steinpruch" in Dürer's hand. The monogram is later, possibly added by Hans von Kulmbach. Dürer probably made this study of rocks in the Schmaussenbuchs quarry near Nuremberg, which was noted for its reddish-coloured, bizarrely formed, rocks. There is a whole series of drawings on this theme which were used as studies for engravings like *St Jerome in Penitence* (B. 61) and *The Penance of St John Chrysostom* (B. 63) of *c*. 1497 which thereby provide a *terminus ante quem* for this watercolour. The motif reappears in the background of *The Penance of St John Chrysostom*. The watercolour is painted *alla prima* in washes of reddish-brown, greenish-blue and yellow hues. It has been considered authentic by Wischer (1886), Winkler (1927 etc.), the Tietzes (1928), E.Schilling (1929), Stadler (1929), Flechsig (1931), Waldmann (1934), Panofsky (1948) and Degenhart-Kuhrmann (1967).

35 ▦ ✺ 29,5×21,9 ▤ ⦂
1495-97

Tree in a Quarry
Milan, Biblioteca Ambrosiana
Watercolour and gouache.
Monogram added later, perhaps by Hans von Kulmbach. The luminous ochre-coloured earth and the intertwined leaves and branches are very delicately painted. The Tietzes did not accept this as an authentic work, but it has been accepted by Winkler (1927), Stadler (1929), Flechsig (1931), Panofsky (1948) and Degenhart-Kuhrmann (1967). Dated 1495-7; painted immediately after his return from Italy, or during the eighteen months which followed, in the environs of Nuremberg.

36 ▦ ✺ 26,2×37,4 ▤ ⦂
1495-97

Pond in a Wood
London, British Museum
Watercolour and gouache.
Monogram — centre top — is false. Formerly in the Sloane Collection. The scene is bathed in the soft, clear light of dawn; the sky is already bright and the water still and sombre, becoming brighter towards the horizon; on the left, forming a sharp contrast, are the stark remains of pine trees which have been struck by lightning, seeming to strain their dessicated trunks vainly towards the growing light. It is one of Dürer's most memorable watercolours. Datable to *c*. 1495-7, after the Italian journey. The Tietzes (1928) dated it *c*. 1499.

37 ▦ ✺ 25,1×36,7 ☐ ⦂
1495-97

Mills on a River Bank
Paris, Bibliothèque Nationale
Watercolour and gouache.
Inscribed "Weydenmull" and the monogram. This is less well known than nos. 29 and 36, to which it is related in type, but equally impressive. Here, instead of a sunset or a dawn scene, we find the feast of

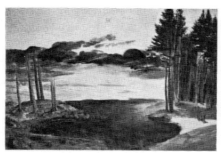

36 (plate VII A)

colours which follows an afternoon storm: above the houses and the enormous trees stretches an expanse of storm-clouded sky. The mills were situated on the River Pegnitz, near the Hallerwiesen, to the west of Nuremberg. The Tietzes (1928) dated this *c*. 1499-1500; Panofsky, 1495-7.

38 ▦ ✺ 16,5×11,2 ☐ ⦂
1496

Holy Family
Rotterdam, Boymans-van Beuningen Museum
Miniature: gouache, pen and gold on vellum laid down on wood. Formerly in the Koenigs Collection. Probably painted (see no. 9) as a New Year

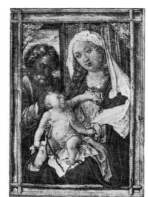

38

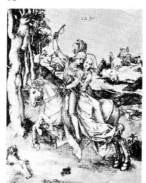

39

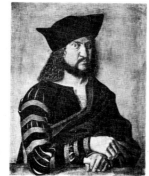

40

greeting. The Tietzes accepted it as an almost certainly authentic work and pointed out the combination of German (e.g. Schongauer) and Flemish influences (e.g. Bouts and van der Goes) with Italian ones (the inclusion of St Joseph transforms the theme of "Mother and Child" into a virtual "sacra conversazione"). Panofsky (1948) accepted it only provisionally and dated it, if genuine, *c*. 1496.

39 ▦ ✺ 21,5×16,5 ⦂ ▤ ⦂
1496?

Young Couple on Horseback
Formerly in Berlin, Kupferstich-kabinett
Pen and watercolour. The date (1496) may be authentic, but the monogram is spurious. This is an incisively drawn, subtly coloured and well balanced composition. The motif is based on a representation from the Housebook of a happy couple, born under the sign of Jupiter — the sign of good fortune according to medieval astrology — on their way to the hunt. Parts of the composition e.g. the dog, tree, house etc. also appear in *The Horseman and the Lansquenet* (B. 131, see p. 118) of 1497. Panofsky thought that this watercolour might be a copy, possibly by Dürer himself, of a drawing of 1492-3 which had earlier used the motif from the Housebook Master. The same motif also inspired Hans Baldung Grien. The Tietzes did not accept this as an authentic work.

40 ▦ ✺ 76×57 ▤ ⦂
1496

Portrait of Frederick the Wise, Elector of Saxony
Berlin, Staatliche Museen
The monogram may be spurious. The painting was commissioned from Dürer during the period of the Elector of Saxony's residence in Nuremberg. It is possible that some minor passages are by another hand. The figure, dressed in black and gold, dominates the picture space; the green background and the ledge on which he leans both serve to emphasise the three-dimensional quality of the figure. Frederick the Wise was one of Dürer's most loyal admirers. Dürer also portrayed him in an engraving of 1524.

41 ▦ ✺ 22,5×28,7 ☐ ⦂
1496-97

Quarry
London, British Museum

37 (plate VII B)

The image is abstracted in the same sort of way as no. 33. The finely drawn rocky mass is painted in watercolour and bounded by a contour so that it appears suspended against the blank background. The Tietzes (1928) rejected this work, and Conway (1910) and Pauli (1911) dismissed it as a fake. Panofsky accepted it and dated it 1495-7.

42 ▦ ✺ 16,3×34,4 ▤ ⦂
1496-97

View of Nuremberg from the West
Formerly in Bremen, Kunsthalle
For present location see no. 2.
Watercolour and gouache.

41

43

used as the nucleus around which the rest of the composition is organised. The Tiergärtner and Neue towers have been identified and it has thus been possible to establish the point from which this view was taken.

43 ▦ ✺ 21,4×16,8 ▤ ⦂
1496-97?

Quarry [?]
Berlin, Kupferstichkabinett
Watercolour and gouache. The monogram and date (1510) are fake. Panofsky dated it 1495-7, the Tietzes *c*. 1510 because the motif reappears in the famous engraving of *The Knight, Death and the Devil* (B. 98 see p. 117) which is dated 1513. It is quite possible that this watercolour was painted during the period when Dürer made several *plein-air* studies, i.e. the 1490s; equally it is possible that it is related in date to the engraving.

The Dresden Altarpiece
Dresden Gemäldegalerie
Commissioned for the Schlosskirche at Wittenberg by the Elector Frederick the Wise. In

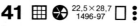

42 (plate VI B)

Inscribed in Dürer's hand, top centre, "Nörnperg'; the monogram added later. Formerly in the Grünling Collection. One of Dürer's most famous watercolours. Executed after his return from Italy, as most Dürer scholars have agreed. The coach road, which both divides and unifies the whole composition, is painted in muted colours; it is most effectively

1496-7 Dürer painted only the central panel. The two side wings were executed in 1503-4 and are probably not by Dürer himself; they appear to be connected in some way with the outbreak of the plague (St Anthony and St Sebastian were both protectors against contagious diseases).

44 ▦ ✺ 105,5×42,5 ☐ ⦂

A. St Anthony
The left hand panel of the *Dresden Altarpiece*. Like the right hand panel, this is of disputed authenticity. The Tietzes thought that the two paintings displayed some of the characteristics of Cranach's work, but Cranach was only appointed to the Court at Wittenberg in 1505 so that his authorship is impossible if the generally accepted date of execution is correct. (Gerstenberg, MK 1912). However, it seems reasonable to accept Panofsky's dating of 1503-4, which has been confirmed in a more recent critical study (J. Bialostocki, 1959, etc.), and the two pictures should probably be considered as the work of Dürer and assistants.

44 ▦ ✺ 105,5×95 ☐ ⦂
1496-97

B. Virgin Adoring the Infant Jesus
Unquestionably authentic. The

inclusion of the scene with St Joseph in the background, and also the physical type of the Virgin both derive from Flemish sources (see Schürer, ZK 1937). Pauli (ZBK 1915) thought that Agnes Dürer might have modelled for the Virgin. The Tietzes (1927) followed Justi and Flechsig in pointing out stylistic analogies between this and Italian pictures such as Bramantino's *Adoration* (Milan, Biblioteca Ambrosiana) for the hands, and Giorgio Schiavone's *Virgin and Child* (London, National Gallery) for the angel. The Tietzes also related it to Mantegna's *Dead Christ* (Milan, Brera). Quite apart from the question of pictorial design, the iconography of this picture is unusual: the pathos engendered by the intimations of life and death, and strange twilit atmosphere of the painting, were created intentionally by Dürer. It is a joyless Adoration: the Child is too pathetically small and is sleeping too deeply, and the yellowish colouring and stiffness of the figure both suggest that it is actually a corpse, thus evoking the theological parallel between

44 A **44 B** (plate VIII)

44 C

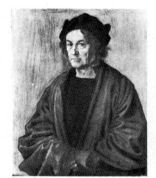

45

48 (plates XI–XII)

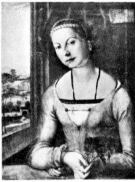

46

47

the sleep of infancy and the sleep of death.
The Adoration and the Lamentation are fused in a single image. It should also be remembered that Venetian representations of the Virgin Adoring the Child, which show the Virgin with the Child sleeping in her lap, often prefigure the Pietà.

44 ▦ ✸ 112×42,5 ▢ ⁝
1497

C. St Sebastian
Right hand wing of the altarpiece. See note to no. 44 A.

45 ▦ ✸ 51×40 ▢ ⁝
1497

Portrait of Dürer's Father
London, National Gallery
Inscribed on the back "1497. ALBRECHT. THVRER. DER. ELTER. VND. ALT. 70 IOR". Given as a gift to Charles I of England by the City of Nurem-

46 ▦ ✸ 58,5×42,5 ▢ ⁝
1497

**Portrait of Katharina Fürlegerin
(with her hair done up)**

berg. It remained in England, was bought by the Marquess of Northampton and in 1904 was acquired by the National Gallery. It is evidently the best of four replicas of a lost original; the others, which are identical in size, are at Erlangen, Frankfurt, and Syon House (Duke of Northumberland collection).

Lützschena, von Sternburg Collection (?)
Inscribed in top right hand corner, on a painted scroll, "Also pin ihr gestalt/in achcehe Jor alt/1497". On the neck of the sitter's dress are the initials "KM DDEW", and on the white underblouse "KAE". Underneath the painted scroll, but now no longer visible, was the Fürlegerin coat of arms.

The Tietzes accepted the painting as a genuine Dürer; Panofsky considered it to be the best of two copies of a lost original of 1497 (the other version was in the Goldschmidt Collection in Paris and has now disappeared without trace). The sitter is a young woman dressed for dancing — the costume and coiffure are like those in the drawing L. 703; she proffers eryngium flowers and wormwood in her right hand. From the coat of arms originally on the painting the sitter has been identified as Katharina Fürlegerin at the age of eighteen. As the same girl is apparently portrayed in no. 47 (which has survived only in copies, and is of the same date), but with her hair loose, eyes lowered and hands clasped in prayer in an image which suggests the pose of both a Virgin adoring the Child and a Penitent Magdalene, the iconographical differences and therefore the moral content of the two representations have been discussed at great length by German scholars. They have probed the symbolic significance of the plaited hair, and of the loose hairstyle (particularly when covered by a veil or small cloth), and of the erotic connotations of the eryngium flowers and the wormwood. In no. 46 they have discerned Pleasure, Love or *Voluptas*, and in no. 47 Virtue, Piety or *Castitas*. A parallel has been drawn with the engraving *The Combat of Virtue and Pleasure in the Presence of Hercules* (B. 73 see p. 116), of 1498–9, for the theme of the struggle between Virtue and Pleasure. The whole question is complicated by the fact that although both sitters have in common certain physical

characteristics, the identification of nos. 46 and 47 as portraits of one and the same sitter is far from conclusive.

47 ▦ ✸ 56×43 ▤ ⁝
1497

Portrait of Katharina (?) Fürlegerin (with her hair loose)
Frankfurt, Städelsches Kunstinstitut
Canvas mounted on wood.
This is the best of three known replicas of a lost original (the monogram is obviously spurious). The version in Augsburg shows an almost imperceptibly thin veil over the hair. The Budapest version shows a prayer book on a balustrade in front of the young woman, who clasps her hands in humble prayer. The sitter is Katharina (?) Fürlegerin (see no. 46); she has been identified on the basis of a facial resemblance (which is arguable) to the sitter in no. 46, the date 1497 on the Augsburg version, and the appearance of the Fürlegerin coat of arms. Gümbel (1928) suggested that the sitter in no. 46 was in fact one Cordula von Wolfsthal, who married Anton Tucher (see no. 112) in 1497, and that no. 47 represented Anna — not Katharina — Fürlegerin. Panofsky (1948) disagreed with Gümbel, pointing out the absurdity of accepting the coat of arms as evidence of identity for one picture and not for the other, quite apart from the question of date. It is possible that the portraits are of the sisters Katharina and Anna Fürlegerin and were executed in the same year as a single commission.

48 ▦ ✸ 52×41 ▤ ⁝
1498

Self-portrait
Madrid, Prado
Signed and dated, with an inscription on the wall below the window sill "1498/Das malt Ich nach meiner Gestalt/Ich war sex und zwanzig Jor alt/Albrecht Dürer", followed by the usual monogram. The picture was presented to Thomas Howard, Earl of Arundel, in 1636, by the Municipality of Nuremberg, and

passed to Charles I; and in 1827 it was acquired by the Prado. Although the prototype for this and the *Portrait of Katharina Fürlegerin* is generally accepted to be a portrait by Dirk Bouts of 1462 (London, National Gallery), as Panofsky has observed, the main characteristics of this picture are Italianate: it combines a basically Flemish scheme with an Italianate sense of monumentality. If we leave aside the *Self-portrait with Eryngium Flower* (no. 12), painted for his fiancée, this work of 1498 represents the first autonomous self-portrait in German art. It was painted in the same year that Dürer achieved an international reputation through the *Apocalypse* engravings. He depicts himself as a man of learning and culture. If this seems almost commonplace in the context of Italy, we should remember that it challenged the German image of the artist. The scale, the monumental conception, the bright colour, the modish dress, with braided sleeves, the gloves and elegant pose, the dignity expressed in the oblique gaze and impassive expression of the sitter, are all indicative of the Italian derivation of the painting. It is undoubtedly the most compelling of Dürer's early self-portraits.

The Tietzes (1928) considered it to be a *pendant* to the *Portrait of Dürer's Father* of 1497 (no. 45). There is a copy in Florence (Uffizi).

49 ▦ ✸ 41×32,4 ▤ ⁝
1498

Soldier on Horseback
Vienna, Albertina
Pen and watercolour. As well as the date and monogram this

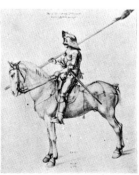

49

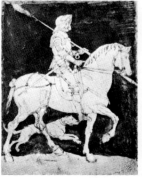

Autograph drawing (24,6 × 18,5) in the Biblioteca Ambrosiana, Milan, connected with no. 49.

94

bears the inscription "Dz ist die Rustung zw der Zeit/im Tewtzschlant gewest" ("This is the armour worn in Germany now") at the top. At the bottom the date 1498 and monogram. The costume study reappears in the engravings *St George on Horseback* (B. 54) of 1508 and forms the basis for the drawing *Armoured Knight on Horseback* (Milan, Biblioteca Ambrosiana), which is also before 1513, and thus preparatory to the engraving *The Knight, Death and the Devil* (B. 98 see p. 117). In the Milanese drawing Dürer drew the horse and horseman on the recto first and evidently traced them onto the verso, adding the dog. The Milan version shows a more sophisticated knowledge of animal anatomy.

50 ⊞ ⊕ 50 × 39 1498? ☐ ⋮

A. Virgin in Half Length (Haller Madonna)
Washington, National Gallery of Art, Kress Collection
This is the principal face of the picture, which is painted on both sides (see no. 50 B). In the lower left hand corner is the coat of arms of the Haller von Hallerstein family, who commissioned the work; in the lower right hand corner there is another coat of arms, which has not been identified.
It was published by Friedländer (P 1934) when it appeared as a Giovanni Bellini, and was attributed by him to Dürer on account of the transparent, glazed colours which resemble the colouring in the *Self-portrait* of 1498 (no. 48), which, moreover, is almost exactly the same size. The Tietzes pointed out the very Venetian features of the Virgin. The gesture of the Child's left arm anticipates Eve's pose in the *Adam and Eve (Fall of Man)* engraving (B. 1 see p. 117). The Tietzes also pointed out that the use of the landscape motif on the left is like that in the *Fürlegerin* portrait (no. 46) of 1497, which has led some scholars to ascribe this painting to the same year; Panofsky, however, accepts this date for the back of the panel (50 B) and dates the Madonna 1498–9.

B. Lot and his Daughters Fleeing from Sodom and Gomorrah
Reverse of 50 A. As in the *Virgin in Half Length* the Venetian influence is very pronounced, particularly in the small figures, which are somewhat reminiscent of the *Tucher* portraits (nos. 54–7). There are traces of Mantegna's influence in the austere rocky landscape. In the background the two cities seem to explode rather than burn, and Panofsky has compared the motif of the conflagration with that in the woodcut of the *Babylonian Whore* (B. 73) of 1496–7.

51 ⊞ ⊕ 30 × 19 *1498-99* ☐ ⋮

Christ in the Sepulchre, with the Symbols of His Passion

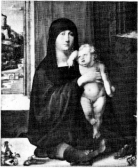

50 A (plate IX)

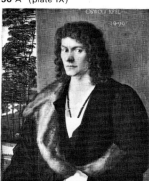

52 A (plate XIII) 52 B (plate XIV A) 52 C (plate XIV B)

Karlsruhe, Staatliche Kunsthalle
Published by Pauli (P 1935). Panofsky (1948) disagreed with the attribution, but his opinion was based only on a photograph, and he thought that the painting was still in a private collection at Aschaffenburg, whereas in fact it had already been acquired by the Museum in 1941. Winkler (1957), Musper (1965) and Grote (ZK 1965) all attributed it to Dürer, and Grote ascribed it to 1498–9 because of its stylistic affinities with the figure of Christ in the *Large Passion* series of woodcuts (and particularly with the *Ecce Homo*, B. 9 [see p. 118], for both the face and the Crown of Thorns).

52 ⊞ ⊕ 49,6 × 39 1499 ☐ ⋮

A. Portrait of Oswolt Krel
Munich, Alte Pinakothek
Inscribed at the top "OSWOLT KREL", and dated 1499. The portrait was formerly in the collection of the princes of Oettingen-Wallerstein. It is one of Dürer's most famous portraits, and, together with nos. 52 B and 52 C, forms part of a triptych — see K. Martin (1963), who cites Jacob Elsner's *Conrat Imhof* for this kind of

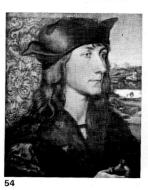

54

structure. It is an intense, rather sombre portrait. Krel, who was the son of a respected Swabian family and an agent for a Ravensburg commercial concern in Nuremberg up to 1502, appears to have spent a month in prison on account of a carnival joke he had played on a prominent Nuremberg citizen. In the portrait his gaze seems abstracted and almost threatening; the set of his mouth is determined, his nose and chin jut out, his forehead is low; he is set against a blood-red curtain which serves to isolate him from the landscape background and seems to emphasise his inner tension. The immediacy with which the sitter's mood is captured in this portrait never appears again in Dürer's work.

52 ⊞ ⊕ 49,3 × 15,9 1499 ☐ ⋮

B. Wild Man with Coat of Arms
Munich, Alte Pinakothek
Together with 52 C this forms the shutters to the *Portrait of Oswolt Krel* (52 A). The panels were discovered by Braune (MJBK 1907) from a detailed description in the records of the Princes of Oettingen-Wallerstein; at that time the wings were separated from the

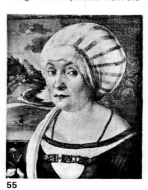

55

portrait. The heraldic crests on the two panels belong to the Lindau branch of the Krel family; they are supported by savages (appositely underlining the mood of Oswolt Krel).

52 ⊞ ⊕ 49,7 × 15,7 1499 ☐ ⋮

C. Wild Man with Coat of Arms
Munich, Alte Pinakothek
See note to 52 B.

53 ⊞ ⊕ 25 × 26,5 ▤ ⋮

Oriental Archer on Horseback
Milan, Biblioteca Ambrosiana
Drawing in pen and watercolour. Monogram and date (1514) added by Hans von Kulmbach. Authenticated by Winkler (1936), and Panofsky (1948), who dated it 1494–5, but rejected by Weixlgärtner (1927), the Tietzes (1928), and Oehler (1957) who attributed it to Kulmbach. It was exhibited as by Dürer in *Dürer und seine Zeit*, (Munich, 1967–8) when Kuhrmann, in the exhibition catalogue, confirmed it as a Dürer on grounds of stylistic analogies with drawings of the same subject in the Albertina and the British Museum, and suggested a date of before 1500.

54 ⊞ ⊕ 28 × 24 1499 ▤ ⋮

Portrait of Hans Tucher
Weimar, Schlossmuseum
The inscription along the top of the brocade screen behind the sitter reads "Hans Tucher 42 ierig 1499". On the back is the Tucher family coat of arms. Dürer painted the four small portraits of the two Tucher brothers and their consorts in 1499. The portrait of Nicholas Tucher has disappeared. The composition of the remaining portraits is similar to that of the Prado *Self-portrait* (no. 48) of 1498, with bust length figures, in three quarter view, seated in a space which is defined by the window frame and enlivened by a landscape view through the window; the architectural setting of the 1498 *Self-portrait* is here replaced by a brocaded screen, but the space is still restricted. The precise observation of detail in the brocaded backgrounds of all three portraits parallels the meticulous psychological analysis. The portraits in each pair would have been facing each other. It is possible

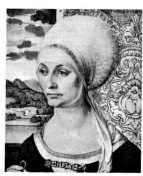

56 (plate XV)

that the paintings may have been cut slightly along the bottom edges and along the sides on which the landscapes appear.

55 ⊞ ⊕ 28 × 24 1499 ▤ ⋮

Portrait of Felicitas Tucher
Weimar, Schlossmuseum
Inscribed along the top of the brocade curtain "Felitz Hans. Tucherin. 33 Jor alt Salus 1499". Painted as a *pendant* to

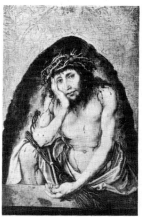

51

53

the portrait of her husband Hans, and at the same time as the portraits of her in-laws Elspeth and Nicholas (see nos. 54, 56 and 57).

56 ⊞ ⊕ 28 × 22 1499 ▤ ⋮

Portrait of Elspeth Tucher
Kassel, Gemäldegalerie
Inscribed along the top of the brocaded curtain "Elspet Nichlas Tuchern 26 Aet 1499", and the initials "NT" appear on the clasp of the sitter's dress. A portrait of her husband Nicholas almost certainly existed, but has now been lost. The similarity in both composition and size to nos. 54 and 55 is obvious.

57 ⊞ ⊕ *28 × 22* (?) 1499? ▤ ⋮

Portrait of Nicholas Tucher
See notes to nos. 54–56.

58 ⊞ ⊕ 28 × 25,6 1500? ☐ ⋮

Portrait of a Young Man
Munich, Alte Pinakothek
The dimensions indicated include two strips which have been added at the sides, each measuring 2.3 cms.
According to Buchner (1953) — who based his opinion on the traditional attribution transmitted by Murr (1778) but questioned as early as 1831 by J. Heller — the sitter may be the second son of Albrecht Dürer

the Elder, Hans (Johann) who was born in 1478 and was at one time thought to be the Hans Dürer admitted to the Nuremberg tailors' guild in 1507 (see J. Baader "Zahns Jahrbücher für Kunstwissenschaft" 1868). F. Rieffel (1919) thought that the portrait might be of the young Grünewald. As Panofsky has pointed out, there is no similarity between the sitter in this portrait and the sitter in the silverpoint drawing of 1503 (Philadelphia, Lessing Rosenwald Coll.) which is, according to the inscription, a portrait of Dürer's brother Hans.

59 ▦ ◉ 67×49 / 1500 ▤ ⋮

Self-portrait (in a Fur-collared Robe)
Munich, Alte Pinakothek
The painting is inscribed on the left with a monogram and the date 1500, but the date has been disputed by scholars; on the right is the inscription "Albertus Durerus Noricus/ ipsum me propriis sic effin/ gebam coloribus aetatis/anno XXVIII". Thausing (1876) questioned the authenticity of the inscription (under which a butterfly shaped scroll is just visible). Friedländer, Heidrich, Haack and Wölfflin all preferred to date the painting to the second Italian journey. X-rays have, however, confirmed that the 1500 date is authentic, and Kehrer (1934) and Buchner (1953) both suggested that Dürer had partially repainted the picture at a later date. Flechsig (1928) pointed out that the butterfly motif appears in works after 1518, and suggested that the repainting may have taken place circa 1520. Winzinger (ZKW 1954) rejected the idea that the face had been repainted, and asserted that only the background had been slightly modified.

The portrait apparently represents Dürer as Christ, but is evidently not intended to be blasphemous or a statement of proto-Reformation ideas. The figure is shown in a centralised, frontal pose, which is unusual in Dürer's work, set off against a dark background; his right hand is shown in the position traditionally and exclusively associated with the Redeemer

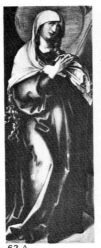

62 A

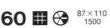

62 B

62 C

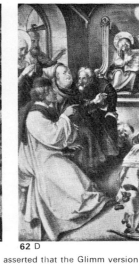

62 D

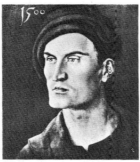

58

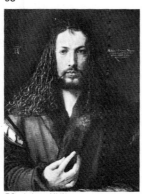

59 (plate XVI)

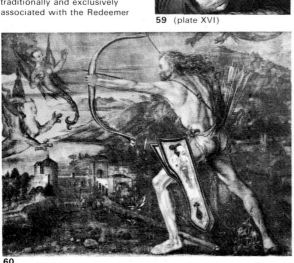

60

blessing. The significance of the painting is left in no doubt: the hieratic pose, severe brown robe, symmetrical disposition of the hair which falls in ringlets about the face, and the atmosphere of other-worldiness which emanates from it, all combine to underline the symbolic significance and to give a quality which can only be described as universal or timeless. The picture may have been intended by Dürer as an *Imitatio Christi;* a more usual representation of the theme was that of the sitter in the guise of Christ carrying the Cross. There is also, perhaps, another meaning illustrated in this picture, which is the credo of Dürer's times that the power of the artist derived directly from the power of God: it was his duty to create, and in this sense he was the "eritis sicut Deus". These underlying meanings in the *Self-portrait* of 1500 contrast with the arrogant narcissism of the Prado *Self-portrait*.

60 ▦ ◉ 87×110 / 1500 ▤ ⋮

Hercules Killing the Stymphalian Birds
Nuremberg, Germanisches Nationalmuseum
This is the only extant painting by Dürer using a mythological theme. The drawings L. 207 and L. 347 are related to it. At the beginning of the sixteenth century almost all private and public commissions in Germany were for religious paintings or for portraits. Thus the decorations for Frederick the Wise's castle were rather unusual: there were four paintings illustrating the myth of Hercules, including a *Hercules Killing the Stymphalian Birds with Bow and Arrow.* The most obvious influences in this painting are those of Pollaiuolo for the figure of Hercules, but there are other references to Italian painting. It seems likely that this was originally in Frederick's *Aestuarium* at Schleissheim, together with the *Mater Dolorosa* now in Munich (no. 62 A).

61 ▦ ◉ 151×121 / *1500* □ ⋮

Lamentation of Christ
Munich, Alte Pinakothek
Listed in the inventory of the Grand Duke of Munich's Collection, which was compiled between 1608–13. The painting was executed around 1500 for the goldsmith Glimm; upon restoration in 1924 the portrait figures of Glimm and his family reappeared in the lower right and left hand corners of the picture. The main compositional element is a triangle which has the figures of Nicodemus, St John the Evangelist and Joseph of Arimathaea at its angles. Compared with the woodcut *Lamentation* of 1498–9 (B. 13) this painting is much closer to the classic Italian Renaissance conception of the theme; in the woodcut, the emphasis on the dramatic content tends to make the poses and expressions of the group around the Dead Christ at the Sepulchre exaggerated, but in this painting, the reinterpretation of the theme is magnificently inventive and coherent. Flechsig (1928) considered, on account of the parallels with the engravings of the *Life of the Virgin* and the *Green Passion,* that the picture was painted in 1503. The link between this and the Holzschuher *Lamentation* (no. 70) has been considered variously: whereas the Tietzes (1937) and Panofsky (1948)

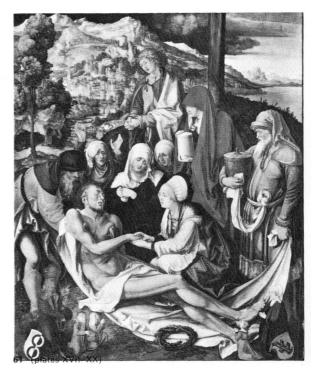

61 (plates XVII–XX)

asserted that the Glimm version is the earlier one, Schilling (1920), and more recently Winkler (1957), have argued that the Nuremberg (Holzschuher) version was painted c. 1498. The Tietzes also suggested that the Munich version had been painted with the help of workshop assistants, and Thausing (1884) thought it possible that Hans von Kulmbach had collaborated on the work. Flechsig's opinion that the British Museum drawing L. 230 of 1503 is a life study for the head of Christ has been refuted by Winkler (1936).

Polyptych (The Seven Sorrows of The Virgin)

According to Buchner (MJBK 1934–6) the *Mater Dolorosa* (no. 62 A) formed the central element of the first polyptych commissioned by Frederick the Wise for the Schlosskirche at Wittenberg and was surrounded by the seven *Scenes from the*

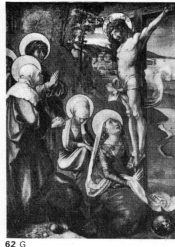

62 E **62 F** **62 G** **62 H**

Life of Christ now in Dresden (nos. 62 B–H). The drawing L. 660 (Berlin, Kupferstich-kabinett), which Winkler (1936) asserts was reworked in 1512, gives us an idea of the probable structure of the group, showing that the *Mater Dolorosa* would have been flanked on either side and also subtended by the Dresden pictures.

62 ⊞ ⊗ 109×43 *1500* ▤ ⦂

A. Mater Dolorosa
Munich, Alte Pinakothek
Formerly inscribed with a false monogram and date (1515). The painting appears to have been cut down by about eighteen cms. at the top. Restoration in 1935–6 revealed the point of the sword, the halo, and the shell niche which is just discernible in the background, thus dispelling earlier doubts about the iconography of the figure, which Beenken (1928) and Flechsig (1931) had interpreted as a Virgin Annunciate.

62 ⊞ ⊗ 63×45,5 ☐ ⦂

B. Circumcision
Dresden, Gemäldegalerie
Together with the other six paintings listed here (nos. 62 C–H), this came from the Schlosskirche at Wittenberg. Although the original idea for the polyptych was worked out by Dürer, as the drawing L. 664 (for the executioner in no. 62 F) and the engraving B. 42 (the monkey in no. 62 D) prove, Panofsky thought that the seven panels could not have been executed by Dürer himself, although they are traditionally assumed to have come from his workshop as did the *Mater Dolorosa*. The series has been attributed to a variety of people, notably Schäuffelein (Scheibler-Thieme, 1892) and the Master of the Benedict Legend (Dörnhöffer, 1906; Panofsky, 1948). Bock (1929) referred to copies, by a follower of Cranach, in the Library of the University of Erlangen.

C. Flight into Egypt
See notes to 62 B. The monogram is a later addition.

D. Christ amongst the Doctors
See notes to 62 B.

E. The Bearing of the Cross
See notes to 62 B.

F. The Nailing on the Cross
See notes to 62 B.

G. The Crucifixion
See notes to 62 B.

H. The Lamentation of Christ
See notes to 62 B.

63 ⊞ ⊗ 28,4×13 *1500* ☐ ⦂

Nuremberg Woman Dressed for the Home
Milan, Biblioteca Ambrosiana
Pen and watercolour. The subject is identical with the *Nuremberg Woman Dressed for the Home* in the Albertina (no. 64), but is not signed. It should not be considered as a mere replica of the Albertina drawing; in fact it may even be the first version of the subject as the handling of the rather sober colour appears to be fresher and more spontaneous. It has been attributed to Dürer by Thausing (1876), Ephrussi (1882), Flechsig (1931), who dated it to before 1500, Winkler (1937 and 1957), Panofsky (1948), and Degenhart-Kuhrmann (1967). Meder (1905) and Pauli (1915) considered it to be a copy, and the Tietzes considered it a poor example of work of the school of Dürer (1928 and 1933).

64 ⊞ ⊗ 32×21,1 *1500* ▤ ⦂

Nuremberg Woman Dressed for the Home
Vienna, Albertina
Watercolour and pen. The three Albertina studies of a Nuremberg woman dressed for the home, for church, and for a dance (see also nos. 65 and 66) were evidently not conceived as preliminary studies for something else but as completely independent drawings. This particular drawing is inscribed at the top "also gett man in Hewsern Nörmerck"; there is a monogram at the bottom of the drawing. The work is datable to 1500. It has been suggested that the model was Agnes Dürer, but there is no evidence.

65 ⊞ ⊗ 32,5×21,8 1500 ▤ ⦂

Nuremberg Woman Dressed for Dancing
Vienna, Albertina
Pen and watercolour. One of the series of drawings already mentioned (see no. 64) and exquisitely drawn. Monogram on lower edge. At the top, in Dürer's writing, "also gan die Nörmerger frawen zum thanz 1500" is inscribed.

66 ⊞ ⊗ 32×20,5 1500 ▤ ⦂

Nuremberg Woman Dressed for Church
Vienna, Albertina
Written at the top in Dürer's hand is the following:

"Gedenckt mein in Ewern Reych 1500. Also geht man zu Nörmerck in die Kirchn". Monogram on lower edge. The figure reappears in the woodcut *Marriage of the Virgin* (B. 82) of 1504. This is the third drawing in the Albertina series (see nos. 64 and 65). There is another version in the British Museum (no. 67).

67 ⊞ ⊗ 31,7×17,2 *1500* ☐ ⦂

Nuremberg Woman dressed for Church
London, British Museum
Identical to no. 66, but not a copy and this may have been the first version.

There is no monogram, but it is inscribed, apparently in Dürer's hand, "Eine Nörmengerin als man zw Kirchen gatt". Winkler and Panofsky have accepted this as authentic.

68 ⊞ ⊗ 32,3×21,1 1500* ☐ ⦂

Young Woman Dressed for Dancing

Portland, Oregon, Le Roy Collection
Inscribed in Dürer's hand, "Also gand dy Junckfrouwen zum danz zu Normwerk". Unlike the other drawings in this series, the model is seen full face and appears to be younger. The Tietzes dated it *c.* 1500 and Panofsky dated it 1501.

63 **64** **65**

66 **67** **68**

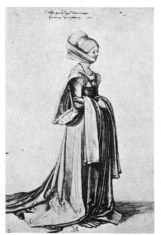

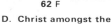

69 ⊞ ⊗ 16×32,3 1500* ☐ ⦂
Covered Bridge at Nuremberg
Vienna, Albertina
Pen and watercolour.
The exquisite landscape is reminiscent of Altdorfer and Wolf Huber. Haendke dated it after 1506.

70 ⊞ ⊗ 147×115 ☐ ⦂
Lamentation of Christ
Nuremberg, Germanisches Nationalmuseum
Traditionally attributed to Dürer and thought to have been painted soon after the Munich version; it combines characteristics of the woodcut *Lamenta-* *tion*, B. 13, with those of the Munich painting (no. 61). From the woodcut it takes the general layout of the landscape background (which is very Italianate), the pose of Christ and the distribution of the mourners, and from the painting the figures of the Virgin, the Holy Women and Joseph of Arimathaea. Along the bottom edge of the picture the donor's family are ranged in prayer; on the left the male and on the right the female members of the Holzschuher-Gruber family. The Tietzes (1927) and Panofsky (1948) rejected this work, but Schilling (JK 1928) and Winkler (JKW 1928) accepted it as authentic and dated it *c.* 1498.

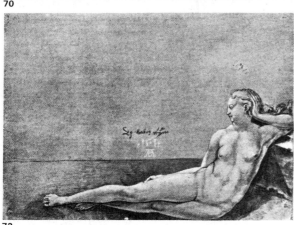
70

72

69

71 ⊞ ⊗ 10,9×13,4 ☐ ⦂
Alpine Castle
Paris, Louvre
Watercolour and gouache, supposed to be on vellum although in fact the ground is paper sized with gesso. Rusconi (1936) claimed to have identified the subject as the Castello di Segonzano, but the watercolour is evidently a copy of a section of the *St Eustace* engraving, B. 57 (see p. 116), which was the largest and one of the best known of Dürer's engravings. The preparation of the ground is quite uncharacteristic of Dürer's methods. Panofsky did not consider this work to be authentic and pointed out its derivation from the engraving mentioned above; the Tietzes rejected it (1928).

72 ⊞ ⊗ 220×170 1501? ▤ ⦂
Reclining Nude
Vienna, Albertina
Pen and wash drawing on green ground (paper). Monogram and date (1501) and an inscription "Dz hab ich gfisyrt", which has been variously interpreted as confirmation that the drawing was done from the life (Thausing, 1876) or that it was based on a system of proportional modules, which Justi (*Konstruierte Figuren . . .* 1902) claimed to have worked out. The Tietzes (1928) supported the view that it was drawn from the life, and they also pointed out the links between this and two engravings (see p. 116) (B. 71 and B. 73) and with *Nemesis* (B. 77). Springer considered the authenticity of this work questionable, but assigned it to 1508 if genuine.

73 ⊞ ⊗ *1502*? ▤ ⦂
Two Squirrels
Dodgson (*A. Dürer*, 1926) assumed that a painting of this subject existed, probably watercolour as there are several variants including one which has a false monogram and is dated 1512 (indicated as in the Rosenthal Collection in Vienna) and a partial version (watercolour, 25 × 18, in a private collection in England) which has Hans Hoffman's monogram and is dated 1578. Both Winkler and the Tietzes (1938) accepted this hypothesis, and dated the work 1502.

74 ⊞ ⊗ 19,2×21,4 *1502* ▤ ⦂
Parrot
Milan, Biblioteca Ambrosiana
The monogram and date (1513) were evidently added later, perhaps by Hans von Kulmbach. This delightful watercolour demonstrates Dürer's sensitive observation when drawing from the life. The drawing is incisive, but at the same time conveys the soft, downy quality of the bird's head and wings. This was used as a study for the parrot in the *Virgin with a Multitude of Animals* (no. 96) of *c.* 1503, and in the *Adam and Eve* engraving of 1504. According to legend the parrot was supposed to have been able to salute the Emperor with an "Ave Caesar" parodying the Christian "Ave Maria"; its green impermeable plumage was supposed to have symbolised the purity of the Virgin Mary. Winkler considered this an authentic work, and dated it 1495–1500; the Tietzes suggested ca. 1502, and Panofsky 1502/3 while Kuhrmann accepted a date at the beginning of the sixteenth century. Weixlgärtner (1927) rejected it.

75 ⊞ ⊗ 21,5×22,6 1502 ▤ ⦂
Young Hare
Vienna, Albertina
Watercolour and gouache. Monogram and date certainly authentic. Drawn from the life (note the reflection of a window in the eye, and the cast shadow on the ground). This drawing of a young hare, is comparable to Leonardo's drawings; Dürer manages to convey an extraordinary wealth of detail with his brush. It is an exquisitely drawn, highly expressive work, and is justifiably one of the best known and most popular of Dürer's watercolours. A copy from the Gay Collection is now in the Louvre.

76 ⊞ ⊗ 11,7×10,4 ☐ ⦂
Bunch of Violets
Vienna, Albertina
Watercolour and gouache on vellum. Brion (1966) considered it to be an authentic work of 1502, but the Tietzes

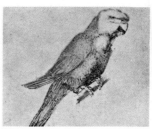
73 74

75 (plate XXVII) 78

and Panofsky rejected it and, in spite of its obvious quality, their view must be shared.

77 ⊞ ⊗ 11,7×15 *1502-03* ☐ ⦂
Small Piece of Turf
Vienna, Albertina
Watercolour and gouache on vellum. Springer (1914) and the Tietzes (1928) thought it of questionable authenticity; Panofsky thought that it was likely to be by Dürer.

78 ⊞ ⊗ 22,8×16,6 *1502-03* ▤ ⦂
Head of a Roebuck
Bayonne, Musée Bonnat
Fake monogram and date (1514). The Tietzes (1928) dated it *c.* 1502–3, as did Panofsky (1948); according to Flechsig (1928), however, it would be 1498.

79 ⊞ ⊗ 23,3×12,7 *1502-03* ☐ ⦂
Duck
Paris (?), Gulbenkian Collection
Watercolour on vellum, heightened with gold. Not listed in the Lisbon catalogue of the Gulbenkian Foundation. It resembles works of the early years of the sixteenth century, i.e. *c.* 1502, rather than 1515, the date indicated by the later inscription. It is similar to a well-known work by Jacopo de'Barbari (Munich, Alte Pinakothek, 1504).

80 ⊞ ⊗ 27,2×34,9 *1502-03* ☐ ⦂
Heron
Berlin, Kupferstichkabinett
Watercolour on vellum. Accepted as authentic by Winkler (JK 1939) and Panofsky (1948).

81 ⊞ ⊗ *1502-03*? ☐ ⦂
Cormorant
Lausanne, Strölin Collection
Published as an authentic work by Campbell Dodgson (OMD 1939); but Panofsky, judging from a photograph, considered its authenticity questionable,

noting the weak drawing (in, for example, the claws). He suggested a date of 1502–3 if genuine. Possibly a workshop drawing with parts by Dürer.

82 ▦ ✇ •1502-03•? ☐ ⁝

Bird of Paradise
London, Koch Collection
Watercolour and gouache.
Panofsky thought its authenticity very improbable.

83 ▦ ✇ 59,5×37,5 •1502-03•? ☐ ⁝

Two Birds of Paradise
Erlangen, Universitätsbibliothek
Watercolour and gouache; unusual size. Technically rather dull, like no. 82, to which it is also related in subject-matter. Authenticity very improbable.

84 ▦ ✇ 26,3×22 •1503• ☐ ⁝

Alkanet (Anchusa Officinalis)
Formerly Bremen, Kunsthalle
Watercolour and gouache. Possibly by Dürer. Panofsky thought it dubious, but if genuine of 1503.

85 ▦ ✇ •1503•? ☐ ⁝

Buttercup (Ranunculus Acris)
Formerly London, Bale Collection. Watercolour and gouache. Dubious.

86 ▦ ✇ 28,8×15 ▤ ⁝

Celandine (Chelidonium Maius)
Vienna, Albertina
Watercolour and gouache on

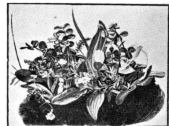

76 **77**

79 **80**

83 **84**

86 **87**

vellum. Inscribed with the date 1526, which is certainly false. Panofsky considered it (as he did nos. 87 and 88) of dubious authenticity. Possibly a workshop copy.

87 ▦ ✇ 35,5×26,6 ▤ ⁝

Columbine (Aquilegia Vulgaris)
Vienna, Albertina
See notes to no. 86 for all details, including false date.

88 ▦ ✇ 29,2×15 ▤ ⁝

Pansy, Pimpernel and Heal-All
Vienna, Albertina
Watercolour and gouache on vellum. Same characteristics as no. 86, but no date.

89 ▦ ✇ 77×31 ☐ ⁝

Iris (Gladiolus)
Bremen, Kunsthalle
Watercolour and gouache. According to Panofsky, this and no. 90 are more likely to be authentic than nos. 86–8; probably c. 1503. However, it is by no means certainly authentic, and the dimensions are usual for a Dürer watercolour. The Tietzes attributed it to Dürer's workshop and suggested that it might be a copy of an original by Dürer; this theory seems acceptable.

90 ▦ ✇ 54×17 ☐ ⁝

Turk's Cap Lily
Formerly Bremen, Kunsthalle
Watercolour and gouache. Similar subject and style to no. 89 (see notes to above). For present location see no. 2.

91 ▦ ✇ 35×11,6 ☐ ⁝

Wild Lettuce
Bayonne, Musée Bonnat
Watercolour and gouache. Formerly identified as a tobacco plant. Panofsky thought it of dubious authenticity.

92 ▦ ✇ 9,7×11,8 ☐ ⁝

Lily
Bayonne, Musée Bonnat
Gouache and grisaille on vellum. Likely not by Dürer.

93 ▦ ✇ ——— ▤ ⁝

Peony
Bamberg, Staatsbibliothek
Watercolour and gouache on vellum. Signed by Hans Hoffmann but related to an original by Dürer, according to Winkler and Panofsky.

94 ▦ ✇ ——— ☐ ⁝

Peonies
Vienna, Albertina
Watercolour and gouache on vellum. There is a copy (23.3 × 32.2) in Berlin (Kupferstichkabinett).

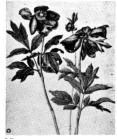

92

95

95 ▦ ✇ 37,7×30,3 ☐ ⁝

Peonies
Bremen, Kunsthalle
Watercolour and gouache. Considered authentic by Brion, who referred it to 1505. Panofsky thought it questionable but, if genuine, 1503.

96 ▦ ✇ 32,1×24,3 •1503• ☐ ⁝

Virgin with a Multitude of Animals
Vienna, Albertina
Pen and watercolour. Some motifs from earlier drawings, such as the *Parrot* (no. 74) and the *Crab* (no. 18), reappear

88

89

90 **91**

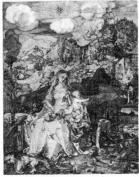

96 (plate XXIX)

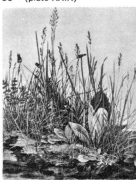

97 (plate XXVIII)

98

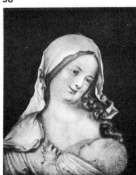

99

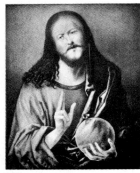

100

here, together with the griffon, stag-beetle (no. 195), wood-pecker, sparrow, butterfly, screech-owl, goats, sheep, swans, stork and the tethered fox which surround the serene and dignified Virgin and Child, in a landscape scattered with flowers and stretching far into the distance. One of the most obvious qualities of this work lies in Dürer's habitual delicacy of handling. Panofsky related the kneeling shepherd to the *Death of Orpheus* drawing, L. 159 (Hamburg, Kunsthalle), the stork to the drawing L. 821 (Ixelles, Musée), and the sheepdog to the drawing L. 388 (Windsor) and to the *St Eustace* engraving (p. 116). The small screech-owl re-appears in the illuminated initial for a page of Aesop's *Vita e fabellae* (Venice, 1505) possibly painted by Dürer for Pirckheimer (see no. 103 M).

97 ▦ ✦ 41×31,5 / 1503 ▤ ⋮

Great Piece of Turf
Vienna, Albertina
Watercolour and gouache.
Dated 1503 in lower right hand corner. This is a justifiably famous watercolour.

98 ▦ ✦ 42,2×26,8 / *1503* ▤ ⋮

Jousting Helmet : Three Views
Paris, Louvre
Watercolour and gouache, over pen drawing. Used as a study for the engravings B. 100 and B. 101 (p. 116). The monogram and date (1514) are both fake, and the precise date to which this watercolour should be assigned is a matter of speculation. Dürer's master-ful handling perfectly captures the cold glint of the metal and the sheen of the leather and brass. There is an identical helmet in the Higgins Armory (Worcester, Mass.) which was part of a suit of armour made by the armourer Siebenbürger of Nuremberg, but as he was born in 1510 this particular helmet obviously cannot have been the actual model (as was once supposed, AN 1940).

99 ▦ ✦ 24×18 / 1503 ▤ ⋮

Virgin Suckling the Child
Vienna, Kunsthistorisches Museum
A charming small painting in bright, brilliant colour.

100 ▦ ✦ 57×48 / 1503-04 ▤ ⋮

Salvator Mundi
New York, Metropolitan Museum
This has been identified with the painting listed and des-cribed in Imhoff's inventory of 1573 (no. 22). According to Thausing (1876) it was later owned by F.R.Reichardt of Munich. The painting is un-finished and thus has a rather peculiar appearance, but as C.Ricketts (BM 1907) has pointed out, it is precisely this incompleteness which is interesting, because it shows that Dürer had altogether

assimilated the influence of Jacopo de'Barbari and Antonello, and allows us to examine Dürer's method of under-drawing. Flechsig (1928) and Kuhn *(A Catalogue of German Paintings . . .,* 1936) both identified the picture as the central element of the so-called *Bremen triptych,* which would have had the Bremen pictures *St John the Baptist* and *St Onuphrius* (nos. 102 B & A) as its wings. Panofsky (1948) rejected this thesis on the grounds that the dark back-ground of the centre panel would have broken the con-sistency of the landscape background in the two flanking panels, thus producing a very unlikely structure. The Tietzes suggested a date of 1503 for the picture.

The Jabach Altarpiece

Scholarly opinion as to how this polyptych should be reconstructed is still divided. The four works mentioned below almost certainly belong together. Some Dürer scholars have included the *Adoration of the Magi* (Florence), no. 106, as the central panel, because this painting was also origin-ally in the Schlosskirche at Wittenberg and therefore must have been commissioned by Frederick the Wise; the date of the Adoration (1503-4) makes it contemporary with the panels.

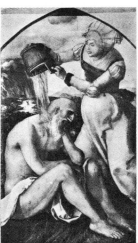

101 A

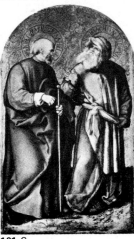

101 C

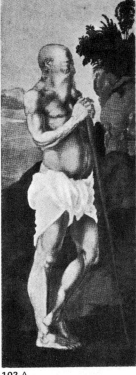

102 A

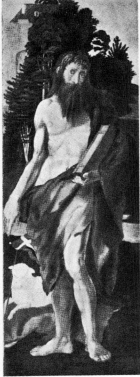

102 B

101 ▦ ✦ 96×51 / 1503-04 ▢ ⋮

A. Job and his Wife
Frankfurt, Städelsches Kunstinstitut
This and no. 101 B obviously combined to form a single image originally, and were probably the outside faces of the wings of a triptych; when closed, the landscape back-ground would have been con-tinuous between the two

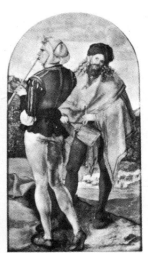

101 B (plate XXX)

101 D

panels. It has also been suggested that the two panels were originally one, were subsequently divided into two and trimmed on all sides, which would account for the fact that the various elements which should be con-tinuous in the painting do not now quite fit together. Kugler (1854) put forward the hypothesis that the two scenes would have formed the outside of the Munich panels (no. 101 C and D) and that they had been sawn off at some stage. A technical examination of the wood has confirmed that this is the case. Flechsig (1928) thought that the centre panel would have been a *Virgin and Child with St Anne;* Kauffman (WRJ 1938) suggested the *Adoration of the Magi* of 1504 (no. 106); for various reasons, including the fact that the Munich panels evidently always had arched tops, this is unlikely. Panofsky (1948), following Heller (1827), was of the opinion that the Job scenes belonged to a single painting, and there is some support for this view in a drawing of the school of Cranach the Elder (Berlin, Kupferstichkabinett, no. 1292), which was executed while the paintings were still at Witten-berg, showing a unified composition. The iconography of the panels has been vari-ously interpreted. It is probable, however, that the scene was intended to convey the idea of derision, not only because the facial expressions appear to express mockery, but because, in Christian sym-bology, the story of Job — an innocent and resigned victim — was often used as a prefigura-tion of the Passion, so that it cannot be fortuitous that the Christ in the frontispiece of the *Large Passion* and that in famous *Melencolia* are shown in the same pose, conveying an attitude of resignation. The theme of Job — who was subjected to great suffering and then redeemed and venera-

ted as the protector of victims of skin diseases and the plague – seems to have been particularly apposite, since Frederick the Wise is known to have been a hypochondriac and since there was an outbreak of the plague in Germany at precisely this date.

101 🔲⊕ 94×51 1503-04 ▢ ⋮

B. Two Musicians
Cologne, Wallraf-Richartz-Museum
See notes to no. 101 A.

101 🔲⊕ 96×54 1503-04 ▤ ⋮

C. St Joseph and St Joachim
Munich, Alte Pinakothek
Signed, in monogram, on the knob of St Joseph's staff. The date (1523) was removed at the end of the nineteenth century, when it was realised that it had been added later. Von Hellwig (DM 1813) indicated that they had originally belonged in "the private chapel of a Cologne aristocrat", who, according to Kugler (1854), would have been a member of the Jabach family. Flechsig stated that the two wings had probably been commissioned by Lazarus Spengler, the clerk of the works of the church of St Sebaldus in Nuremberg, basing his suggestion on the iconography of the panels in which St Lazarus is included. The paintings are now usually considered as autograph works, but have been considered by some scholars as products of Dürer's workshop, Wölfflin (1926) proposed a date of 1503–5, which has been generally accepted.

101 🔲⊕ 97×55 1503-04 ▤ ⋮

D. St Simeon and St Lazarus
Munich, Alte Pinakothek
See notes to 101 C. The monogram appears on St Lazarus's pastoral cope.

102 🔲⊕ 58×21 *1503-04* ▤ ⋮

A. St Onuphrius
Bremen, Kunsthalle
This belonged, together with no. 102 B, to the Praun Collection in Nuremberg and later to the Heinlein Collection; it was left to the present collection by H. Klúgkist (1851). The two paintings were the lateral wings of a small triptych (Tietze, 1927); Panofsky has rejected the suggestion that the central element of the triptych would have been the New York *Salvator Mundi* (no. 100) because that picture has a dark background which does not match the landscape background of the panels with *St Onuphrius* and *St John the Baptist,* and this would have produced a composition quite untypical of Dürer's work. The combinations of the half length figure of the *Salvator Mundi* with the full length figures of the Saints would also have been rather unlikely. It seems probable, therefore, that the

central panel has been lost, or even that it was never executed. Judging from the positions of the Saints within the panels it seems possible that they were part of a series of saints perhaps intended for a more complex polyptych. The paints are very Venetian in character, which led Hartt (AB 1940) to interpret St Onuphrius as a Job, because the figure appears to be modelled on Bellini's *St Job* for the S. Giobbe altarpiece in Venice (now in the Accademia); it may also be worth noting that the figure resembles the Frankfurt *Job* (no. 101 A) and was presumably painted from the same model. Panofsky pointed out a similar juxtaposition between St John the Baptist and St Onuphrius in the woodcut B. 112.

B. St John the Baptist
Formerly Bremen, Kunsthalle
See notes to no. 102 A.

Book Illuminations for Willibald Pirckheimer

The following is a list of illuminations in books in Willibald Pirckheimer's library, which may be attributable to Dürer. The phrase "illuminations in books" seems more appropriate than "illuminated books" since, apart from the first example (no. 103 A), these are not real illuminations, but small, delicately painted decorative motifs, usually showing Pirckheimer's coat of arms enclosed by putti, dolphins, or swags of fruit and flowers; these are, moreover, the work of a craftsman rather than an artist. With one or two exceptions these decorations are not usually considered to be by Dürer himself, but the work of his assistants after his designs. For this type of decorative idiom, Dürer could have drawn on his early experience as an apprentice goldsmith in his father's workshop. Where only the Pirckheimer coat of arms appears, we can assume that the illuminations belong either before his marriage (13 October 1495) or after the death of his wife (17 May 1504). Stylistically they seem to be closer to work of around 1504. Where both the Pirckheimer and Rieter coats of arms appear the decorations must obviously belong between 1495–1504. In the following list of illuminations, the identifying symbols used for no. 103 B are valid for all the subsequent entries up to no. 103 M; details of date, size, location etc. are entered separately where relevant.

103 🔲⊕ 30×21 *1504* ▢ ⋮

A. Pastoral Scene
London, London Library
In an edition of Theocritus, Venice (Aldus), 1495. Both the Pirckheimer and Rieter coats of arms appear on shields suspended from the trees on right and left, so it must have been painted before 17 May 1504.

103 A

103 🔲⊕ 9×20 *1504* ▤ ⋮

B. Cupids Seated on a Bear and a Unicorn, jousting
Rotterdam, Boymans-van Beuningen Museum
Illustration in Aristotle's *Historia Animalium*, Venice (Aldus), 1495. As in 103 A, the emblems of both the Pirckheimers and the Rieters appear, thus dating this before 17 May 1504.

C. Cupids on Cornucopias, fiddling
Copenhagen, Kongelige Bibliotek
This is in Simplicius's *Commentary* on the works of Aristotle (Venice, 1499). Both coats of arms appear, thus, before 1504.

D. Cupids and Panel Inscribed in Greek
London, British Museum

103 B **103 C**

103 D **103 E**

103 G

103 F

103 H

103 J

103 I

103 K

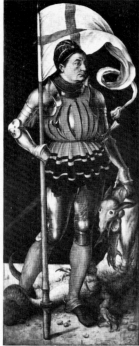

104 A (plate XXII A)

Cut out from Suidas' *Lexicon Graecum* (Milan, 1499). Date uncertain as there are no coats of arms.

E. Cupids Supporting Willibald Pirckheimer's Coat of Arms
Rotterdam, Boymans-van Beuningen Museum
On a copy of Appianus's *Historia Romana de Bellis Civilibus* published in Venice in 1477. Rather poor quality. The Rieter coat of arms is absent.

F. Cupids Supporting Willibald Pirckheimer's Coat of Arms
Berlin, Fürstenberg Collection
On a copy of Flavius Josephus's *Opera* (Verona, 1480). Like 103 E, rather mediocre. Rieter arms absent.

G. Pirckheimer's Coat of Arms
Rotterdam, Boymans-van Beuningen Museum
On a copy of the *Anthologia Graeca* published in Florence in 1484. Similar in quality to 103 E. Rieter arms absent.

H. Two Cupids on Dolphins with Pirckheimer's Coat of Arms
Hanover, Provinzialbibliothek
On a copy of Aristotle's *Organon*, Venice (Aldus), 1495–7.

I. Cupid with Pirckheimer's Coat of Arms
Location unknown
On a copy of Urbanus Bolzianus Bellunensis's *Institutiones Graecae Grammaticae* (Venice, 1497). Rieter arms absent. After 17 May 1504.

J. Cupids with Pirckheimer's Coat of Arms
Rotterdam, Boymans-van Beuningen Museum
On a copy of Aristophanes' *Comoediae Novem*, published in Venice in 1498. Rieter arms absent; after 17 May 1504.

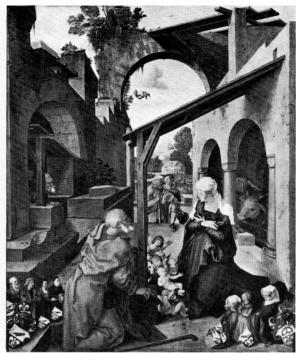

104 B (plates XXIII–XXV)

K. Two Siren's Supporting Pirckheimer's Coat of Arms
Location unknown
On a copy of *Etymologium Magnum Graecum* published in Venice in 1499. Rieter arms absent. After 17 May 1504.

L. Wild Man and Female Nude with Pirckheimer's Coat of Arms
Cambridge, Mass., Hofer Collection
In a copy of Aesop published in Venice in 1505. It may have been executed after a design by Dürer but there is no evidence of Dürer's hand.

M. Screech-Owl
Cambridge, Mass., Hofer Collection
Initial on volume mentioned above (103 L).

The Paumgartner Altarpiece

The triptych consists of a centre panel (no. 104 B) and two lateral wings (no. 104 A

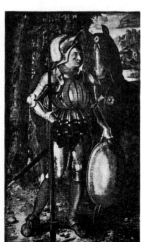

104 ▦ ✪ 157×61 *1502-04* ⬚ ⦂

A. St George
Assumed to be a portrait of Stephan Paumgartner. This and no. 104 C originally had an *Annunciation* painted in grisaille on the exterior

and C), which were originally painted on both sides. Acquired by Maximilian I from the Katharinenkirche in Nuremberg (1613). The date traditionally associated with the painting (1498) probably refers to the Paumgartner's commission for the picture. The panels with the two saints may have been painted slightly earlier than the central panel, and are related to Dürer's studies of human proportion, as drawings and engravings made 1500–4 demonstrate. *The Nativity* was probably painted *c.* 1504, and it is generally agreed to be contemporary with the *Adoration of the Magi* in the Uffizi (no. 106).

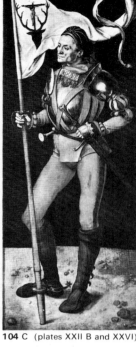

104 C (plates XXII B and XXVI)

(104 A). The plain, dark background in both these side panels was at some stage changed to a landscape, but this overpaint was removed during the present century.

A¹. Virgin with the Dove (part of an Annunciation)
Painted on the ouside of the *St George* panel (104 A). Modern Dürer scholars do not consider this as Dürer's work. Röttinger (JKS 1907) attributed it to one of the Wechtlins; Winkler (K 1961) attributed it to Hans Baldung Grien. It could have been painted in Dürer's workshop, under his supervision.

104 ▦ ✪ 155×126 *1504* ⬚ ⦂

B. Nativity
In the background is the Annunciation to the Shepherd; in the lower corners the members of the donor's family appear: on the left three men: Martin, who died in 1478, and his sons Lukas and Stephan, together with an old man whose coat of arms has been variously identified – Baumgarten (D H 1910) thought that he was one of Martin's great uncles; von Schmelzing (M J B K 1937–8) interpreted the figure as Martin's widow's second husband. On the right hand side are Martin's wife Barbara (d. 1494) with her daughters Maria and Barbara. The Tietzes (1928 and 1937) thought that Hans Schäuffelein might have worked on this painting. Martin (1963) cited a drawing in the British Museum (152. 198) as a copy of 104 B probably by a member of Dürer's workshop.

C. St Eustace
Assumed to be a portrait of Lukas Paumgartner. There is a woodcut *St George* (dated 1506) by Cranach which bears

an extraordinarily close resemblance to this work. Dürer's painting may also have inspired an Italian intarsio choirscreen (*c.* 1500–5) now in the Victoria and Albert Museum in London.

C¹. Angel of the Annunciation
Formerly on the outside of the *St Eustace* panel (no. 104 C); known only through copies (see Winkler). See also notes to 104 A, and 104 A .

105 ▦ ✪ 21×26 *1504* 🗎 ⦂

Elk
London, British Museum
Pen and watercolour. Inscription 'Heilemut'. Dated 1519, with monogram, but probably executed *c.* 1504.

106 ▦ ✪ 100×114 1504 🗎 ⦂

Adoration of the Magi
Florence, Uffizi
Date and monogram inscribed on a stone slab next to the Virgin at the bottom of the picture. This is the most important work of the decade

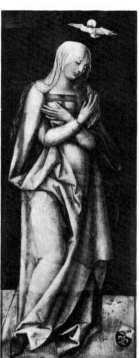

104 A¹ (plate XXI)

which separates Dürer's first and second visits to Italy, and perhaps the only entirely authentic painting of this period, outside portraiture. The Italianate characteristics of this work, the lighting, compositional rhythms, the scale and perspective of the ruined buildings, and the landscape, appear to have become more pronounced on the eve of Dürer's departure for Venice for the second time. There is something almost obsessive in the motif of the repeated arches which stand intact amidst the crumbling remains of the buildings, and in the appearance of Dürer himself, depicted as the most imposing and sumptuously attired of the three Magi. Like the Jabach panels (no. 101 A–D) this was com-

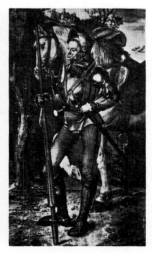

Nos. 104 A and 104 C before the removal of the overpainting of the background.

missioned for the Schloss-
kirche at Wittenberg; it was
also painted at the same time
and is more or less the same
size as the combined Jabach
panels, and has thus been
considered to be the centre
panel of the *Jabach Altarpiece.*
Kauffman (1938) claimed to
have discovered documenta-
tion to support this theory in
two descriptions: the first is an
anonymous source, incorpora-
ted in Matthäus Faber's
*Kurzgefasste Nachricht von der
Schloss- und Akademischen
Stiftskirche in Wittenberg,*
1717, written when the painting
was still in Wittenberg; the
second description is dated 28
June 1619 when it had already
been transferred to the Im-
perial "Kunstkammer" in
Vienna, where it remained from
1603 until 1792. Both
descriptions specify that a St
Joseph was in the painting;
the earlier one specifically
describes him as forming part
of a group together with the
animals tied to the manger.
There is, however, no St
Joseph in either the Uffizi
picture or the drawing in the
Erlangen Universitätsbibliothek
(an early sixteenth-century
copy of Dürer's painting made
when the picture was still at
Wittenberg). Kauffmann con-
cluded that the St Joseph
mentioned in the two docu-
ments must therefore be the St
Joseph in the Munich panel
(no. 101 C), in spite of the
fact that neither description
refers to the existence of wings
for the *Adoration.* Dürer
certainly did not paint a St
Joseph — a figure long regarded
as a rather humorous character,
and often represented sleeping
— but it is quite possible that
the figure was added to the
composition some time around
1600 when St Joseph became
a more prominent figure in the
Catholic liturgy, and that this
same figure was later removed.
This would explain the content
of the sources quoted by
Kauffmann and disprove his
theory that this painting is
connected with the *Jabach*
panels. In fact both of the
descriptions used by Kauffman
describe the *Adoration* un-
equivocally as a single picture
("Tafel" in the first case and
"Stuck" in the second) which
makes the view that this picture
belonged to a triptych totally
unlikely. In iconographical
terms it would be extremely
difficult to justify a link between
this work and the *Job* scenes.

107 ⊞ ✺ 42,5×34,5 ⬜ ⁝
1504?

Portrait of a Young Man
Budapest, Szépmüvészeti
Múzeum
In a very poor state of preserva-
tion. Of disputed authenticity.
Buchner (P 1928) and the
Tietzes (1938) related it on
stylistic grounds to Hans von
Kulmbach's work; Panofsky
thought that it might be a
portrait of Dürer's brother
Endres, painted in 1504;
the date is suggested by
the Leonardesque "sweetness"
of the portrait, and by com-

105

107

108

parison with the Albertina
drawing (L. 533) executed in
1514, which shows Endres ten
years older.

108 ⊞ ✺ 45×30 ⊟ ⁝
1504

Portrait of a Young Man
Indianapolis, Clowes Collection
Inscribed at the top (1504.
ALT 25). The fact that the
sitter is holding an eryngium
flower suggests that this may
be a "betrothal portrait" (see
no. 12). Tietze (1933) pub-

lished it as a Dürer, but later
(1938) ascribed it to an Upper
Rhenish Master in the manner of
Hans Baldung Grien; Panofsky
related it to the painting dated
1491 and signed spuriously
H.H. in the Metropolitan
Museum, New York (23.255).

109 ⊞ ✺ 32,5×24,5 ⊟ ⁝
1505

Portrait of a Young Woman
Vienna, Kunsthistorisches
Museum
In the Vienna museum since
1923. Formerly in a private
collection in Warsaw. It is
thinly painted, and may be
unfinished.

110 ⊞ ✺ 35,8×27,6 ⊟ ⁝
1505

Portrait of a Bearded Man
Kroměřiž, Czechoslovakia,
Umělecko historické Muzeum
Dated 1505. Published by
Frimmel (K 1888–9) as a good
early copy of a Dürer. Benesch
(P 1928) accepted it as an
authentic work; the Tietzes
(1937), with some reservations,
considered that it might be a
self-portrait. Panofsky thought
that it was neither a self-portrait
nor even by Dürer, and singled
out the decorative use of the
numerals as quite uncharacter-
istic of Dürer. The work appears
to be related stylistically to the
Borghese Gallery *Portrait of a
Man* (no. 111).

111 ⊞ ✺ 36×26 ⊟ ⁝
1505

Portrait of a Man
Rome, Galleria Borghese
This may be the "head of an
old man . . . by Alberto Duro"
listed in the Aldobrandini in-
ventories of 1626 and 1682,
and is certainly the painting
mentioned in the Borghese
inventory of 1700 under Dürer's
name, and in the Deed of
Trust of 1833 under Holbein's
name. Waagen (1867) identi-
fied it as a Dürer and thought
that is was probably a portrait
of Pirckheimer; Longhi
(*Precisioni* . . . 1928) linked it
with the Kromeriz portrait (no.
110), which is also dated
1505, but thought that the
present painting should be
ascribed to a later date.

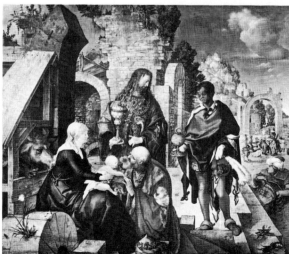
106 (plates XXXI–XXXII)

Benesch (P 1934), who had
originally suggested that it was
the work of the young Hans
von Kulmbach (P 1928),
accepted Longhi's identifica-
tion. Panofsky (1948) dismis-
sed both the identification of
the sitter as Pirckheimer and
the attribution to Dürer,
together with no. 110. Della
Pergola (*Catalogue*, 1059)
rejected the attribution to
Dürer (formerly supported by
De Rinaldis, 1948) and sug-
gested that it could be by C.
Amberger or a close follower of
Dürer.

112 ⊞ ✺ 46×33 ⬜ ⁝

Portrait of a Young Man
Darmstadt, Grand Duke of
Hesse Collection.
Tempera and oil. Formerly
thought to be a portrait of
Frederick II of the Palatinate
(Peltzer, *Albrecht Dürer . . .*
1905) and later thought to be
a portrait of Anton Tucher, the
husband of Cordula von
Wolfsthal (see note to no 47).
The picture is either by Dürer
or by a copyist of his original
(Friedländer, 1901), but its
authenticity has been ques-
tioned on various occasions.
Probably the work of a Franco-
nian or Middle Rhenish Master,
circa 1505 (Panofsky, 1948).

113 ⊞ ✺ 52×40 ⬜ ⁝

**Portrait of a Young Man as
St Sebastian**
Bergamo, Accademia Carrara
Provenance from the Lochis
Collection, with an attribution
to Dürer; listed in the Bergamo
Catalogue, until 1930, as an
authentic work. Friedländer
(*Ciceronefestschrift*, 1928),
who emphasised the badly
damaged head, and Winkler,
considered that the transforma-
tion of the figure into a St
Sebastian, and the addition of
the halo, had taken place at a
later date, and in other respects
compared it to the *Virgin with
the Siskin* (no. 116) and the
Tucher portraits (nos. 54–7).
The Tietzes did not accept the
attribution to Dürer, in spite of
the resemblance between this
and the *Krel* portrait (no. 52
A); they ascribed it to another
artist resembling Cranach
working under the influence of
Dürer's style of the end of the
century. Panofsky (1948) and
all the more recent historians
have rejected the work. Prob-
ably by a Franconian or Middle
Rhenish master.

The Ober St Veit
Altarpiece
114 ⊞ ✺ *1506* ⬜ ⁝

Ober St Veit near Vienna,
Erzbischöfliches Palais
Commissioned by Frederick the
Wise for the Schlosskirche at
Wittenberg, probably at the end
of 1504 or the beginning of
1505. Composed of a central
panel of a *Calvary*, with
a *Bearing of the Cross* on the
left and a *Noli me tangere* on
the right, on the inside of the
wings, and a *St Sebastian* and

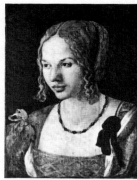
109 (plate XL)

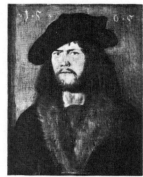
110

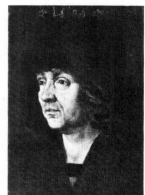
111

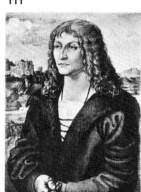
112

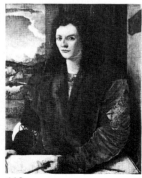
113

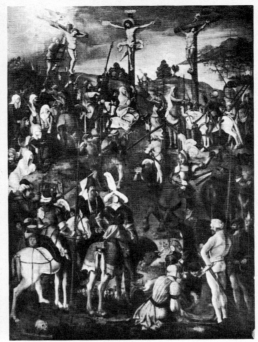

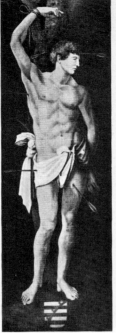

114

a *St Roch* on their exteriors. Dürer probably intended to paint the central panel himself, leaving the wings to be executed by workshop assistants, but in fact the whole project was entrusted to Hans Schäufelein when Dürer left for Italy in 1505. Drawings by Dürer would have provided the basis for the wings (L. 188 – L. 191), but the composition of the centre panel must have been by Schäufelein himself, borrowing various motifs from engravings and woodcuts by Dürer, as Panofsky has shown (B. 54 of 1505, published in 1508; B. 88; B. 9; B. 11). There is a variation on the *Calvary* in Basle (Öffentliche Kunstsammlung).

115 🔲 ⊕ 162×194,5 / 1506 ▤ ⋮

The Brotherhood of The Rosary (The Feast of the Rose Garlands)
Prague, Národní Galerie

Signed with a Latin inscription on a scroll held up by the artist, who is shown in the middle distance on the right, "Exegit quinquemestri spatio Albertus Durer Germanus MDV (I)", with the usual monogram. It is a rigidly symmetrical composition, based on a triangle which has sides formed by the figures of the Pope and the Emperor and an axis passing through the crown, the Virgin and Child and the lute-playing angel. The picture is designed to illustrate the idea of a universal brotherhood of Christianity: on the right, behind the Emperor, are lay figures; on the left, behind the Pope, are the clergy; the strongly characterised faces suggest that they are all portraits, although almost none of them, apart from the Pope, the Emperor, the artist, and the architect of the new Fondaco dei Tedeschi in Venice (Master-Hieronymus) and someone assumed to be Burcardus de

Burcardis (see no. 118) are identifiable. The dignitary standing next to Dürer may be Fugger, the head of the German confraternities, who was Dürer's host when he was in Venice. According to the inscription on the painting the whole work was finished in five months, but from the evidence of the extant letters it seems to have taken considerably longer. There were two German confraternities in Venice, one was a confraternity of Nuremberg merchants, the other, headed by Fugger, comprised the merchants of other German cities. The church of S. Bartolomeo near the Fondaco was administered by the Germans. The picture was installed in the second chapel on the left of the nave and remained there until the beginning of the seventeenth century.

The Confraternity of the Rosary had been founded in 1476 by the Dominican Jacob Sprenger. The painting was

only given the title *The Feast of the Rose Garlands* in the mid-nineteenth century, but there is no doubt that the theme of the painting concerns the Cult of the Rosary. F. H. A. van der Oudendijk Pieterse (*Dürers Rosenkranzfest en der Iconografie der Duites Rosenkranzgroepen van der XV en het begin der XVI eeuw*, Amsterdam, 1939) has done a detailed study of the iconography. Panofsky (1948) was interested in the symbolism which links actual roses with the beads of the rosary; he also pointed out the links between Dürer's picture and earlier *Rosenkranzbilder*, i.e. before 1500, which confirms the fairly widespread existence of the Cult of the Rosary at the end of the fifteenth century, although the Feast of the Rose Garlands itself was not officially instituted until 1573. *The Feast of the Rose Garlands* marks Dürer's total assimilation of the Renaissance. He considered Bellini to be the greatest Venetian painter, and it is Bellini's influence which transforms his art: the musical angel is a direct tribute to Bellini, as are also the Imperial mantle and the Pope's cope; but there are also recognisable echoes of Northern masters such as Stephen Lochner, Conrad Witz, the Master of Flémalle and the van Eycks. There are copies in Vienna and at Hampton Court.

116 🔲 ⊕ 91×76 / 1506 ▤ ⋮

Virgin with the Siskin
Berlin, Staatliche Museen
Inscribed, on a painted scroll in the bottom left hand corner, in Dürer's hand "Albertus durer germanus faciebat post Virginis partum 1506" followed by the artist's monogram. The Tietzes (1937) related it to Titian's *Virgin with the Cherries* (Vienna, Kunsthistorisches Museum) – Titian borrowed the figure of St John from the Dürer. Panofsky related this painting to the Bremen drawing L. 112 which was among others used as a study. The composition is a much reduced and simplified version of the

central part of the *Feast of the Rose Garlands*. There is no reference to this important work in Dürer's correspondence.

117 🔲 ⊕ 65×80 / 1506 ▤ ⋮

Christ amongst the Doctors
Lugano, Thyssen collection
Besides the monogram and date the painting bears an inscription on a piece of paper sticking out of the book in the lower left hand corner of the picture, "opus quinque dierum". It was executed during Dürer's second stay in Venice, and is identifiable with the painting mentioned by Dürer in a letter to Pirckheimer of 23 September 1506: "know that my picture [*The Feast of the Rose Garlands*] is finished, likewise another, the like of which I have never done before". The compositional concept of the picture is obviously Italianate in derivation, for example the compact grouping of the figures, and the Leonardesque doctor seen in profile to the right of Christ, but it can justifiably be described as "Gothic"; it is a partly decorative, partly symbolic scheme composed around the central motif of the four hands. According to Thausing (1876) it would have been a gift from Dürer to Giovanni Bellini, in whose possession it was when Lotto saw it. (In his *Sacra Conversazione* of 1508, Galleria Borghese, Rome, Lotto used Dürer's motif of the scribe for his St Onuphrius). One of the doctors reappears in the *Christ and the Adulterous Woman* by Palma Vecchio (Rome, Museo Capitolino). There are several drawings related to this work, for instance the studies for Christ's head and hands (in the Blasius Collection, Brunswick, and the Albertina, Vienna). Kenneth Clark has put forward the hypothesis that the painting is a copy of a lost composition by Leonardo (*Leonardo da Vinci*, 1939); J. Bialostocki defined the complex problems posed by the picture in an exemplary study in the *Journal of the Warburg and Courtauld Institute*, (Vol. 22, 1959).

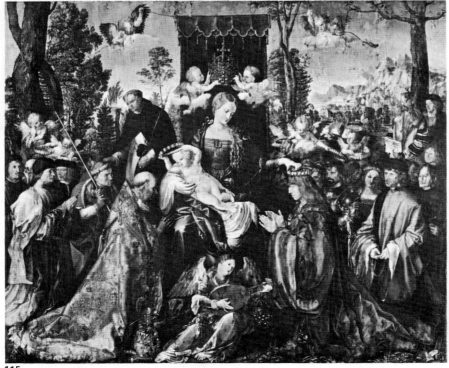

118 ▦ ⊕ 31,5×26,6 / 1506 ▤ ⦂

Portrait of a Young Man
Hampton Court, Royal Collection
Formerly in the collection of Charles I. This very striking portrait, which is dated and signed, was painted in Venice; the sitter may be Burcardus of Speyer. The identification of the unknown young man (who also appears amongst the spectators in *The Feast of the Rose Garlands*) is based on the existence of a miniature with an inscription in the Weimar Schlossmuseum, published by K.F.Suter (ZBK 1929–30). A comparison between the miniature, in which the composition has been elaborated, and which shows the figure in half length (Panofsky, 1948), suggested to the Tietzes (1937) that the Hampton Court picture was originally larger. Giovanni Bellini's influence is evident, particularly in the intentional understatement of the psychological characterisation of the sitter (Friedländer, 1919).

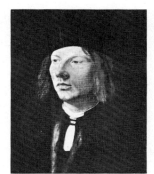

118

119 ▦ ⊕ 47×35 / 1506 ▤ ⦂

Portrait of a Young Man
Genoa, Palazzo Rosso
Besides the monogram and date (1506), the painting bears the inscription "Albert Dürer germanus faciebat post virginis partum". F. Filippini (BA 1929) has identified this with the picture of an Italian which Dürer mentioned in his Netherlandish Diary, for which he was paid two florins. The authenticity of this painting has never been seriously questioned, although some qualified doubts have been expressed on account of the ruinous state of preservation; these doubts have been dispelled since the painting has been cleaned.

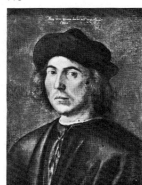

119

120 ▦ ⊕ 28,5×21,5 / 1506-07 ▤ ⦂

Portrait of a Woman
Berlin, Staatliche Museen
Painted in Venice. The monogram at the top is not by Dürer. The letters A D also appear in the embroidered trimming of the dress. Although the sitter bears no resemblance to Agnes Frey (Dürer) she has usually been identified as Dürer's wife – this would account for the initials on the braid; but as the initials ES are also clearly visible in the decorative pattern on the braid, the identification

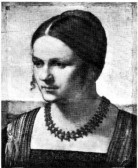

120 (plate XXXIX)

cannot be certain. Panofsky has criticised the recent restoration of the work: the background is uncharacteristically tonal, the light is too diffuse, and the pale blues of the sky seem particularly suspect. It may be, of course, that Dürer's approach to modelling had become more tonal, with the assimilation of Venetian influences, and that he had realised that light could be used independently of structure and diffused throughout the painting. This is undoubtedly a masterpiece, but it is also an exception to the general tenor of his work.

121 ▦ ⊕ 47,8×36 / *1507 ▤ ⦂

Virgin and Child
Bagnacavallo, Monastero delle Cappuccine
Discovered by Longhi, who published it in 1961 (PA no. 139). The painting has been in the monastery since it was founded in 1774, but nothing is known of its previous history, although a mediocre neo-classical copy of it is known (possibly made to preserve the original from the Napoleonic lootings) and there is an engraving of it by Marabini with the title *Madonna del Patrocinio*. The picture was undoubtedly painted during the second stay in Italy. Longhi has pointed out that the influence of Bellini and Antonello has become very pronounced and that there are also echoes of Montagna in this work, although Northern motifs such as the coif covering the Virgin's forehead, the sloping shoulders, the asymmetrically arranged hair, and the shallow enclosing space are still very much in evidence. Longhi favoured Bologna as the probable place of execution rather than Vicenza or Venice. Dürer visited these towns evidently with the intention of meeting Jacopo de'Barbari and learning the secrets of perspective from him; if the picture was painted in Bologna, it would have been the last picture painted in Italy. It is in an excellent state of preservation, but appears to have been cut slightly down the sides.

122 ▦ ⊕ — *1507 ▤ ⦂

Virgin and Child (Alpine Madonna)
Together with the Bagnacavallo picture Longhi (PA 1961) indicated another *Virgin and Child* of 1505–7, which has been dubbed the "Madonna of the Alps", because of the landscape background. The painting appeared in the trade unpublished. The stylistic references suggested by the painting are numerous, and it would be impossible to make a definitive identification of the locality as there are no identifiable topographical references in the picture.

123 ▦ ⊕ 209×81 / 1507 ▤ ⦂

A. Adam
Madrid, Prado
Painted, together with the Prado

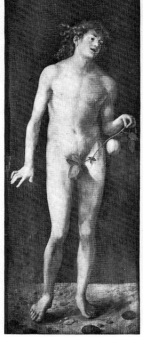

123 A (plates XLI A–XLII)

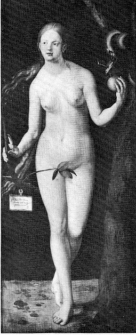

123 B (plates XLI B and XLIII)

Eve (no. 123 B), on Dürer's return from his second visit to Italy. Although the two paintings would fit together almost perfectly, they were unquestionably painted as separate pictures, as both contemporary copies and the separate signatures indicate. Dürer has used the theme as an excuse to paint two nude figures. *Adam* is signed with Dürer's customary monogram, in the lower right hand corner of the picture, whereas *Eve* has an inscription on a card hanging from the apple branch which she carries in her right hand, "Albertus Dürer almanus/ faciebat post virginis/partum 1507 A.D.". She is shown accepting the forbidden fruit from the serpent.

The two paintings belonged to Queen Christina of Sweden who gave them to Philip IV.

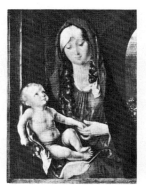

121

the proportions attenuated. The figures in the engraving are classical in their calm composure whilst those in the paintings seem to be caught in the movement of a dance and are infinitely more alluring as images of the nude figure. Panofsky considered the painted figures to be more "Gothic" than those in the engraving. He stated that "Gothic taste preferred soft, lyrical moods to the hard, dramatic (or 'epic' ones), and generally tends to 'feminise' the beauty of the male while the opposite is true of classical and clasicistic art". Another feature distinguishes the paintings from the engraving: the print is endowed with symbolism which is quite absent from the paintings: Adam is shown clinging to the rowan tree (the tree of life and wisdom) on the left, and the apple tree

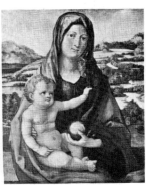

122

(symbol of love) is between the two figures; in the rowan tree is a parrot representing wisdom and charity, whilst in the apple tree is the serpent, i.e. the devil. The charged relationship between the two figures is echoed by other motifs like the mouse crouching between Adam's feet and the cat at Eve's feet which is tensing itself for the kill. Panofsky (1948) cited an extract from Marziano Cappella's edition of *De nuptiis Mercurii et Philologiae* by the Bohemian humanist Johannes Dubravius (published in Vienna in 1516) containing a description of a painting of Adam and Eve

of Spain. The two paintings represent the first life-size nudes in the history of German painting. In them Dürer returned to a theme which is fundamental throughout his career, that of the human figure. He had already treated it in a monumental fashion in the engraving B 1, *The Fall of Man (Adam and Eve)* of 1504 (see p. 117), but whereas the canon of measurement in the engraving is eight heads, here it is nine, and whereas in the former the contours of the figures are sharply and firmly defined, the anatomical articulation precise, and the poses statuesque, here the contours are continuous,

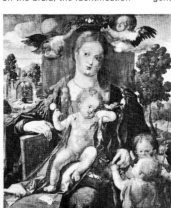

116 (plates XXXVII–XXXVIII)

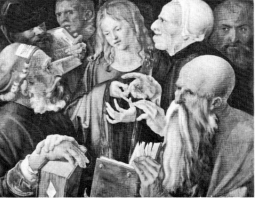

117 (plates XXXIII–XXXVI)

124 A

124 B

(bought for 120 ducats by the Bishop of Bratislava, Johannes Thurzo, to whom Dürer also sold the *Virgin with the Iris*, (no. 128)), which so exactly fits the Prado pictures that one would be tempted to say that they are identical, were it not for the fact that the tree is described as "in the middle", and it is unlikely that a commentator as perspicacious as Dubravius would have been mistaken on such a point. In the contemporary copies of both paintings (panel; Uffizi, Florence, 212 × 85) which have been attributed both to Dürer's workshop and to Hans Baldung Grien (to whom Frizzoni also ascribed the Prado originals) the animals reappear, but are not the same as those in the engraving. There is also another contemporary version, with variations, in the Altertums museum at Mainz.

123 ⊞ ✇ 209×83 1507 ▤

B. Eve
Madrid, Prado
For all details, see note to 123 A.

124 ⊞ ✇ 35×29 1507 ▤

A. Portrait of a Young Man
Vienna, Kunsthistorisches Museum
Monogram and date. Listed in the inventory of the Imperial Kunstkammer of 1619 (no. 82). The Tietzes (1937) thought that the sitter was probably a German merchant in Venice. Painted on both sides.

B. Avarice
The image has been interpreted as Dürer's revenge on the patron (his name is not known) who refused to accept the painting at the stipulated price. It is obviously inspired by Giorgione's *Portrait of an Old Woman* (Venice, Accademia) as Tietze (1937), Morassi (*Giorgione*, 1942) and Richter (AA 1942) have all observed; this would confirm the hypothesis that the picture was painted in Venice (see 124 A).

125 ⊞ ✇ 30×20 1507 ▤

Portrait of a Young Girl/Boy
Berlin, Staatliche Museen
Oil on vellum, stuck on wood.
Monogram and date (1507). Probably painted in Venice, although Dürer took it back to Germany with him as it is listed in the Imhofschen inventory of 1573. Apart from the *Self-portrait* of 1500 (no. 59) this is the only full face portrait by Dürer; it does not appear to have been painted on commission (particularly in view of the ground) but seems rather to have been painted as a personal gift, or as a memento for Dürer himself. The sitter was originally taken to be a girl, but more recent writers have interpreted it as a young boy and Panofsky (1948), with some justification, connected it with the model for *Christ amongst the Doctors* (no. 117). An extract from a letter from Canon Lorenz Beheim of Bamberg (a friend of both Dürer and Pirckheimer) which alludes to Dürer's susceptibility to handsome young men has been invoked as confirmation of the identification of the sitter as a boy. There is no reason, of course, why a girl should not have modelled for both this picture and for the figure of the twelve-year-old Christ, and the eyes, mouth, rounded countours of both neck and shoulders, and the play of light across the bare bosom suggest that this is in fact a girl.

126 ⊞ ✇ 40×32 ▤

Portrait of a Man
Washington, National Gallery, Mellon Collection
Acquired by the Mellon Collection in 1937. Published by Winkler as an authentic Dürer (*Dürer*, 1928). More recent historians have accepted Buchner's opinion (*Festschrift für M.J.Friedländer*, 1927) that this is by Hans Schäufelein. Monogram and date obviously fake.

127 ⊞ ✇ 45,1×35 ▤

Portrait of a Woman
New York, Metropolitan Museum of Art
Tempera and Oil. Formerly in the Bache collection, New York. It became the focus of a violent controversy when A.L. Mayer (P 1929) published it as a work by Dürer of 1506 (the painting actually bears a monogram and 1506 date, both fake) Tietze (WJK 1930–2) immediately rejected it; Friedländer (AA 1934–5) thought it was a Dürer; Panofsky (1948) considered it as an obvious forgery of a North Italian painting, and the Tietzes (1938) came round to the view that it was a fake. In the Museum catalogue of 1947 it is listed as a Dürer.

128 ⊞ ✇ 149×117 1508? ▤

Virgin and Child (Virgin with the Iris)

London, National Gallery
The monogram is not authentic, and X-rays have shown that the 1508 date was added later, as also the Virgin's veil. The painting was acquired by the National Gallery in 1945 and has a history of controversial attributions. Thausing (1876), on the evidence of the replica which was in the Prague Rudolphinum (exhibited as a

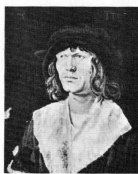

125

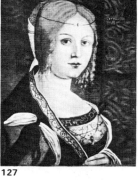

126

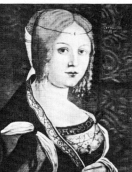

127

Dürer in the Nuremberg exhibition of 1928), considered it to be identical with the "Maria-bild" offered by Dürer to Jacob Heller in 1508, first for fifty, then thirty, and finally twenty-five florins. In fact the "Maria-bild" which Heller saw in Dürer's Nuremberg workshop in the summer of 1507 was subsequently sold for 72 florins to Johannes Thurzo, Bishop of Breslau. Friedländer (*Repertorium für Kunstwissenschaft*, 1906) thought that it was by an imitator, and Glück (JKS 1909–10) put forward the hypothesis that this was a work of the so-called Dürer "revival" which took place at the Court of Rudolph II at the end of the sixteenth and the beginning of the seventeenth centuries.

The painting has also been considered as the result of collaboration between Dürer and his pupils. C.Dodgson (*The Dürer Society*, 1902), C. Phillips (*Daily Telegraph*, 26 February 1902, and 14 June 1906) and C.Rickets (BM 1906) all followed up this hypothesis, and identified Baldung's hand; Flechsig (1928) and the Tietzes (1937) accepted this identification. Dodgson restated his thesis (BM 1948), and it was taken up by Panofsky (1948), although with some qualifications, insofar as he was able to relate details to specific drawings by Dürer, as for instance L. 637 of 1503, for the iris, the woodcut B. 99 of 1504–5 for the general composition, and the drawing L. 525 of 1512 – the Albertina *Virgin and Child* – for the Child.

Winkler (1957) supported Glück's thesis that the picture was the work of an unidentified painter, based on Dürer drawings and motifs. In his very informative entry to the National Gallery Catalogue of 1959, Michael Levey rejected the painting on the grounds that he was unable to assign it to a convincing date because it contains Dürerian motifs from different periods. Levey accepted that the work was from Dürer's workshop and suggested that, from the first, it was never intended to be passed off as an original work by the master. There is no certain reference to this paint-

ing in Dürer's own writing or in that of his contemporaries, and an identification of it with the "Mariabild" can only be speculative. The provenance has not been traced further back than 1821 in Nuremberg (Heller, *Das Leben und die Werke Albrecht Dürers*, 1827); it passed to the Felsenberg Collection in Vienna and then came to England.

There are two variations on the painting. The one already mentioned, in the Národni Galerie in Prague, is almost identical in size (panel 149 × 120) and may have come from the workshop (the Tietzes considered it as a copy of the London Picture). A second version is in the Benedictine Monastery at Wilhering in Austria. Neither of these variations has a monogram or date, which suggests that Levey's thesis is correct.

129 ⊞ ✇ 99×87 1508 ▤

Martyrdom of the Ten Thousand
Vienna, Kunsthistorisches Museum
Oils on wood, transferred to canvas. Besides a monogram in the centre of the composition there is an inscription, to the right of the self-portrait of the artist, resplendent in his French cloak bought in Venice, "Iste fatiebat año domini 1508/ alberto Dürer aleman". Dürer's companion may be identifiable as the humanist Conrad Celtes (but this identification, which Panofsky (AB 1942) accepted, has been dismissed by Gümbel). The painting was ordered by Frederick the Wise for 280 florins; later it passed to the Granvelle collection, and in 1600 to Rudolph II. There is a precedent for the subject in Dürer's woodcut of the same theme, B. 117, executed almost exactly ten years earlier. There is also a preparatory drawing dated 1507 (24.4 × 42.8) in the Albertina, in which the composition is still horizontal and Dürer's companion is not shown. The theme is the martyrdom of the 10,000 Christians of Bithynia in 343 by command of Sapor, King of Persia, following Diocletian's

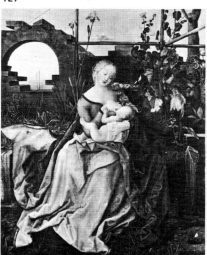

128

129 (plate XLIV)

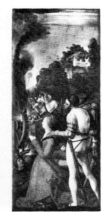

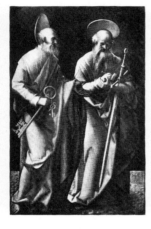

130

edict. Compared with the engraving, the painting has been expanded and modified. The horrifying torture of Bishop Acabius has been suppressed — in the woodcut he is shown having his eyes gouged out — and is replaced by the cruci- . . fixion, in the left hand corner, of the two thieves; the thieves are shown already hanging on rough-hewn crosses whilst Christ's cross, made of planks, lies on the ground between them and Christ himself stands erect amidst his tormentors and the martyrs. The woodcut is used as the basis for the painting, but expanded in both volume and perspective to make one of Dürer's richest and most complex compositions. The picture was engraved (Tull, 1521) to demonstrate the relationship between solid objects and surrounding space. The Tietzes (1937) pointed out a drawing of the painting in Copenhagen. A copy by J.C. Ruprecht of 1643 is mentioned in the Kunsthistorisches Museum catalogue (1963).

The Heller Altarpiece

130 ⊞ ✪ ———— 1507-09 ▤ :

The painting was probably commissioned by Jacob Heller, a rich Frankfurt merchant, as early as 1503, for the Dominican church in Frankfurt. However, it was not begun until 1507 and was finished only in

1509. Dürer originally agreed to paint the altarpiece for the sum of 130 florins, but later attempted to break the contract; he obtained a further 70 florins from Heller, plus 10 florins as a gratuity to his brother, and a present for his wife, but was still not satisfied. He described the work as "painstaking drudgery". About twenty detailed studies exist for the centre panel alone; Heller preserved Dürer's nine letters. These letters now exist in seventeenth-century copies. The polyptych now belongs to the Frankfurt Städtisches Museum. The structure consists of a central panel (now destroyed, but there is a copy) representing the *Coronation of the Virgin* (or possibly an *Assumption of the Virgin*) and two side wings which are painted on both sides: on the insides are the portraits of *Jakob Heller* and his wife *Katharina von Melen* (each 42 × 56) and their respective patron saints, *St James* and *St Catherine of Alexandria* (each 141 × 60); on the outsides, painted in grisaille, are the *Two of the Three Magi* (96.3 × 60) and below two pairs of saints, *St Peter and St Paul* (96 × 60) and *St Thomas Aquinas and St Christopher* (965 × 60). Originally the portraits of the donors each formed a single panel with their respective saints. Sandrart has argued very persuasively that the structure of the whole originally comprised two more wings depicting

St Elizabeth, St Lucy (?), St Lawrence and St Cyriacus, added by Grünewald (the first two have been lost, but the other two are also in Frankfurt). From Dürer's correspondence with Heller we learn that he entrusted the wings to his assistants. Weizsäcker (*Die Kunstschätze des ehemaligen Dominikanerklosters in Frankfurt,* 1923) suggested Dürer's brother Hans as the major contributor to the lateral panels (Tietze, 1937). One of the wings, the left half of the *Adoration of the Magi,* has been lost; *St Peter and St Paul* and *St Thomas Aquinas and St Christopher,* which are also in monochrome, have generally been accepted as shop work, possibly by Hans Dürer. Only the central element was by Dürer himself, and the Dominicans sold it in 1615 to Maximilian I, Elector of Bavaria. In 1729 it was destoyed by fire. A fairly good and presumably accurate copy (panel 185 × 134) which was executed at about the time the original was sold to Maximilian shows the composition of the original (see E. Staedel, 1935, for a detailed study of the iconography). Compositionally the painting divides into two halves, heaven and earth; according to Panofsky (1948) it is related to three iconographical types, as follows: a) to a version of the Assumption of the Virgin (e.g. the Master of the Imhof Altarpiece); b) to fifteenth-century formulae (e.g. Bouts); and c)

to Italian Renaissance models (such as Raphael's *Coronation of the Virgin*). The Italian references are the most evident. In the lower foreground, the apostles are grouped in a concave semi-circle around the empty tomb, complementing the convex group of figures around the Virgin and the Trinity in the upper half of the picture. The convex curve of the upper group and the concave curve of the lower group are perfectly balanced. In the middle distance Dürer depicts himself, elegantly attired, holding an inscribed scroll. Panofsky has related the drawing L. 354 (Bayonne, Musée Bonnat) and several drawings in the Albertina (some of which are dated 1508 and others undated but presumably coeval with the dated ones) and some in Berlin, to the *Coronation* group. He also indicated the large watercolour drawing of the *Assumption and Coronation of the Virgin* (London, British Museum) as the first conception of the subject of the Heller altarpiece. There are no extant drawings for the lateral panels. The whole composition was copied in a smaller portable altarpiece (formerly in the Heller Collection, which F. von Valckenburg (Meder, JK 1902) ascribed to Dürer; Panofsky, on the other hand, thought the authenticity of this work questionable.

131 ⊞ ✪ 31×38 1509? ▤ :

Holy Family

Rotterdam, Boymans–van Beuningen Museum
(Heads only)
Bears a monogram and inscription (both suspect) in Roman lettering "ALBERTVS DVRER NORENBERGENSIS FACIEBAT POST VIRGINIS PARTVM 1509".
The Tietzes (1938) drew attention to the pastiche quality of the picture: it draws on Dürerian (e.g. the head of the Virgin) and Bellinesque

(e.g. the heads of the Child and St Joseph) motifs. The only work by Dürer that can be related to this work is a drawing, which may not be authentic, in the Musée de Peinture, Grenoble.

132 ⊞ ✪ 21,6×31,4 *1511* ▤ ○○

View of Kalchreut

Formerly Bremen, Kunsthalle (For present location see no. 2) Watercolour and gouache. Inscribed "Kalk rewt" in Dürer's writing, with a monogram which, according to Flechsig (1928), is not original. It is an exquisitely painted view of a village to the north east of Nuremberg, seen on a summer day from the top of a small castle nearby, which belonged to Wilhelm Haller in 1511. The dating has been a controversial issue: Panofsky (1948) suggested a date of around 1500, but the summary treatment of the landscape and the way in which the unity between the foreground planes and those in depth is established would suggest the later date (1511) favoured by the Tietzes (1937) and A.M. Cetto (1954). The motif of the two peasants resting in the shade after hop gathering is unusual.

133 ⊞ ✪ 10,5×31,6 *1511* ▤ :

Valley near Kalchreut

Berlin, Kupferstichkabinett
Watercolour and gouache.
According to Bock (*Zeichnungen Deutscher Meister in Kupferstichkabinett zu Berlin,* 1921) the monogram is of dubious authenticity. Evidently made at the same time as no. 132, from a lower viewpoint, so that only the tips of the

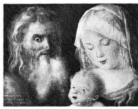

131

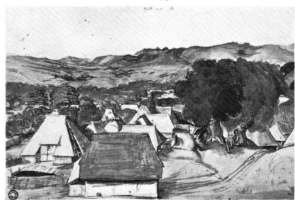

132 (plate XLVII)

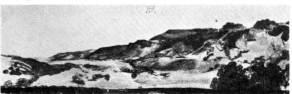

133

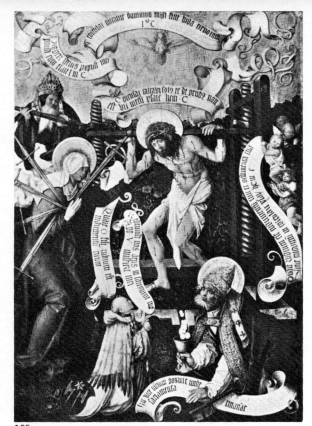

135

Franconian Juras appear. Dated 1514 according to the Tietzes (1937).

134 ▦ ⊕ 135 × 123,4 / 1511 ▤ ⦂

Adoration of the Trinity (All Saints)
Vienna, Kunsthistorisches Museum

In the bottom right hand corner of the painting, next to Dürer's self-portrait is the inscription "ALBERTVS. DVRER/ NORICVS. FACIE/BAT. ANNO. A. VIR/GINIS PARTV./1511" and a monogram. The altarpiece, which was originally enclosed in an elaborately carved frame (now in Nuremberg, Germanisches Museum – the Vienna frame is a modern copy), was commissioned by Matheus Landauer, a rich merchant, for the Allerheiligen Kapelle in the Zwölfbrüderhaus. The chapel was dedicated to the Trinity and All Saints, which determined the theme of the painting. God the Father, robed in Imperial garments, supports the Cross with the crucified Christ; above Him hovers a dove (see the drawing L. 783); to either side and below is a throng of people (divided into groups) all adoring this "Throne of Mercy". The painting divides into two zones: in the upper zone, the Virgin Mary, on God's right hand, leads the Holy Martyrs, and on His left St John the Baptist leads the prophets, prophetesses and sibyls; in the lower zone are the faithful – on the left the ecclesiastics led by two Popes, and on the right lay figures of all ranks headed by a King and an Emperor, with several prominent Nuremberg figures (including members of the Heller and Landauer families). See L. 75. The narrow strip of landscape below the celestial vision is devoid of figures or objects, with the exception of

the solitary figure of the artist, who supports a large tablet with an inscription. Pappenheim (ZDVK 1936) identified the landscape as Lake Garda.

The iconography of this composition is very complex and elaborate: it is based on the Augustinian doctrine according to which the City of God, founded by Abel, and governed by Christ, exists partly in heaven and partly on earth, overlapping with the *terrena civitas*, founded by Cain and ruled by the Devil,

thus creating a confusion which will end only after the Last Judgement with the coming of the true and only Kingdom of God. Here Dürer makes the connection between the theme in the picture and the idea of the Last Judgement quite specific: the frame is conceived as integral part of the representation, it is a door (i.e. the Gate of Heaven) into which the Last Judgement itself has been inserted. This is unquestionably one of Dürer's most profound and inspired works; it is also the most complete expression we have of his assimilation of the Renaissance at both an intellectual and a pictorial level.

The sketch for the altarpiece, now in the Musée Condé in Chantilly (L. 334, pen and watercolour 39.1 × 26.3), was prepared by 1508 (probably the one attached to the contract between Dürer and his patron). It shows the composition enclosed in a frame which is more or less followed in the final version. There is one important difference between the sketch and the finished work: the centrepiece, originally conceived as a rectangular area, has a curved top in the final work perhaps to link it more subtly with the frame. There may have been a gap of several years between the execution of the sketch and the painting, since the project was probably put aside whilst Dürer fulfilled his commitments to Jacob Heller, and the inscription on the frame indicates that the installation of the painting marked the completion of Landauer's chapel: "Matheus Landauer hat entlich volbract das gotteshaus der tzwelf

bruder samt der stiftung und dieser thafell nach xpi gepurd MCCCCCXI Ior" (Matheus Landauer completed the chapel of the twelve brothers together with the asylum and this picture, after the birth of Christ, 1511 years.)

There is a fragment of a cartoon (Boston, Museum of Fine Arts, pen and watercolour, 31.8 × 41.8) of the *Fall of the Rebel Angels*, for a stained glass window in the chapel. Campbell Dodgson (*Old Master Drawings*, 1930–1) identifies this as an authentic Dürer. It is closely connected with the drawing L. 245 (London, British Museum) and was probably executed by Veit Hirsvogel or Hans von Kulmbach following a Dürer design.

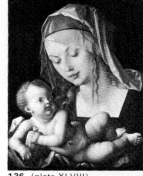

136 (plate XLVIII)

135 ▦ ⊕ 175 × 121 ◻ ⦂

Christ in the Winepress
Ansbach, Gumbertuskirche

The picture fits a description found amongst Dürer's papers in the British Museum (published in facsimile by the Dürer Society in 1911), and corresponds with an authentic drawing in Berlin (Kupferstichkabinett), L. 28, except that in the painting the composition has been reversed and a St Peter with keys has replaced the beardless Pope of the drawing. In the painting Christ is shown inside the winepress, with the Mater Dolorosa and God the Father on one side, surrounded by angels with enormous unrolled Gothic scrolls; the blood of Christ's wounds, transformed into Hosts, is collected in a chalice by St Peter; in the foreground is the

137

138

Donor, Deacon Mathias von Gulpen, adoring the Virgin. As von Gulpen died in 1475 and the composition is decidedly archaic, scholars have assumed that the painting was based on an earlier original (Panofsky); however, although Dürer made a preliminary drawing, the painting was executed by someone else. (The unknown painter of this panel was probably also the author of the Cleveland Museum of Fine Arts *Adoration of the Shepherds* which was formerly attributed to Dürer. See C. H. Kuhn, *A Catalogue of German Paintings . . .*, 1936, 206).

136 ▦ ⊕ 49 × 37 / 1512 ▤ ⦂

Virgin and Child (Virgin with the Pear)
Vienna, Kunsthistorisches Museum

Monogram and date (1512). According to Panofsky (1948) the lower part of the Child's body is related to a drawing of 1506 (L. 332) in the Bibliothèque Nationale, Paris. The Tietzes discerned the influence of Verrocchio in the picture. Friedländer (1921) and Winkler (1929) both related the figure of the Virgin to the same figure in the *Holy Family* of 1509 (no. 131). Several copies of this painting were made during the Baroque period.

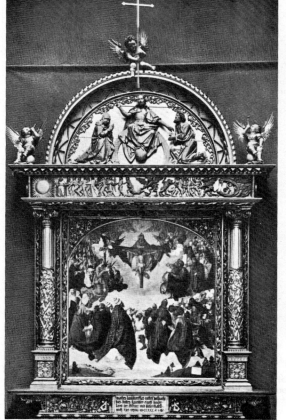

(Top) General sketch for no. 134 (1508: Chantilly, Musée Condé). (Bottom) Drawing of angels fighting (Boston, Museum of Fine Arts) for the window with the Fall of the Rebel Angels (see no. 134).

135 (plates XLV–XLVI)

137 ⊞ ⊗ 28×20 1512 ▤:
Dead Blue Roller
Vienna, Albertina
Watercolour and gouache on vellum, heightened with gold. Possibly inspired by a painting by Jacopo de'Barbari. Monogram and date (1512). Tietze (1938) and Panofsky (1948) both questioned the authenticity of this drawing. There is a copy in the Béhague collection in Paris, together with a *pendant* drawing of a similar bird seen from the back. Panofsky suggested that the latter was a free copy executed to match this copy, but this view is not altogether acceptable, as the backs of the birds appear to have different plumage and the colours on their breasts are different, so the latter drawing may also be a copy of a lost original (see no. 139).

138 ⊞ ⊗ 19,7×20 □:
Wing of a Blue Roller
Vienna, Albertina
Same technique and ground as no. 137, and obviously related in character to the above work.

139 ⊞ ⊗ *28×20* (?) □:
Small Dead Bird, Seen from the Back
The possible existence of such a drawing (probably watercolour and gouache on vellum, with gold) is suggested by the copy in the Béhague collection.

140 ⊞ ⊗ 190×89 1512-13? □:
The Emperor Charlemagne
Nuremberg, Germanisches Nationalmuseum
This painting, which was commissioned together with a companion piece of the Emperor Sigismund (no. 141), was probably intended to hang in the Heiltumskammer (Standards room) in the Schopperhaus on the Market Square in Nuremberg, where the Imperial insignia were kept at night during the *Heiltumfest* (Festival of the Standards). The Imperial insignia, carried for the first time by Charlemagne, were entrusted to the City of Nuremberg by the Emperor Sigismund in 1424. A preparatory sketch of c. 1510 (L. 785), formerly in the Lubomirski Museum in Lemberg, indicates the terminating date *ante quem non* for the commission. There are also other drawings for the project and evidence of Dürer's icono-

140

141

Preliminary drawing for paintings nos. 140 and 141 (1510; formerly in Lemberg, Lubomirski Museum).

graphical researches on the effigies. Dürer received 85 florins for the work, but did not see fit to add either the date or his monogram. Both pictures have bombastic inscriptions painted on the frames.
 A partial copy exists of the *Sigismund* picture (in the stores of the Kunsthistorisches Museum, Vienna), and together with the *pendant Charlemagne* (in trade), both spuriously dated 1514, was published by Isarlo (LA 1947) as an authentic work done from the life.

141 ⊞ ⊗ 189×90 1512-13? □:
The Emperor Sigismund
Nuremberg, Germanisches Nationalmuseum

142

143

Pendant to no. 140 (see notes above for all details).

142 ⊞ ⊗ 32×25 1514? ▤:
St Jerome
Siena, Pinacoteca Nazionale
Monogram in top right hand corner; the date 1513 was formerly visible (Tietze, 1938). Thausing (1884) questioned its authenticity, as did the Tietzes and Panofsky (1948). Brandi, however (Catalogue, 1931), attributed it to Dürer, pointing out that the attribution, based on the monogram (the only part of the inscription still visible) went back to 1852. In 1931 Brandi and Futterer transcribed the inscription on the left of the painting, "Sanctus Hieronimus ora pro nobis" and on the right, "Albertus Dürer Nurbergensis faciebat post Virginis partum 1514". The picture is finely painted, comparable technically to the Uffizi *Apostles* (nos. 144 and 145) which are dated 1516 and there seems to be no reason to question the authenticity.

143 ⊞ ⊗ 19,5×17,5 1514? ▤:
Salvator Mundi
Formerly Bremen, Kunsthalle
Of questionable authenticity according to the Tietzes (1938)

and Panofsky 1948); according to the latter only the obviously spurious monogram and date account for the attribution to Dürer. The Tietzes, however, considered that a painting by Dürer himself of this same subject, also dated 1514, may have existed, as the numerous known replicas of the theme suggest. The picture may have been cut down along the bottom edge, and is in an extremely poor state of preservation (also, heavily restored). Friedländer (1921) dated it c. 1503. Flechsig (1928) accepted it as an authentic work and dated it c. 1514.

144 ⊞ ⊗ 45×38 1516 ▤:
St Philip
Florence, Uffizi
Inscribed "Sancte Philippe ora pro nobis 1516", together with the monogram. A *pendant* to no. 145. These are both very striking images, painted with considerable detail. They belong to Dürer's fully mature period. According to Baldinucci (*Notizie . . . III*, 1728) they were given by the Emperor Ferdinand II to the Grand Duke of Tuscany on his visit to Vienna in 1620. Meder (JKS 1902) indicated a *Head of an Old Man* (St Peter?) in a private collection as a possible companion piece to these two paintings, but Panofsky (1948) rejected this hypothesis on the ground that this painting is in oil, whereas nos. 144 and 145 are in tempera; probably a free copy of the *St Philip*.

145 ⊞ ⊗ 46×37 1516 ▤:
St James
Florence, Uffizi
Pendant to no. 144 (see note above). Inscribed "Sancte Jacobe ora pro nobis 1516", together with monogram.

146 ⊞ ⊗ 32×29 1516 ▤:
Virgin and Child (Virgin with the Pink)
Munich, Alte Pinakothek
Vellum, mounted on wood. Monogram and date (1516) in a cartridge at the top. The painting belonged to the Elector of Bavaria in 1530. The iconography is unusual because the Child is shown clasping a pear in his hands and ignores the carnation preferred to him by the Virgin. K. Martin (1963) pointed out that the Virgin's halo is painted in the same manner as that of the 1516 *Virgin* (New York, Metropolitan Museum, no. 149) which is of questionable authenticity. According to L. Justi (*Konstruierte Figuren und Köpfe unter den Werken Albrecht Dürers*, 1902) the Virgin's head is constructed on Vitruvian principles.

147 ⊞ ⊗ 29×27 1516 ▤:
Portrait of Michael Wolgemut
Nuremberg, Germanisches Nationalmuseum
Dürer evidently added the

second part of the inscription in the top right hand corner in 1519 immediately he heard the news of his former master's death. It reads, "Das hat Albrecht Dürer abconterfet noch seine lermeister michel wolgemut im Jor 1516 und er was 82 jor und hat gelebt pis das man zelet 1519 jor do ist er verschieden an sant endres dag fru ee dy sun awff gyng" ("Albrecht Dürer made this likeness of his master Michel Wolgemut in 1516 and he was 82 years old and lived until 1519 and passed away on St Andrew's day before the sun went down"). This is one of Dürer's most moving portraits. Thausing (1884) and others have regarded it as a copy. The inscription has long been a source of controversy: Voll (*Allgemeine Zeitung*, 1897) pronounced that both parts were by the

144

145

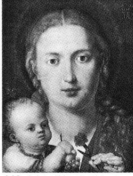

146 (plate IL)

147

148

150

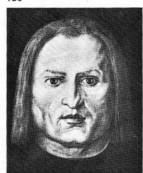

151

same hand but not authentic.
Flechsig (1928) inferred the
existence of a *pendant* portrait
of Wolgemut's wife. There is
a mediocre copy of this
picture in Rome (E 1947).

148 ⊞ ⊗ ⁴¹,⁵×³³ ₁₅₁₆ 🗐 ⋮

Portrait of a Clergyman
Washington, National Gallery
(Kress Collection)
Vellum mounted on wood.
Monogram and date. Flechsig
followed the traditional identi-
fication of the sitter as Johannes
Dorsch, parson of the church
of St John in Nuremberg,
although there is no docu-
mentary evidence to support it.

149 ⊞ ⊗ ²⁹,⁷×²⁰,⁵ ₁₅₁₆? 🗐 ⋮

**Virgin Seated with the
Child on Her Lap
(Virgin in Half Length)**
New York, Metropolitan
Museum of Art
Indicated as an authentic work
in the catalogue (1924).
The attribution, long controver-
sial, was rejected by the Tietzes
(1938) and Panofsky (1948).
The painting bears a mono-
gram and date (1516) and
recent cleaning has revealed
an elaborate inscription which
has caused ever greater doubts
as to the authenticity of the

work. There is a replica in a
private collection (indicated by
Frimmel, *Blätter für Gemälde-
kunde*, 1906), thus adding
weight to the hypothesis that
the original of this painting
has been lost.

150 ⊞ ⊗ ³⁹,⁵×³²,⁵ 🗐 ⋮

Portrait of a Man
Berlin, Staatliche Museen
Indicated as a Dürer by Buchner
(WRJ 1930) who ascribed it
to the second decade of the
sixteenth century. The Tietzes
(1938) rejected the attribution
to Dürer, as did Panofsky
(1948).

151 ⊞ ⊗ ²⁶×²¹ ₁₅₁₆₋₂₀? ▢ ⋮

Head of a Man
New York, Hickox Collection
Vellum mounted on wood.
Formerly in the von Nemes
collection in Munich. The
Tietzes (1937) considered it
authentic; of questionable
authenticity according to
Panofsky (1948), particularly
in view of the repainted areas.
Dodgson (1926) related it to
the drawing L. 270 (London,
British Museum) of 1520; the
Tietzes ascribed it to a slightly
earlier date, c. 1516, and
Panofsky accepted a date of
between 1516–20, if genuine,

152 ⊞ ⊗ ¹⁶⁸×⁷⁴,⁸ ₁₅₁₈ 🗐 ⋮

Lucretia
Munich, Alte Pinakothek
Formerly in the *Kunstkammer*
of the Grand Duke of Munich.

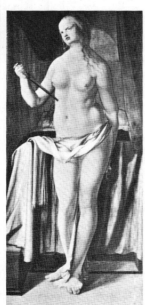

152

153

The loin cloth which is draped
around the figure standing at
the foot of a bed was enlarged
presumably around 1600. There
are two known preparatory
drawings (Vienna, Albertina)
L. 516 and L. 515. Suida
(*Leonardo und sein Kreis*,
1929) connected the drawing
with Leonardo's *Leda*, which
Dürer would certainly have
known. Waagen dated the
painting 1508; the Tietzes
(1937), as also Panofsky,
thought that it was begun in
1508 soon after the drawings,
but only resumed and com-
pleted some ten years later,
in 1518. According to
Winkler (1937) the whole
painting belongs to 1518. W.
Stechow (*Beiträge für Georg
Swarzenski zum 11 Januar
1951*, 1951) analysed the
connections between the figure
and Florentine and Roman
examples of this type.

153 ⊞ ⊗ ⁵³×⁴³ ₁₅₁₈ 🗐 ⋮

Virgin in Prayer
Berlin, Staatliche Museen
Acquired from the Morosini-
Gattemburg sale (Venice,
1894). See no. 154 for a pos-
sible *pendant*. There is a
reasonably faithful copy dating
from the end of the sixteenth or
the beginning of the seven-
teenth century in the
Accademia, Venice.

154 ⊞ ⊗ ⁵³×⁴³ (?) ₁₅₁₈* ? 🗐 ⋮

The Redeemer
New York, Private Collection
Panofsky published a painting
with this subject (BM 1947)
which had obviously been
repainted at least twice and cut
down to 48 × 39 cms. from the
presumed original size (indi-
cated above) and never
completed, although its present
appearance was established
c. 1600. He considered it as
a *pendant* to no. 153, con-
ceived and begun in 1518.

155 ⊞ ⊗ ⁴⁹×⁴⁰ 🗐 ⋮

Virgin and Child
Berlin, Staatliche Museen
In spite of the monogram and
date (1518) inscribed in gold,
this is evidently not an authen-
tic work, but a copy of a lost
original or an imitation. The
first hypothesis, favoured on
account of the fact that the
fake date is stylistically
appropriate, was accepted
by Posse in the Catalogue
of 1928. The Tietzes
(1938) compared the facial
characteristics with the Munich
Virgin and Child (no. 146) and
the Florence *Virgin and Child*
(no. 182).

156 ⊞ ⊗ ⁶⁰×⁴⁹,⁹ ₁₅₁₉ 🗐 ⋮

**Virgin and Child with
St Anne ("Anna Selbdritt")**
New York, Metropolitan
Museum of Art
Tempera and oil, transferred to
canvas from original panel. This
famous painting was originally
in Gabriel Tucher's collection
in Nuremberg, and was acquired
by Maximilian I, Elector of
Bavaria via the Nuremberg art

149

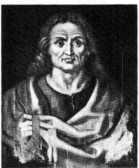

154

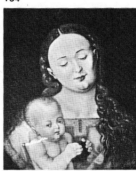

155

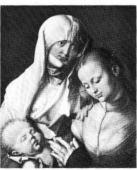

156 (plates LI–LIII)

dealer Rösslen, in 1630; sub-
sequently the painting was at
Schleissheim for more than two
hundred years. Heller (1827)
catalogued it as an original
work, and mentioned a small
copy in the same collection
at Schleissheim. In 1852 the
painting, which was discoloured
and damaged by varnishing and
restoration, was sold as a pre-
sumed copy. Becker (1857)
considered it to be the work of
a contemporary imitator of
Dürer and it was subsequently
considered in this light or
treated as a copy by a number
of scholars, including Waagen.
It was Friedländer (1911) who
finally identified it as authentic.
Friedländer (1921) ascribed it
to 1516–20. There are two
drawings related to this paint-
ing: one is a study dated 1519
for the figure of St Anne
(modelled possibly by Agnes
Dürer) in the Albertina, Vienna,
L. 560; the other is a study for
the Child, dated 1520, in the
Kunsthalle, Hamburg, L. 832.

157 ⊞ ⊗ ⁸³×⁶⁵ ₁₅₁₉ 🗐 ⋮

The Emperor Maximilian I
Nuremberg, Germanisches
Nationalmuseum
Although Dürer would already
have been in the employ of
Maximilian I for several years,
the opportunity to paint this
portrait only arose in 1518 at
the Diet of Augsburg when
Dürer was able to make the
pencil drawing of the Emperor
(Vienna, Albertina, L. 546) on
which this is based (see also
no. 158); the Emperor posed
for the drawing on 28 June.
There are drawings of details
which are made use of in both
painted portraits. Maximilian is
shown holding a pomegranate,
which is a secular symbol of
unity and peace. This version
is probably the picture which
Dürer took to Holland with him
and offered to Lady Margaret
(Maximilian's daughter and the
Governor of the Low Countries)
who refused it (Panofsky). At
the top there is a long en-
comiastic inscription referring
to Maximilian's achievements.

158 ⊞ ⊗ ⁷³×⁶¹ ₁₅₁₉ 🗐 ⋮

The Emperor Maximilian I
Vienna, Kunsthistorisches
Museum.
This appears to be the principal

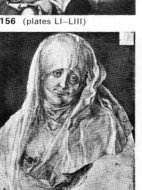

*Preliminary drawings for painting no. 156. (Left) St Anne (Vienna,
Albertina). (Right) Head of the Child (Hamburg, Kunsthalle).*

157

Preliminary drawing for painting no. 157 (Vienna, Albertina).

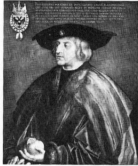

158 (plate L)

Study for the pomegranate in painting no. 158.

version of the two almost identical versions of the subject (see no. 157). This may also be the later version as the changed position of the hands, compared with both no. 157 and the Albertina drawing of *Hands Holding a Pomegranate* (made slightly later than the portrait life drawing), would suggest.

159 ⊞ ⊗ —— 目⋮

Portrait of a Man
Milan, Borromeo Collection
Monogram and date (1519) obviously spurious, as also the indication of the sitter's age as 48. The identification of the sitter as Johannes Tscherte,

mathematician and architect to the Emperor, is completely un-substantiated (see Panofsky who pointed out, in this connection, the woodcut portrait of Tscherte of 1521, B. 170). Thode (JK 1893) ascribed the painting to Dürer, but there is no evidence to support this attribution. The painting is now not considered to be authentic.

160 ⊞ ⊗ ⁶⁹ˣ⁵³ 1520? ☐ ⋮

Portrait of Jacob Fugger the Rich
Munich, Alte Pinakothek
Formerly in the collection of the Grand Elector. The Tietzes (1937) have stated that the background was repainted in 1760. The date (1500) on the back of the canvas was added later. The portrait is based on a well-known drawing of Fugger (Berlin, Kupferstich-kabinett, L. 826) of 1518. The painting was presumably made in 1520 — the date inscribed on a copy in the collection of the Törring family in Munich (Thausing). The Tietzes considered this to be a workshop painting, but Panofsky (1948) thought it an authentic work.

161 ⊞ ⊗ ⁴⁰ˣ³⁰ 1520 ▤ ⋮

Old Man Wearing a Red Beret
Paris, Louvre
The picture has been identified – unconvincingly – with the *Head of an Old Man* which was in the collection of the Governor of the Low Countries in 1780. Weth-Muller (*Albrecht Dürers niederländische Reise*, 1918) identified the sitter as the Portuguese agent Brandano, of whom Dürer made a charcoal drawing in 1520.

162 ⊞ ⊗ ²⁵,⁵ˣ²¹,⁵ 1520 ☐ ⋮

Head of a Woman
Paris, Bibliothèque Nationale
The expression of austerity and melancholy in this portrait suggests that it is not an idealised portrait of Agnes Dürer, as Conway (1905) and Pauli (ZBK 1915) – who dated it 1497 – suggested; Tietze (1928) agreed with this dating. Panofsky (1948), however, accepted the date 1520 proposed by P.du Colombier (1927–8), and related it to the drawing L. 270, dated 1520. The modelling and suggestion of volume in this and the two boys' heads (nos. 163–4) in the same collection is almost sculptural. According to Panofsky these three pictures may be identifiable with the '3 Tüchlein' (small canvases) which Dürer noted in his diary as sold in 1521.

163 ⊞ ⊗ ²²,⁴ˣ¹⁹,³ 1520* ☐ ⋮

Boy with his Head Inclined
Paris, Bibliothèque Nationale.
This and the analogous work in the same collection (no. 164) were formerly in the Marolle Collection. According to Panofsky both works belong to 1520, but the Tietzes dated

159

161

164

them to *c.* 1506. Panofsky considered that they belonged with the *Head of a Woman* (no. 162), but the Tietzes saw no connection between them. The attribution of this pair of pictures was made on the basis of a series of drawings, one of which is dated 1520 and the others 1521; they are almost certainly authentic, as a comparison with no. 162 shows, although the latter is both more idealised and more technically accomplished.

164 ⊞ ⊗ ²³ˣ¹⁸ 1520* ☐ ⋮

Head of a Boy
Paris, Bibliothèque Nationale

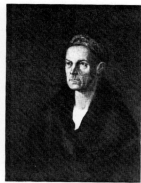

160

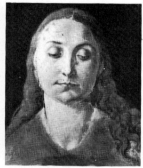

162 (plate LIV)

163

See notes to no. 163 for all details.

165 ⊞ ⊗ ³¹,⁵ˣ²⁶,⁸ *1521* ☐ ⋮

Portrait of Jobst Planckfelt's Wife
Toledo (Ohio), Museum of Art
The identification is based on the style and technique which suggest that this can only have been executed *c.* 1521, during the artist's stay in the Netherlands. It is the only female portrait painted during this period. The sitter was the wife of Jobst Planckfelt, Dürer's host during May 1521 (see no. 171). It was bequeathed to the Toledo Museum of Art

by E. Drummond Lilberg (1936). The Tietzes (1938) considered it authentic, as did Panofsky (1948) – but the latter had some reservations.

166 ⊞ ⊗ ¹⁸,⁷ˣ¹⁹,⁷ 1521 ☐ ⋮

Three Studies of Women's Costumes
Paris, Louvre (Rothschild Collection)
Watercolour drawing with monogram and date and an inscription in old German. Together with nos. 167 and 168 it forms part of a group of three related drawings of agreed authenticity, which were reproduced in woodcut form in the *Habitus praeci-puorum populorum . . .* published in Nuremberg in 1577. The Tietzes (1928) recognised them as late examples of Dürer's "ethnographical" interests, already evidenced in, for example, the costume studies of Nuremberg women (nos. 63–8), and the drawings L. 857 and L. 62 (Milan, Ambrosiana, and Berlin, Kupferstichkabinett), which can also be ascribed to 1521.

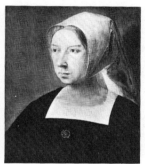

165

167 ⊞ ⊗ ¹⁹¹ˣ²⁰¹ 1521 ☐ ⋮

Two Studies of Women's Costumes
Paris, Louvre, (Rothschild Collection)
See note to no. 166 for all details. The lack of either a monogram or date on this suggested to the Tietzes that it might be a section cut from a larger sheet.

168 ⊞ ⊗ ²⁷⁵ˣ¹⁸⁵ 1521 ▤ ⋮

Study of a Woman's Costume
Paris, Louvre, (Rothschild Collection)
See notes to nos. 166 and 167.

166

167

169 ⊞ ⊗ 60×48 / 1521

St Jerome in Meditation
Lisbon, Museu Nacional de Arte Antiga

There is an entry in Dürer's diary for 2 March 1521 (during his stay in the Low Countries) which reads ''Ich hab ein Hieronymus mit fleiss gemalt von ölfarben und geschenkt dem Rudrigo von Portugal''. The picture was presented to ''Rudrigo'', Ruy Fernández d'Almeida, ambassador of John III. There are some magnificent preparatory drawings connected with the painting (Vienna, Albertina). They consist of studies for the head and an astonishingly simple, classic still life (L. 568–571). Friedländer has discussed this work (*Die altniederländische Malerei*, XII, 1935). There is a copy of the picture by Georg Pencz (dated 1544) in Nuremberg, Germanisches Nationalmuseum.

170 ⊞ ⊗ 51×32 / 1521

Portrait of Lorenz Sterck
Boston, Isabella Stewart Gardner Museum

The monogram has apparently been repainted. The painting was discovered and bought by J.T. Dobie in England (1902); it passed to the art dealer

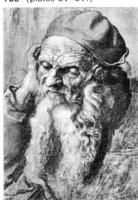

169 (plates LV–LVI)

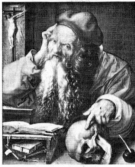

Preparatory drawings for painting no. 169. (Above) Bust of an old man (Vienna, Albertina). (Below) Lectern.

168

Colnaghi, who had it restored by Hauser; the restorations later had to be removed. The sitter was originally erroneously identified as one Lazarus Ravensburger, because of a slight resemblance to the Berlin drawing L. 55. The identification, however, proved unacceptable because Dürer's diary clearly indicates that the Ravensburger portrait was a charcoal drawing mounted on a panel. By eliminating the other two possible sitters mentioned by Dürer during his stay in Holland, i.e. Bernhardt von Resten and Jobst Planckfelt, it has been possible to identify this sitter as Lorenz Sterck, the Tax Collector. The work is obviously of high quality, in spite of the restorations and the fact that the painting has apparently been reduced along both vertical edges, as the long, narrow format and slight compositional imbalance indicate, and as comparison with the Hampton Court copy which shows both hands, proves.

171 ⊞ ⊗ *31×27* (?) / 1521

Portrait of Jobst Planckfelt
This painting now lost must have been executed in the Low Countries (see nos. 165 and 170), but nothing is known about it apart from the brief reference to it by Dürer himself (see the drawing L. 196, Frankfurt).

172 ⊞ ⊗ 20,6×31,5 / 1521

Head of a Walrus
London, British Museum (Sloane)

Watercolour and pen. As well as the monogram and date, there is an inscription in Dürer's hand ''Das dosig thyr van dem ich do das hawbt conterfett hab, ist gefange worden in der niderlendischen see und was XII ellen land brawendisch mit für (?) füssen''. Dürer put up with considerable inconvenience in order to make this drawing; the animal had already been dead for several days when Dürer did the drawing. It is probably the first ever study of a walrus using the real animal as a model.

172

173

174

173 ⊞ ⊗ 17,7×28

Lion Seen in Left Profile
Vienna, Albertina

Watercolour and gouache on vellum. The monogram and date (1521) appear under the lion's stomach, but according to both the Tietzes and Panofsky this drawing is probably not by Dürer but by one of his imitators. It seems possible that it is a careful workshop copy of a lost original.

174 ⊞ ⊗ 16,8×25

Lion Seen in Right Profile
Formerly in the Breuer Collection in Vienna. Like no. 173, of dubious authenticity. Panofsky (1948) thought that it was not by Dürer although he conceded that it had been etched by Hollar as a drawing by Dürer. Similar to no. 173, but the freer handling suggests that if either of these is to be considered authentic it should be this one.

175 ⊞ ⊗ *17×26* (?)

Lion in Repose
Hollar made another engraving of a lion besides the two mentioned above (nos. 173 and 174); so one must assume that another watercolour analogous to the other two existed.

176 ⊞ ⊗ 90×60 / *1523

Man of Sorrows
Pommersfelden, Count Schönborn Collection

Based on a drawing of 1522 (L. 131) formerly in the Kunsthalle in Bremen which shows Dürer as the Man of Sorrows. There is a mezzotint copy by Gaspar Dooms with a monogram and 1523 date; the copy shows some variations on the painting, and the facial

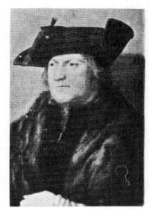

170

176

expression seems closer to that in the drawing, but this may only be the impression given by the photograph which shows that the painting is in very poor condition. The Tietzes and Panofsky accepted it as an authentic work. F.Schneider (MZ 1907) and H.Swarzenski (ZK 1933) established the provenance of the picture from the collection of Bishop Albrecht of Brandenburg (in whose inventory it appears in 1525) and have traced its later history.

177 ⊞ ⊗ 18,7×15,8 / 1523?

Neat's Snout in Front View
London, British Museum

Inscribed with monogram and evidently spurious 1523 date; however, this date seems plausible in view of the stylistic differences between this watercolour and those of animals of some twenty years earlier (nos. 78–83). Although this is only a fragmentary study it is very precisely and powerfully drawn.

178 ⊞ ⊗ 19,9×15,8 / 1523?

Neat's Snout in Profile
London, British Museum

Similar to no. 177 (see note).

179 50×36 1524

Portrait of a Gentleman
Madrid, Prado
The 1524 date is authentic, but
was for a long time read as
1521. On the basis of the date
and the Frankfurt drawing
L. 196 it was identified as the
portrait of Jobst Planckfelt,
Dürer's host in Antwerp, known
to have been painted in May
1521 (see no. 171). It has also
been identified as a portrait of
Hans Imhoff the Elder (who
died in 1522) by Thausing, as
Hieronymus Holzschuher by
Frizzoni, and Lorenz Sterck by
Glück, etc. The correct reading
of the date invalidated all these
suggestions. This sitter is
obviously a man of culture and
of an altogether higher social
status than Planckfelt. The
personage is still unidentified.
The painting was formerly in
the collection of Philip II in
Madrid.

180 30×42 1525

Flood (Dream Vision)
Vienna, Albertina
This is dated and has a long
inscription in Dürer's writing. It
is a moving and extremely
beautiful image, suffused with
a haunting, visionary quality. It
represents a deluge which
Dürer dreamed after Whit-
suntide 1525, and related to a
belief, widespread in the
unsettled Germany of this
period, that the world would
be destroyed by a flood.

The Four Apostles

181 215,5×76 1526

**A. St John the Evangelist
and St Peter**
Munich, Alte Pinakothek
Given to the City of Nuremberg
by the artist, together with the
pendant no. 181 B, in return
for 100 florins for himself, 12
for his wife and 2 for his maid.

177

178

180

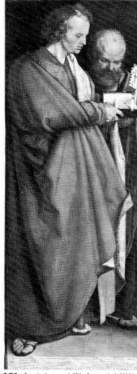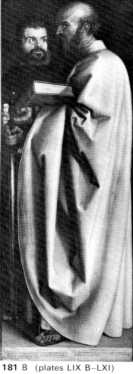

181 A (plates LIX A and LXII) 181 B (plates LIX B–LXI)

These are two of Dürer's
most important late paintings
and his last large scale works.
Voll (SM 1906) and Panofsky
(1948) considered that no.
181 B was begun as the wing
of a triptych and represented
St Philip, that this saint was
subsequently changed to a St
Paul with St Mark added, and
that the metalpoint drawing of
St John the Evangelist, dated
1525 (L. 368, Bayonne, Musée
Bonnat), which was never
engraved, is a study for the
present painting. The docu-
mentary evidence relating to
the series of engravings of the
apostles which Dürer began to
publish in 1523 indicates that
there was also a St Philip
(B. 46) which was signed and
dated 1523, with the date
corrected to 1526 (for which
there is a drawing in the
Albertina, signed and dated
1523). Panofsky further sug-
gested that Dürer might have
held back the publication of
the St Philip print in 1523 and
decided to use the figure and
that of its *pendant*, St James,
for two larger than life size

paintings, using St Philip for
the first. In 1525 (the date of
the Bayonne drawing) Dürer
must have changed his
original plan: the St James was
transformed into the St John
the Evangelist, accompanied by
St Peter, of this picture, and in
the other, St Philip was re-
placed by St Paul, with a sword
replacing the earlier staff, the
right hand lowered, the head
altered, and the figure of St
Mark added. This hypothesis
has not been confirmed by
either the scientific examination
of the panels carried out by the
museum or by K. Martin's
recent work. On the other hand
a similar theory that the two
panels, now united, were
intended originally as the wings
of a triptych similar to Bellini's
Frari Altarpiece of 1488 is more
plausible: the long narrow
format of the panels strengthens
this view. None of the various
suggestions put forward as to
the subject of the centre piece
of this supposed triptych – a
Sacra Conversazione (Pauli;
Panofsky); a *Crucifixion*
(Springer); a *Transfiguration*

(Ephrussi); a *Last Judgement*
(Thausing) – can be accepted
as definitive, as there is no
evidence in either the drawings
or in Dürer's writing to support
them. It is possible that the
commission for the projected
triptych failed to materialise
and that Dürer decided to offer
the panels to the city as a
"small gift" or "memento"; they
were completed with long
inscriptions invented by Dürer
and written by a professional
calligrapher named Johann
Neudörffer. The inscriptions are
of an admonitory and morali-
sing character. Catholics and
Protestants have attempted to
interpret them to their own
advantage, but they are anti-
sectarian.

With the support of some of
its most influential citizens,
including Pirckheimer, the City
of Nuremberg had decided to
"give leave to the Pope" in the
Spring of 1525, and it was
perhaps for this reason that the
triptych originally planned by
Dürer was abandoned.
The four Saints, however, were
general Christian images rather
than specifically Catholic ones.

The Reformation erupted
with such explosive violence
that many of its original sup-
porters, like Pirckheimer, were
alienated and returned to
Catholicism. Dürer's paintings
bear witness to the event
through their inscriptions. In
1627 these inscriptions were
sawn off when the paintings
were transferred from Protes-
tant Nuremberg to Catholic
Munich, and they have been
restored to the paintings only
recently.

Some art historians have
attempted to discover whether
there is a kind of hierarchic
discrimination in the placing of
the Saints: in the foreground
are St John – Luther's favourite
Evangelist – and St Paul – who
is generally accepted as the
spiritual father of all Protestants
(who are called Paulines for
precisely this reason); obviously
intentionally subordinate to
these two, in the background
of each panel, are St Mark and
St Peter (the latter still shown
with his keys as primate of the
church). Quite recently the
figures have been identified as
portraits of Nuremberg worthies.
The calligrapher Neudörffer
informs us, in a short book of
1546, that the four saints
represent the four humours:
the sanguine, the choleric, the
phlegmatic and the melan-
cholic, which are here identified
with four essential forms of
religious experience. According
to Panofsky, the ruddy com-
plexioned but gentle St John
represents the sanguine; St
Mark, with his yellowish skin
and gnashing teeth, is the
choleric (his symbol is the
lion); the forbidding, "dusky
faced" St Paul – who intro-
duced asceticism to Christian-
ity, the melancholic; St Peter,
tired, an old man with down-
cast eyes, is the phlegmatic.
Sulzberger (GBA 1959) pointed
out that these might have been
inspired by Raphael's cartoons
of the *Acts of the Apostles*
in Brussels.

181 214,5×76 1526

B. St Mark and St Paul
Munich, Alte Pinakothek
See note to 181 A for all details.

182 43×31 1526

**Virgin and Child (Virgin
with the Pear)**
Florence, Uffizi
Accepted as an authentic work
by various art historians, in-
cluding the Tietzes (1938) and
Panofsky (1948), although the
latter agreed with Stechow
(AB 1944) who suggested
that the painting should be
scientifically examined. This is
a late work, in which the
compactness of volume and
the fresh, bright colours are
combined with Flemish
reminiscences.

183 48×36 1526

Portrait of Jacob Muffel
Berlin, Staatliche Museen
Inscribed at the top: "EFFI-
GIES. IACOBI. MVFFEL./
AETATIS. SVAE. ANNO.

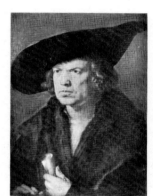

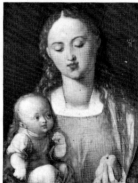

179 (plate LVII)

182 (plate LVIII)

183 (plate LXIV)

LV./SALVTIS. VERO. MDXXVI." followed by Dürer's monogram. The painting was transferred from the original panel to canvas in 1870. Formerly in the Schönborn Collection at Pommersfelden; later in the Narischkine Collection in St Petersburg; acquired in Paris in 1883.

Muffel was mayor of Nuremberg when Dürer presented the *Four Apostles* to the

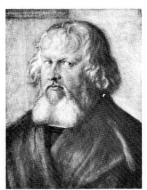

184 (plate LXIII)

Coats of arms of the Holzschuher and Münzer families, on the back of no 184.

city, so there may possibly be some connection between the panels and this portrait. Both this picture, and no. 184, to which it is related sylistically and which has identical dimensions, were painted for Nuremberg dignitaries and presumably for some official purpose, probably to hang in some public building. In both portraits the features are sculpturally modelled, and colour is subordinate to line. The background in both is light blue, which is unique amongst Dürer's portraits of men. Panofsky (1948) has discerned in them a deliberate contrast of character, achieved by a subtle, probably intentional, humour. The Tietzes mention two copies in Nuremberg, one in the Germanisches Nationalmuseum and one in a private collection.

184 ▦ ✛ 48×36 1526 ▤⋮

Portrait of Hieronymus Holzschuher
Berlin, Staatliche Museen
Bears, besides the monogram (on the right), an authentic inscription: "HIERONIMVS. HOLZSCHVHER. ANNO. DONI. 1526/ETATIS SVE. 57". The painting forms a pair with no. 183. The sitter was a

senator and a member of the Council of Seven of Nuremberg. On the back of the picture are the Holzschuher and Münzer coats of arms, enclosed in a laurel wreath, and the date 1526. The Tietzes indicated a copy by Hans Hoffmann of 1578, in the Schlossmuseum at Gotha (formerly in the Praunschen Kabinett).

185 ▦ ✛ 37×37 1526 ▤⋮

Portrait of Johannes Kleberger
Vienna, Kunsthistorisches Museum
A greyish-blue roundel containing a simulated sculptural relief portrait of the sitter. Around the edge of the medallion is the inscription "E. IOANI. KLEBERGERS. NORICI. AN. AETA. SVAE. XXXX". In the four corners are painted Kleberger's coat of arms and emblem and Dürer's monogram and the date. Although the head is painted in naturalistic colours (i.e. not monochrome like the background), the parallel with Greek and Roman examples is quite obvious. It is Dürer's only portrait of this type, and one of his most striking and effective images, perhaps for precisely this reason. The sitter, a native of Nuremberg, was the son of a man of humble origins (one Scheuenpflug), who had been obliged to leave Nuremberg, but later returned under another name and with an immense fortune; he fell in love with Pirckheimer's favourite daughter, Felicitas, and married her in 1528, in the face of strong opposition from Pirckheimer, but abandoned her after a few days, and went to France. His

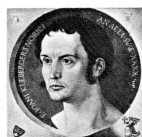

185

186

wife died one and a half years later. Kleberger spent the rest of his life in Lyons, gradually giving away all his fortune. On his death, the poor erected a wooden statue to "le bon Allemand", of which a replica still exists. The unusual iconography of this magnificent portrait was probably inspired by Hans Burgkmair's series of woodcuts of Roman Emperors (A. Burkhard, *Burgkmair*, 1932). The Tietzes (1938) also pointed to a probable source in Mantegna, as well as "the twelve ancient Emperors in medallions" engraved by Marcantonio Raimondi "of which Raphael sent some to Flanders to Albert Dürer" (Vasari, *Life of Raimondi*). On Kleberger's death the painting passed to his stepson Willibald Imhoff; later it passed from the Imhoff Collection to Rudolph II

186 ▦ ✛ 52,5×27,8 1527 ▤⋮

Head of a Child with a Long Beard
Paris, Louvre
Monogram and date authentic. Panofsky was originally dubious about the painting but then proposed (1948) an identification of the painting with another described by Camerarius in the Latin translation of *de Symmetria Partium* (1532) as executed without preliminary drawings. We do not know whether Dürer was recording the appearance of a genuine freak (like all his generation he was fascinated by this kind of curiosity) or whether the image was intended to represent the *Paedogeron* (symbolising at one and the same time old age and youth, antiquity and posterity) allegedly represented — according to a mistranslation of Plutarch's *De Iside et Osiride* by the Italian humanist Celio Calcagnini — in the temple at Sais in Egypt. As a type, the face could be compared with the *Boys' Heads* of c. 1520 (nos. 163—4).

187 ▦ ✛ 1527 ▤⋮

Bearing of the Cross
The composition is known only through copies, the best of which (according to Tietze, Panofsky etc.) is the *grisaille* version (panel, 29 × 45 cms.) formerly in the Cook Collection in Richmond. The original must have been a larger panel, painted for the Emperor, (not Maximilian, as some people have suggested, but Charles — by virtue of the date of the picture) and may have been a

gift from the City of Nuremberg. It was described as a "gar chöne grosse taffel" in the inventory of the Imperial *Kunstkammer* of 1621. Van Mander (who mistook the Roman eagle on the large standard for the Nuremberg emblem) described it; so did Sandrart.

The work in the Cook Collection is evidently not the original, because of its size. It was acquired from the Saldanca Collection in Lisbon in 1871, and is almost certainly the version which was sold in 1633 by the Imhoff family of Nuremberg, although several historians have considered it as a later copy. It may in fact be the only version actually made under Dürer's supervision, and must be the version ordered by the Nuremberg dignitaries; but see also the Bergamo and Dresden versions mentioned below. If this is a workshop replica supervised by Dürer, the defects and harshness of style which go side by side with brilliant details in the complex and dynamic composition would be accounted for. The way in which the whole picture is animated is only paralleled in the work of Tintoretto.

There is a long inscription in Latin along the bottom edge of two of the versions, including the Cook one, which reads "ALBERTUS. DURER. SUPER. TABULA. HAC. COLORIS. CINERICII. FORTUITO. ET. CITRA. VLLAM. A. VERIS. IMAGINIBUS. DELINEATIONEM. FACIEBAT. ANNO. SALUTIS. M.D. XXVII. AETATIS. VERO. SUAE. LVI" followed by Dürer's monogram. Panofsky has

interpreted this "On this panel Albrecht Dürer has made a design of ash grey colour, fortuitously, and without the aid of any [design] from real images [without studies from life]". This description is self-explanatory and to the point, but it has been suggested that it is neither authentic nor materially true. It is an explanation rather than an *apologia*, indicating that the event represented has been constructed in Dürer's imagination, without the help of studies from life (although preparatory drawings do exist, the most important being the Uffizi drawing, signed and dated 1520, L. 843). Panofsky, in pointing out that the inscription reflects Dürer's views on "painting out of one's head" or "heart", and in reminding us that Joachim Camerarius, in his introduction to his translation of the treatise on human proportion (*Alberti Dureri de symmetria partium*) constantly emphasises these views and the artist's ability to paint "nulla designatione praemissa" or "nullis antea dispositis delineationibus", conjectures that Camerarius himself, who was very close to Dürer in 1526, may have been the author of the inscription on the *Bearing of the Cross*. Panofsky's thesis is supported by the commemorative tone which is a marked feature of the inscription.

The Bergamo version (panel, 32 × 47 cms.) in the Accademia Carrara — formerly in the Lochis Collection — bears a similar inscription which is followed by the words "Maes Imp.", probably signifying that the work was dedicated to the Emperor or in his collection, and also has Dürer's monogram. This painting is of a quality comparable to the former Cook version, and in fact seems more spontaneously painted, which has suggested to the Museum cataloguers (Ricci, 1924; Morassi, 1930; Russoli, 1967) that this may be an authentic work.

The third version, in Dresden (Gemäldegalerie store) bears only the inscription "Imp. Maes".

Other works attributed to Dürer

The works listed in this section (alphabetically according to places) have in the past been attributed to Dürer on the basis of tradition or of scholarly opinion, but are not now generally accepted by modern Dürer scholars.

188. Holy Family
Basle, Öffentliche Kunstsammlungen
Watercolour on paper (42.2 × 28.3). The Holy Family is shown in the setting of a Renaissance loggia; this unusual iconography has prompted

various interpretations (Glück; Heidrich; Flechsig; Buchner; Hugelshofer). According to Panofsky, however, the work is incompatible with Dürer's spirit in both style and iconography. The Tietzes' opinion (1938) that the present work is a project for a panel by Jörg Breu in the church at Anfhausen, and that it was generally executed in Breu's workshop, has been generally accepted, despite Musper's interpretation (P 1938). The Tietzes also drew attention to a copy on a brown ground and heightened

with gold, bearing Dürer's monogram and the date 1509, which is in the Dresden Gemäldegalerie.

189. Portrait of a Woman
Bergamo, Accademia Carrara
Panel (42 × 33). A. L. Mayer suggested that this was by Dürer (P 1929), but the work has been rejected by almost all Dürer scholars, including the Tietzes and Panofsky. Frizzoni (1907) attributed it to an unknown Venetian master of the late fifteenth century.

190. Portrait of Hans Gunder of Nuremberg
Berlin, Staatliche Museen
Panel (39 × 32.5). The monogram and 1509 date which are visible are both spurious. Provenance from the Yerkes

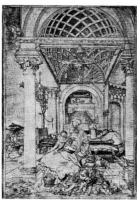

188

190

192
Collection (1900). According to the Museum cataloguers (1966), it is by Martin Schaffner. Winkler (1929) thought that it was a copy of an authentic Dürer of 1509; according to Tietze (*Anzeiger des germanischen Museums*, 1934–5) it may be by Hans Dürer; Panofsky (1948) denied any stylistic connection between this work and Dürer's work, although he conceded that the date (added later) would fit.

191. Portrait of a Man
Brussels, Musée Royal des Beaux-Arts
Panel (22 × 15.5). Friedländer (in *Thieme-Becker*, 1914) proposed an attribution to Dürer which Winkler originally supported but later rejected, as the Tietzes indicated (1938). According to R. Eisler (OM 1943) it would have been painted by Dürer at Antwerp and would be a portrait of the astronomer Nicolaus Kratzer. Panofsky (1948), in rejecting Eisler's assumptions, pointed out that the portrait of Kratzer, made by Dürer when he was in Holland, is specifically referred to in the diary as a drawing (which may be the drawing L. 380 in the Louvre), and that the features of the sitter in the present work do

189

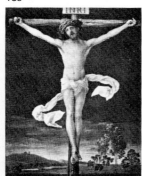

193

195
not remotely resemble those of the famous astronomer, whose physical characteristics are known to us through the Louvre portrait of him by Hans Holbein the Younger painted in 1528 (in which Kratzer appears much younger than the sitter in the Brussels picture which is supposed to have been painted eight years earlier in 1520). The Tietzes saw no connection with Dürer; Panofsky attributed this to the Flemish school.

192. Portrait of a Man in Armour
Cincinnati, (Ohio), Art Museum
Panel (40.1 × 35). Formerly in the Ashburton and Rothschild Collections in London, and in the Amery collection, Cincinnatti. Listed by Friedländer (in *Thieme-Becker*, 1914) as an authentic work. Tietze (AB 1933) attributed it to an anonymous north German painter of around 1540–50, and Panofsky agreed with this (1948).

193. Christ on the Cross
Dresden, Gemäldegalerie
Panel (20 × 16). Monogram and date (1506). This work was well known until the beginning of the century, but lost all interest when it was redated, by common consent, to the second half of the sixteenth century. Probably school of Cranach the Younger.

194. Iris
Escorial, San Lorenzo Monastery
Watercolour and gouache on paper. Of dubious authenticity according to Panofsky (1948), but if genuine *c.* 1503.

195. Stag-Beetle
Paris, Delon Collection
Drawing coloured with tempera, (14.2 × 11.5). Monogram and date (1505) in pen. The tip of the top left claw has been reworked. Accepted as authentic by Lipmann (no. 169); ascribed to the circle of Dürer by the Tietzes (1928) on the basis of differences in handling, and anatomical incorrectness, compared with the stag-beetle which appears in the *Virgin with a Multitude of Animals* (no. 96) and in the *Adoration of the Magi* (no. 106). As the insect appears in both these pictures as well as in copies of this drawing in Berlin and Budapest made by Hans Hofmann, it is possible that there was originally a drawing by Dürer himself.

196. The Trinity and St Michael, St Martin, St Christopher and St George
Nördlingen, Salvatorkirche
Published by Sitzmann (SDK 1933). Not authentic, according to the Tietzes (1938) although they had not seen the original. A provincial work, with very slight Dürerian reminiscences, according to Panofsky (1948).

197. St Augustine (?) with Canons
Rotterdam, Boymans-van Beuningen Museum
Gouache on paper, with Dürer's monogram (not genuine). Executed around 1500, according to Panofsky (1948). It has been considered as an authentic work on the basis of the Albertina drawing L. 697, which belongs to a series of drawings for the stained glass windows commissioned by the Pfinzing and Tetzel families for the cloister of St Egidius in Nuremberg (there is one stained glass window in the museum at Gotha). The drawings, which are now dispersed in various public collections, cannot be

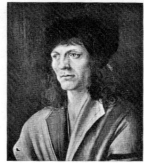

198

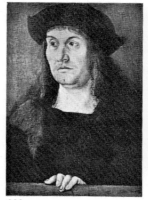

200

attributed to Dürer, but are certainly from his workshop; this work may be, like the drawings, by the Master of the St Benedict Legend (see Panofsky).

198. Portrait of a Young Man
Warsaw, Muzeum Narodowe
Panel (41 × 32). The Tietzes (1932) confirmed Buchner's suggestion that this should be

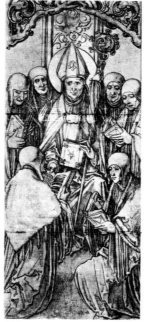

197
attributed to Hans Schäufelein, as did Panofsky (1948); probably datable to around the same time as the *Portrait of Oelhaffen* (no. 200).

199. Altarpiece of St Quirinus
Wimpfen am Berg, Evangelical Parish Church
Sitzmann's attribution of this work to Dürer (SDK 1933) has no historical or stylistic basis according to the Tietzes and Panofsky (1938 and 1948).

202

Coat of arms painted on the back of no. 202.

200. Portrait of Sixtus Oelhafen
Würzburg, Universitätsbibliothek
Panel (43 × 30), dated 1503 and erroneously inscribed at a later date "Sixtus Oelhafen 53. aetatis suae anno MDCIII in Schöllenback". The sitter was a court councillor and politician. He was born in 1466 and would therefore have been thirty seven years old in 1503, not fifty three. The date has been carelessly rewritten, and "in Schöllenback" was added only in 1512. It is not by Dürer; it is now generally ascribed to Hans Schäufelein (as suggested by Friedländer).
The Tietzes (1938) indicated a copy bearing the coats of arms of Oelhaffen and his wife Barbara Rieten, and the date 1508, at Brüssler's, the auctioneers.

201. Standing Nude Woman
Present whereabouts unknown
Tempera on canvas, laid down on paper (21.6 × 8.3). First indicated by Singer (1921), when it was in the collection of Prince Frederick Augustus of Dresden, as an authentic early work. According to Tietze (1927) it is an imitation of Bosch datable to about 1500. Panofsky denied any connection with Dürer.

202. Portrait of a Gentleman (Hans Hermann or Hörman?)
Present whereabouts unknown
Panel (36.5 × 29). Glück (P 1931) and Zimmermann (ZBK 1931–2) made a tentative identification of the sitter, from the coat of arms painted on the back, as Hans Hermann or Hörman, a city councillor of Kaufbeuren. Fairly recently it appeared in trade in New York as an authentic work, although it had already been rejected by the Tietzes (1938); according to Panofsky it would belong to the Swabian rather than the Franconian school of painting. *115*

Appendix
Dürer the engraver

On the next three pages can be found a selection of Dürer's graphic work; its aim is to show the variety and richness of themes of that artist and the wide sweep of his interest. This selection also shows Dürer's dual artistic formations, the German Gothic and the Italian Renaissance.

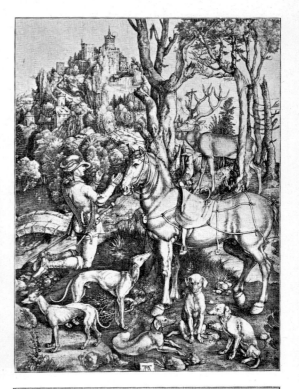

 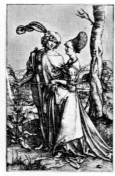 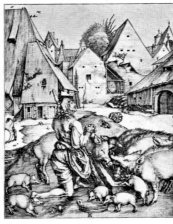

(From left) The Proposition *(c. 1495; etching [all the following are etchings], 15,1 × 13,9; B.93).* The Promenade *(c. 1496–8; 19,2 × 12; B.94).* The Prodigal Son *(c. 1496; 24,8 × 19; B.28).*
(Below, left) The Four Witches *(1497; 19 × 13,1; B.75).*

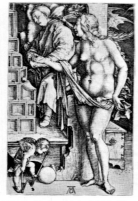 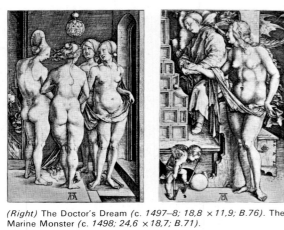 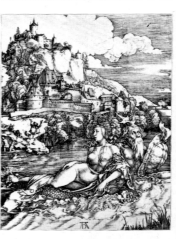 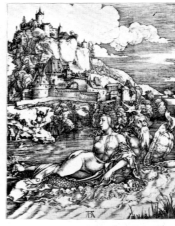

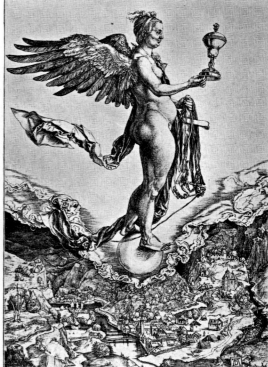

(Right) The Doctor's Dream *(c. 1497–8; 18,8 × 11,9; B.76).* The Marine Monster *(c. 1498; 24,6 × 18,7; B.71).*

(From top) St Eustace *(c. 1500–2; 35,5 × 25,9; B.57).* Nemesis (Die grosse Fortuna; *c. 1501–3; 32,9 × 22,4; B.77).*

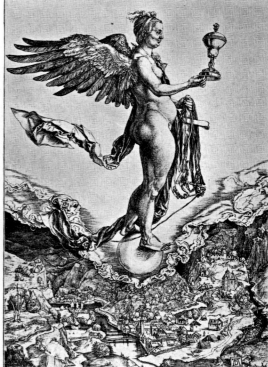

(Above, from left) Hercules (Der Hahnrei *or* Der grosse Satyr; *c. 1498–9; 32,3 × 22,3; 2nd state; B.73).* Death's Escutcheon *(1503; 22 × 15,9; B. 101).* *(Right)* The Cannon *(1518; aquatint, 21,7 × 32,2; B. 72).*

116

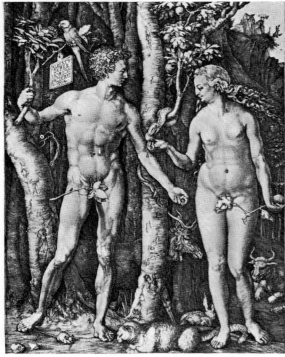

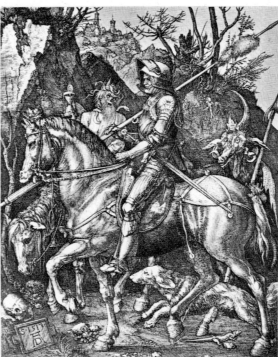
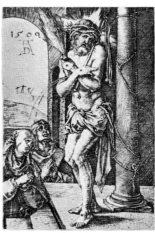

(Above, from left) Adam and Eve (1504; 25,2 × 19,4; 2nd state; B.1). The Knight, Death and the Devil (1513; 25 × 19; B.98). The Large Horse (1505; 16,7 × 11,9; B.97). Christ Crowned with Thorns, the Virgin and St John (1509; from the Small Passion of 1507–13; 11,6 × 7,5; B.3). (Below, from left) St Jerome in his Study (Hieronimus in Gehäus; 1514; 24,7 × 18,8; B.60). Melancholy (Melencolia I; 1514; 23,9 × 16,8; 2nd state; B.74).

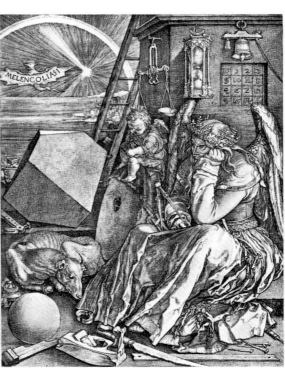

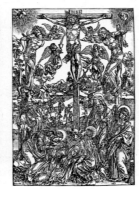
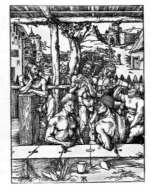

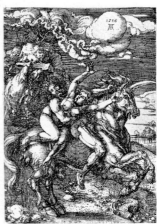

(Above) Peasants Dancing (1514; 11,8 × 7,5; B.90). The Rape on the Unicorn (1516; 30,8 × 21,3; B.72). (Left) Archbishop Albrecht of Brandenburg (1523; 17,4 × 12; B.103). Erasmus of Rotterdam (1526; 24,9 × 19,3; B.107). The Great Crucifixion (xilograph, 57 × 38,9; from the "Albertina Passion", c. 1495). The Men's Bath House (c. 1496; 39,1 × 28; B.128).

117

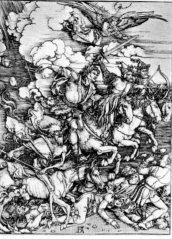
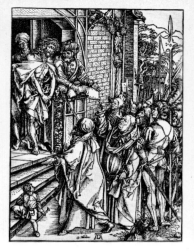
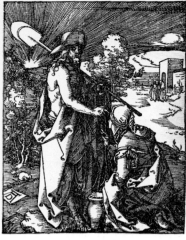

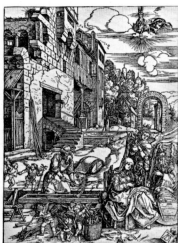
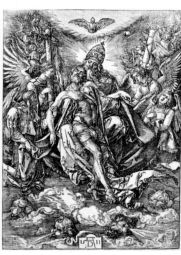

(Above, from left) The Knight and the Lansquenet (c. *1496–7; woodcut [and the following also],* 38,6 × 28; *B.131).* The Four Horsemen *(1497–8; fifth "piece" of the* Apocalypsis cum figuris, *published in 1498;* 39,3 × 28,3; *B.64).* Ecce Homo (c. *1497–8; fifth "piece" of the* Great Passion, *published in 1511;* 39,1 × 28,1; *B.9).* Noli me Tangere (c. *1510; thirty-second "piece" of the* Small Passion, *also published in 1511;* 12,7 × 9,7; *B.48).*

(Left) Rest during the Flight into Egypt *or* The Holy Family in a Courtyard (c. *1501–2; fifteenth "piece" of the* Life of the Virgin, *woodcut, published in 1511;* 29,5 × 21; *B.90).* The Holy Trinity *or* The Throne of Grace *(1511; ibid;* 39,2 × 28,4; *B.122).*

(Below, from left) The siege of a fortress, *1 and 2 (woodcuts,* 22,4 × 38,1 *and* 22,4 × 34,6 *respectively; from Dürer's treatise on fortifications* (Unterricht zur Befestigung der Städte, Schlösser und Flecken, *published in 1527; B.137).* The Rhinoceros *(1515; ibid.,* 21,2 × 30; *B.136).*

(From left) The Triumphal Arch of Emperor Maximilian I *(1515, published c. 1517–8; woodcut,* 340,9 × 292,2; *B.138).* The first two "pieces" of the Triumphal Chariot (c. *1516–8; from* The Triumphal Procession of Maximilian I; *woodcut,* 46,8 × 231,8; *published between 1522 and 1526; B.139).*

Indexes

Subjects and titles